Jen

Madonna

Justin

People
CELEBRITY
Transformations

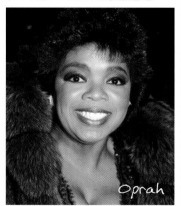
Oprah

George

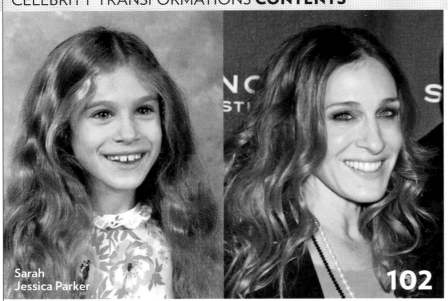

Sarah Jessica Parker

102

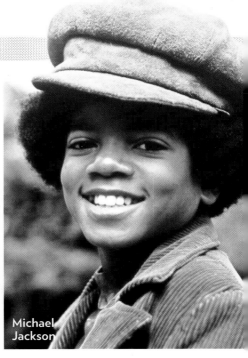

Michael Jackson

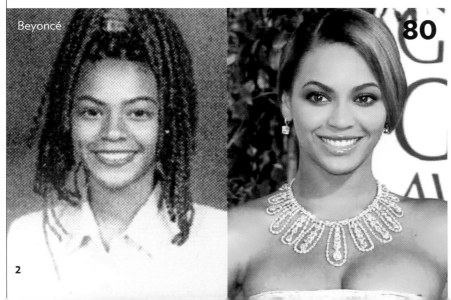

Beyoncé

80

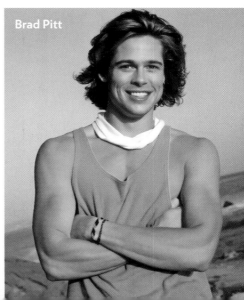

Brad Pitt

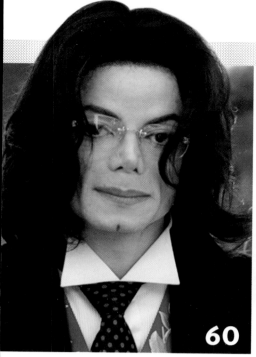

60

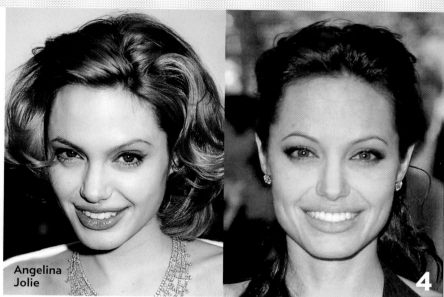

Angelina
Jolie

4

TIME WAITS FOR NO MAN—AND, IN ALL LIKE-lihood, very few women (although all the science isn't in yet). Additionally, researchers have concluded, it's virtually impossible for any man—even **George Clooney**—or woman, whether celebrity or civilian, to live a life unblemished by bad hair days (or decades), regrettable fashion choices and/or embarrassing high school photos. (This may be particularly true of anyone who lived through the '80s.)

From **Madonna** to **Queen Elizabeth,** with ample stops at **Angelina Jolie, Michael Jackson, Brooke Shields, Brad Pitt, Drew Barrymore, Sarah Jessica Parker** and **Britney Spears,** *Celebrity Transformations* takes a photographic look at more than 50 stars and how they grew, from childhood to the present day. Who was a cute baby? Who blossomed after high school? Who doesn't even come *close* to looking their age? To find out, turn the page . . .

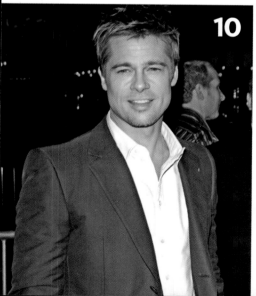

10

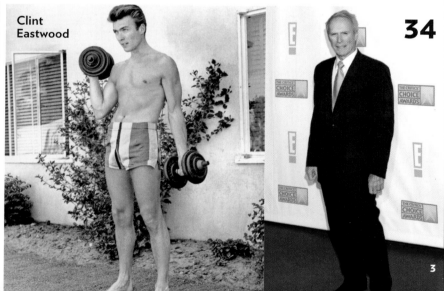

Clint Eastwood

34

MOVIES

BIG STARS—INCLUDING
BRAD PITT, ANGELINA JOLIE,
JOHNNY DEPP, JULIA ROBERTS
AND JACK NICHOLSON—
AND HOW THEY GREW

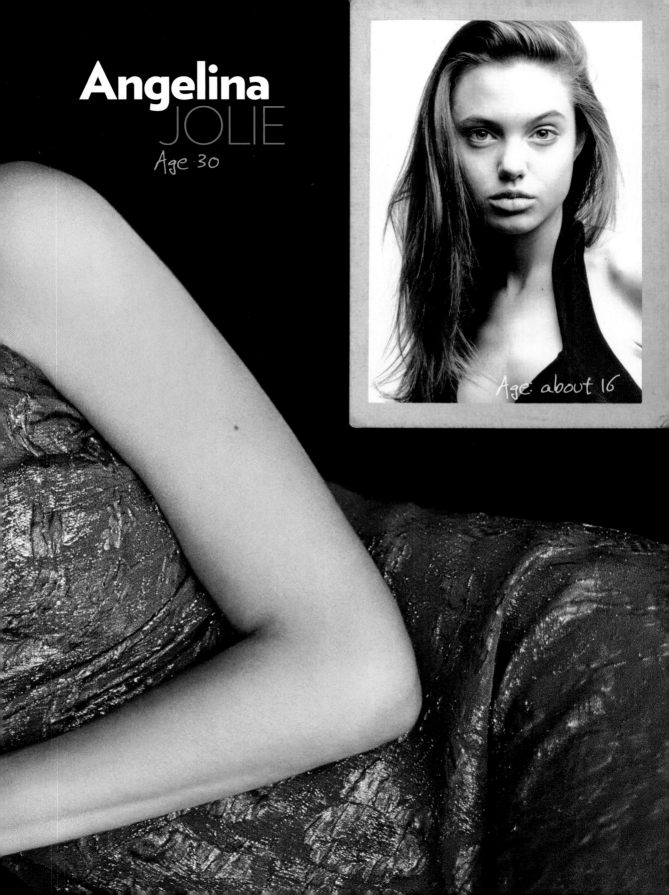

Angelina
JOLIE
Age 30

Age: about 16

Age 2

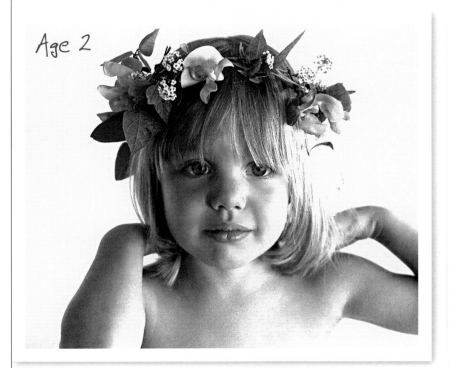

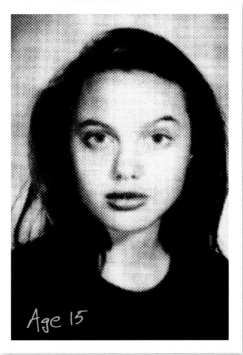

Age 15

ANGELINA Jolie

THE GREAT METAMORPHOSIS: FROM SCARY WILD CHILD TO GLAMOROUS, GENEROUS, JET-SET MOTHER OF SIX

EVERYONE IS SO TAME AND CAREFUL," **Angelina Jolie** once marveled of Hollywood after jumping into the pool, in her Randolph Duke gown, at the Beverly Hilton Hotel when she won a Golden Globe for her role in *Gia.* From her perspective, she was right: No doubt *some* of her fellow actors had studied embalming, collected knives, owned a vial of their spouse's blood and tattooed "What nourishes me also destroys me"—in Latin—below their navels. But Jolie is probably the only Hollywood habitué who did *all* those things.

And then she did something *really* unexpected: Jolie dialed back her wild ways and became a U.N. goodwill ambassador and mother of six—which may provide all the insanity anyone needs. "It's chaos," she says, "but we are managing it and having a wonderful time."

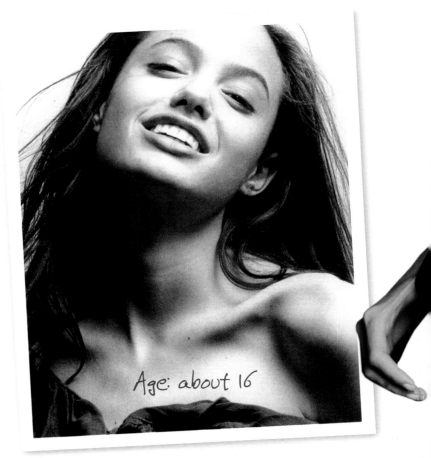

Age: about 16

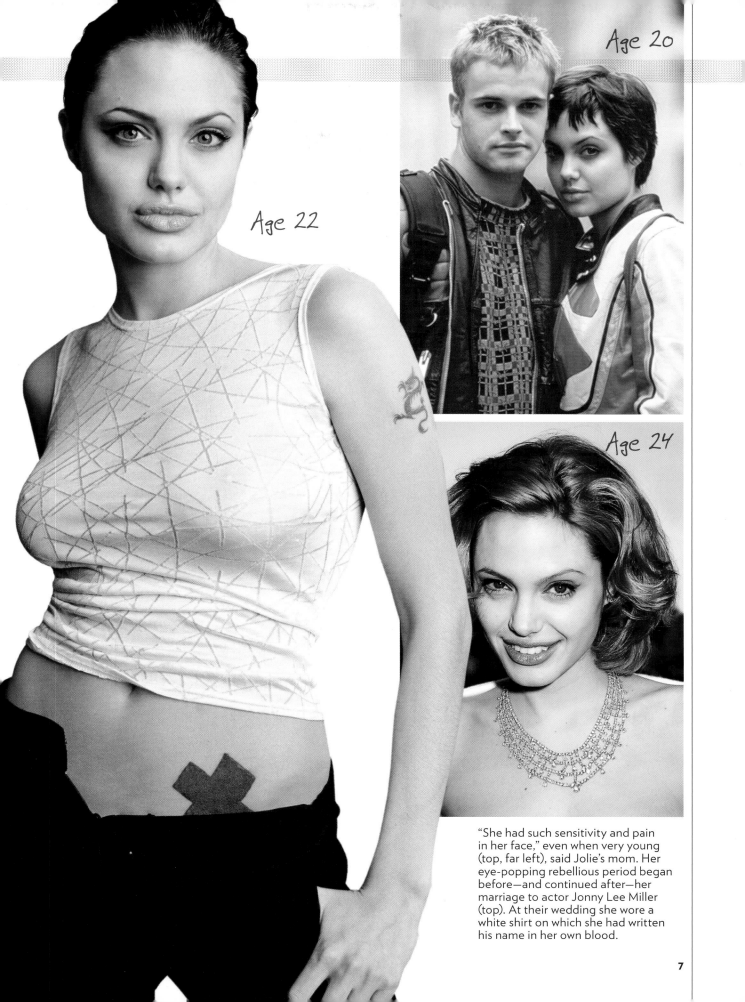

Age 22

Age 20

Age 24

"She had such sensitivity and pain in her face," even when very young (top, far left), said Jolie's mom. Her eye-popping rebellious period began before—and continued after—her marriage to actor Jonny Lee Miller (top). At their wedding she wore a white shirt on which she had written his name in her own blood.

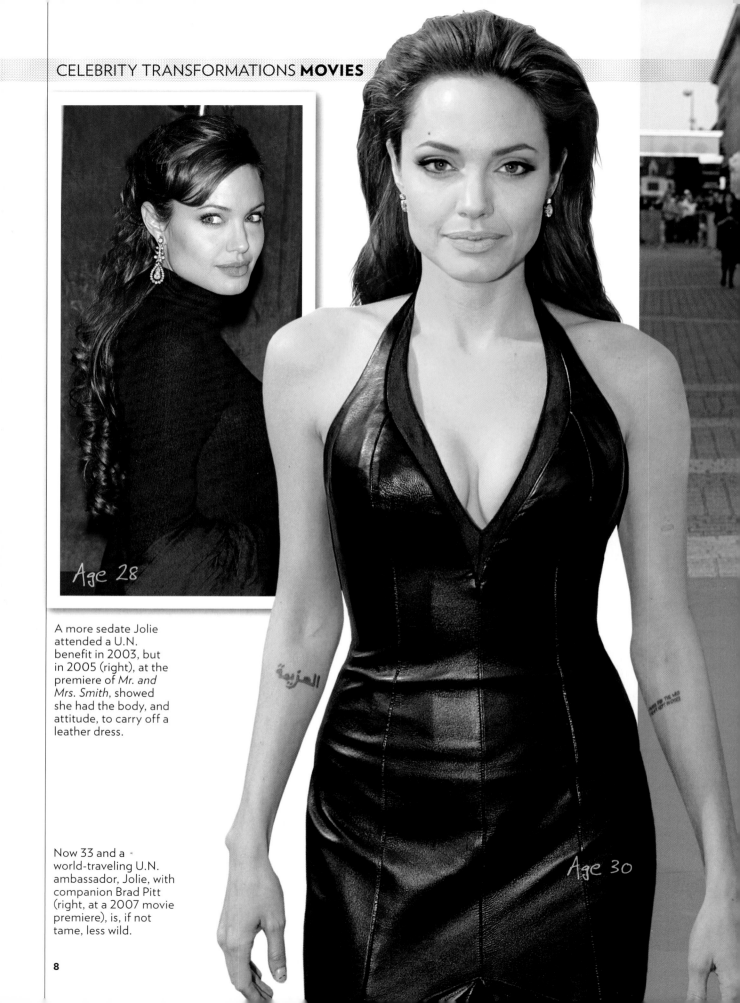

Age 28

A more sedate Jolie attended a U.N. benefit in 2003, but in 2005 (right), at the premiere of *Mr. and Mrs. Smith*, showed she had the body, and attitude, to carry off a leather dress.

Now 33 and a world-traveling U.N. ambassador, Jolie, with companion Brad Pitt (right, at a 2007 movie premiere), is, if not tame, less wild.

Age 30

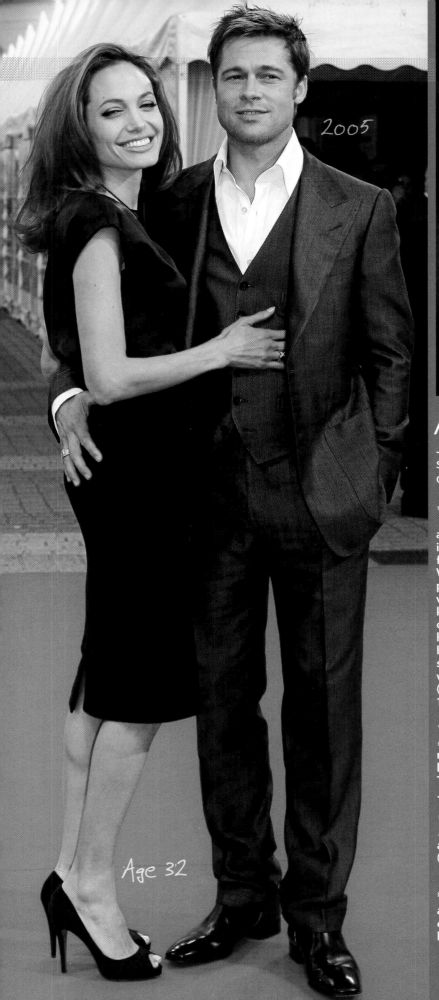

2005

Age 32

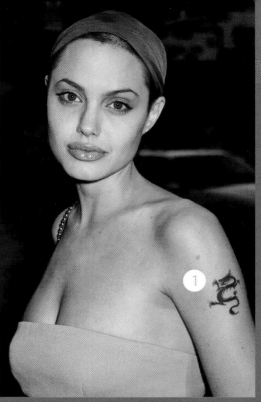

A life in INK

Jolie's body is, in some ways, an open book

1. The actress has at least a dozen tattoos, including a quote from Tennessee Williams, "A prayer for the wild at heart, kept in cages," on the inside of her left arm. On her left shoulder, she started with a dragon (photographed in 1997) . . .

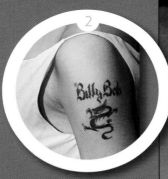

2. Added the first names of then-husband Billy Bob Thornton (2000) . . .

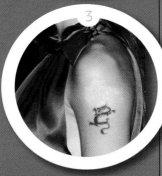

3. Removed Billy Bob after they split (2003)

4. And eventually added the birth coordinates of her six children.

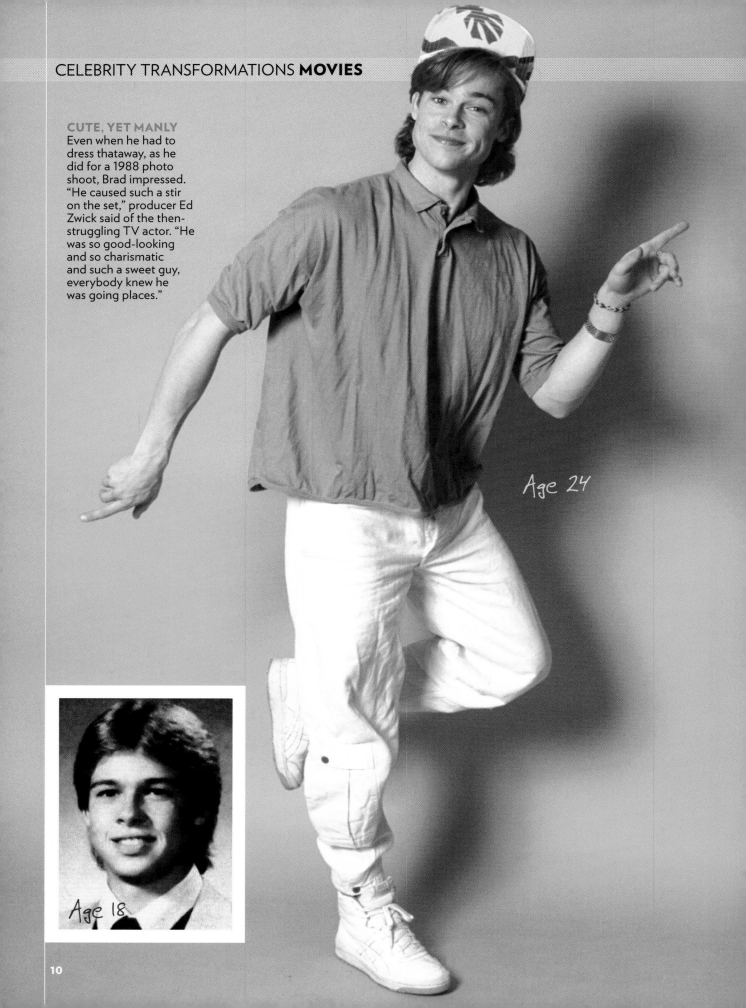

CUTE, YET MANLY
Even when he had to dress thataway, as he did for a 1988 photo shoot, Brad impressed. "He caused such a stir on the set," producer Ed Zwick said of the then-struggling TV actor. "He was so good-looking and so charismatic and such a sweet guy, everybody knew he was going places."

Age 24

Age 18

BRAD Pitt

YES, HE'S FAR, FAR MORE THAN A HUNK. BUT HE'S STILL HOT. IS THAT SO WRONG?

WILLIAM BRADLEY PITT'S OFF-THE-chart hotness first registered at the age of 6, when the choirboy drove his church pianist to distraction. "You couldn't keep from watching Brad," she said. His third grade teacher testified that his high degree of hotocity was "big old blue eyes and dimples"-driven. In adulthood the heat levels could prove dangerous. "When he looked at me," noted a Brad-wobbled waitress, "I was worried I would drop his roast chicken and lemonade in his lap." Others would happily risk worse. "He has the greatest lips," sighed country's Patty Loveless years ago. "I know he's married, but I just love him."

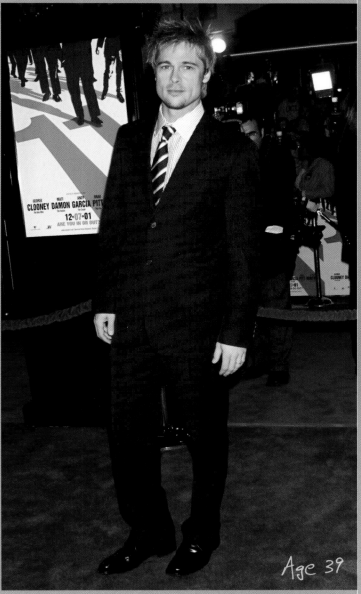

Age 39

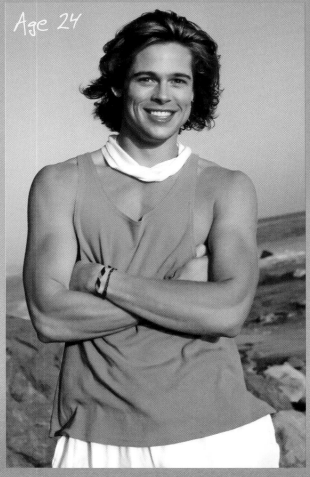

Age 24

WORDS OF LOVE

Brad tends to bring out the gush in even normally reserved fans. "His jawline is so chiseled, it could slice roast beef," wrote *Vanity Fair*'s Leslie Bennetts. "His flowing blond locks glitter as if throwing off sparks. His bronzed muscles . . . might be on loan from Popeye." Confessed Diane Sawyer: "I, of course, am much too spiritual and high-minded . . . to mention the abs." And this from the pages of PEOPLE: "Whatever went into the batter for this beefcake, we wish we could have licked the spoon."

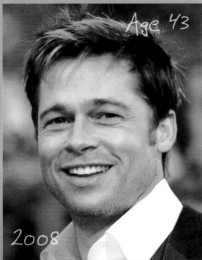

Age 43

2008

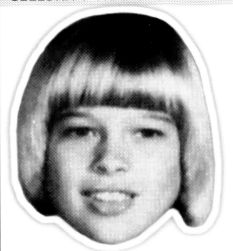

Age: unknown

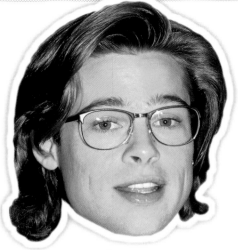

Age 24

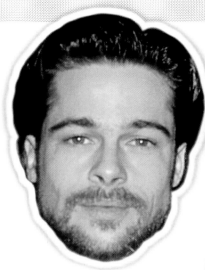

Age 28

BRAD HAIR DAYS

NEW YEAR, NEW DO, new *you*: In the coif department, the guy clearly likes to mix it up. Some highlights (some of which *include* highlights): the classic young Pitt with a Prince Valiant (above, left); the Prep (age 24); the Angelina (30); the "Dude, Where's the Party?" (33); the Retro Lynyrd Skynyrd (39); the Buff Buzz (40); and the contemporary, utilitarian Basic Brad (43).

TOP 'O THE HUNK: THE LONG AND SHORT OF BRAD'S LOCKS THROUGH THE YEARS

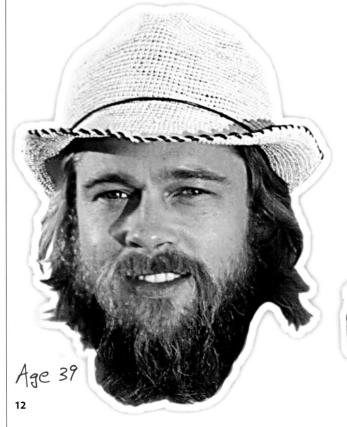

Age 39

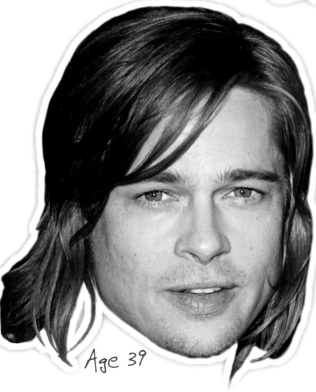

Age 39

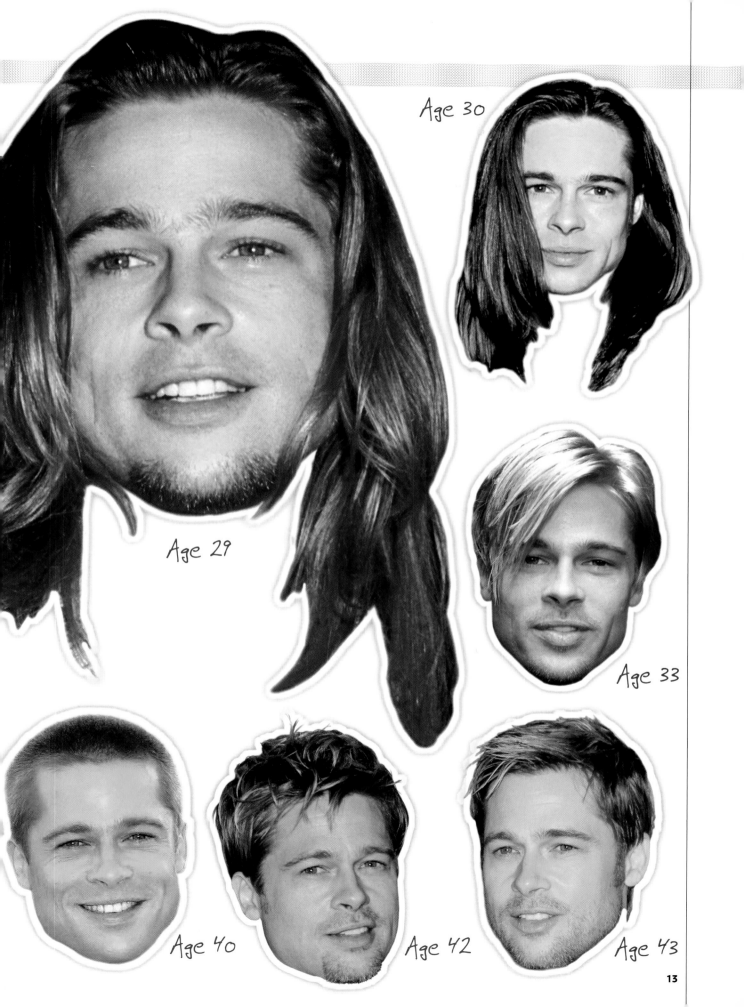

Age 30

Age 29

Age 33

Age 40

Age 42

Age 43

13

Age 9

JULIA Roberts

SAID A COSTAR: "IF I WERE A MOSQUITO WITH JUST ONE WISH,
IT WOULD BE TO LAND ON JULIA ROBERTS' LIPS"

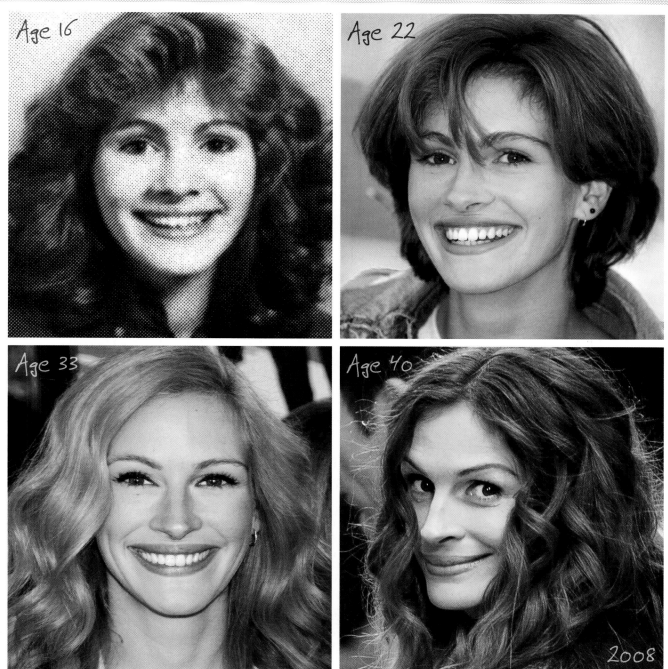

Age 16

Age 22

Age 33

Age 40

2008

AFTER STARRING IN *PRETTY Woman*, **Julia Roberts** sometimes got tagged with the title herself. She became philosophical. "Beats being called Mediocre Gal," she shrugged. "You know what I mean?"

Like *that* was ever going to happen. She arrived in New York at 17, a wannabe, met an agent through her brother, actor Eric Roberts, and began landing small parts. Within four years she was the breakout star of the sleeper hit *Mystic Pizza*, and, she recalled

later, the world began to change. "The first time I felt famous was when I went to the movies with my mom," she recalled. "Someone in the bathroom said, 'Girl in stall No. 1, were you in *Mystic Pizza*?' I paused and said, 'Yeah, that was me.'"

In 1990 *Pretty Woman* launched her into an orbit from which she has yet to return. As a *New York Times* critic wrote in 2006, "[Roberts is] so deeply, disturbingly beautiful that you don't want to let her out of your sight."

The famous smile (which, Roberts once said, "[looks like] I have a hanger in my mouth") started with a gap (far left). It's so powerful, joked one director, "you have to use it sparingly. It's like a weapon." *Flatliners* director Joel Schumacher, meeting the Hollywood newcomer for the first time 20 years ago, was "mesmerized. I kept thinking, 'Where has she been?'"

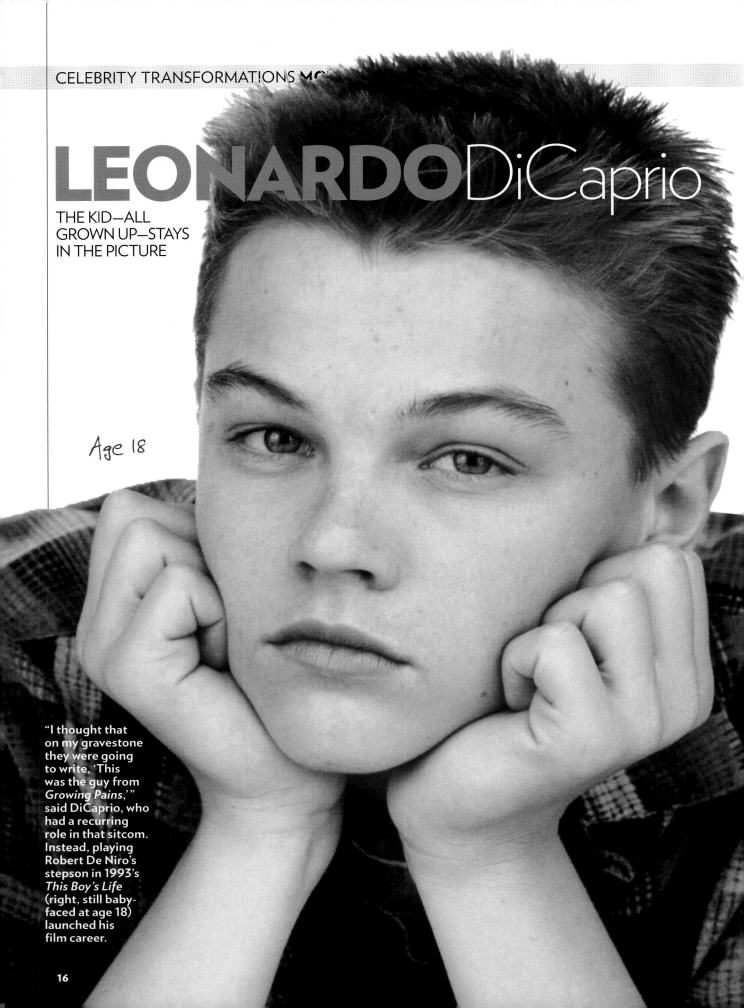

LEONARDO DiCaprio

THE KID—ALL GROWN UP—STAYS IN THE PICTURE

Age 18

"I thought that on my gravestone they were going to write, 'This was the guy from *Growing Pains*,'" said DiCaprio, who had a recurring role in that sitcom. Instead, playing Robert De Niro's stepson in 1993's *This Boy's Life* (right, still baby-faced at age 18) launched his film career.

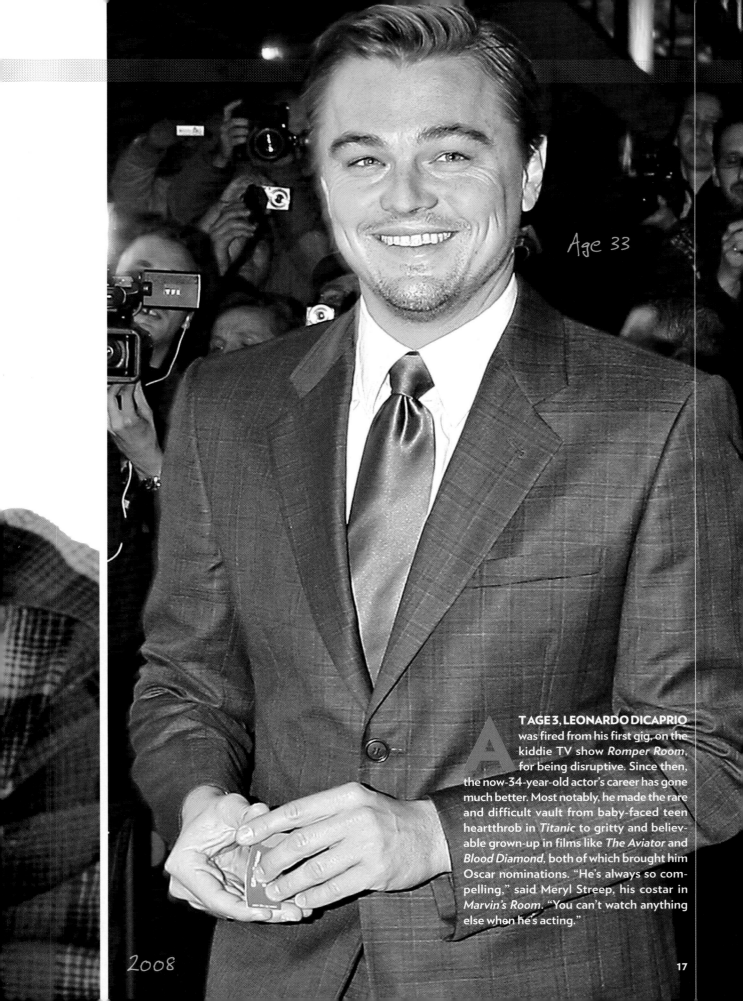

Age 33

AT AGE 3, LEONARDO DICAPRIO was fired from his first gig, on the kiddie TV show *Romper Room*, for being disruptive. Since then, the now-34-year-old actor's career has gone much better. Most notably, he made the rare and difficult vault from baby-faced teen heartthrob in *Titanic* to gritty and believable grown-up in films like *The Aviator* and *Blood Diamond*, both of which brought him Oscar nominations. "He's always so compelling," said Meryl Streep, his costar in *Marvin's Room*. "You can't watch anything else when he's acting."

2008

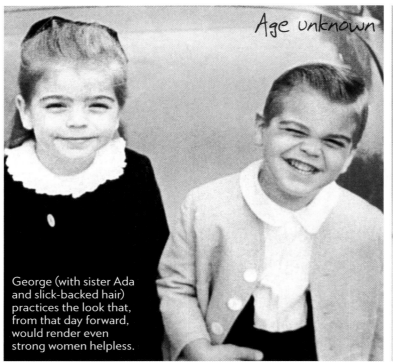

Age unknown

George (with sister Ada and slick-backed hair) practices the look that, from that day forward, would render even strong women helpless.

Age unknown

The bowl-cut— and glasses—would soon be history.

George**CLOONEY**

ACTOR, OSCAR WINNER, HOLLYWOOD ICON:
ONE MAN'S COMPLETE HAIRSTORY, IN 10 PARTS

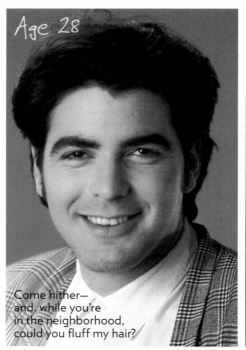

Age 28

Come hither— and, while you're in the neighborhood, could you fluff my hair?

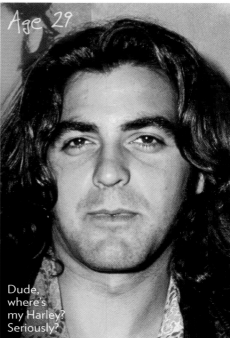

Age 29

Dude, where's my Harley? Seriously?

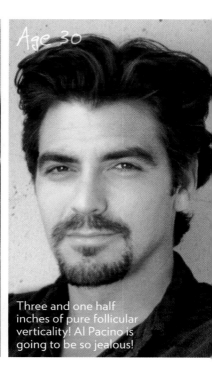

Age 30

Three and one half inches of pure follicular verticality! Al Pacino is going to be so jealous!

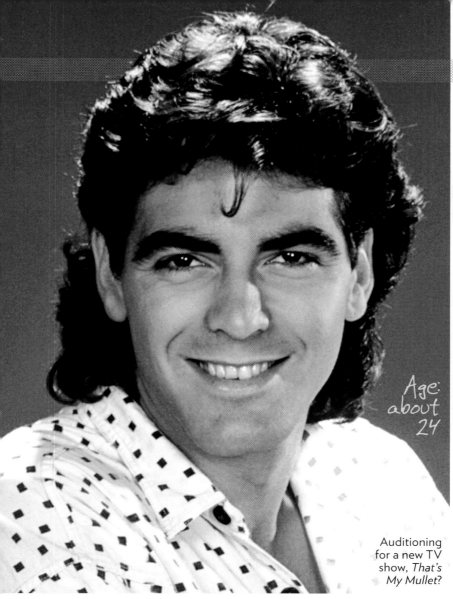

Age: about 24

Auditioning for a new TV show, *That's My Mullet*?

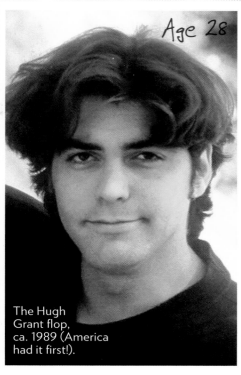

Age 28

The Hugh Grant flop, ca. 1989 (America had it first!).

MANE MAN
The look—winsome, with a side order of wry—was there from the beginning (far left, winking). But the hair—thick, floppy, wavy, tamed or gloriously independent—has changed with the times and, like Carbon 14, can be used for precise dating. Bowl cut? So '70s. Metrosexual caveman? 1990. Salt-and-pepper smoothie? Right here, right now.

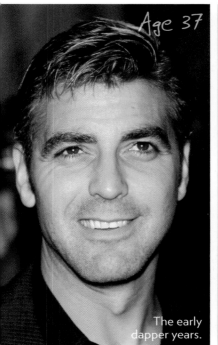

Age 37

The early dapper years.

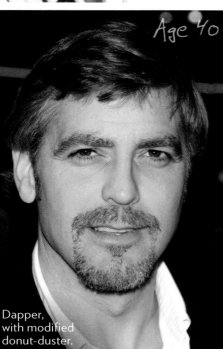

Age 40

Dapper, with modified donut-duster.

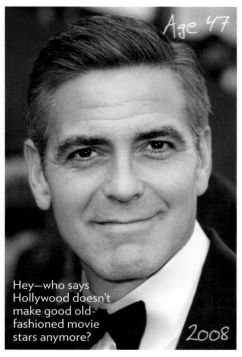

Age 47

Hey—who says Hollywood doesn't make good old-fashioned movie stars anymore?

2008

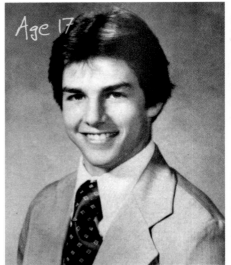

Age 17

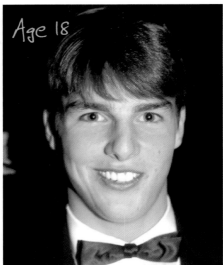

Age 18

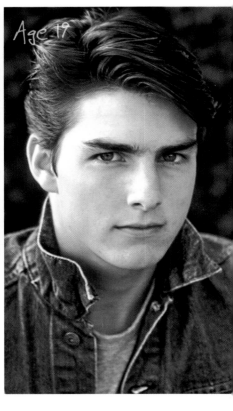

Age 19

Tom**CRUISE**

YOUNG MR. TOM CRUISE MAPOTHER IV CAME TO HOLLYWOOD
AND MADE HIMSELF VERY MUCH AT HOME

AS A KID HE WAS DYSLEXIC, **NOT EXCEP**-tionally tall, and, says **Tom Cruise**, "I never felt particularly good-looking." Many would agree he was wrong about the last part, and tenacity made up for any other shortcomings. "When everybody else was out partying, I was working," he says of his approach to his goals. Intensity? "He's very focused," said a coworker. "If he's shaking your hand, he looks you in the eye, and that's the only thing he's doing." *Jerry Maguire* costar Renée Zellweger felt the same focus—in a different way. "You'd look into his eyes, and he'd really be there, he'd really be in love with you," she said. "And then the director would yell, 'Cut!' Tom would leave the set, and you'd have to go into therapy for six months."

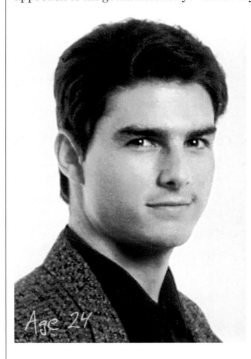

Age 24

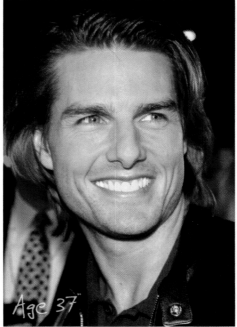

Age 37

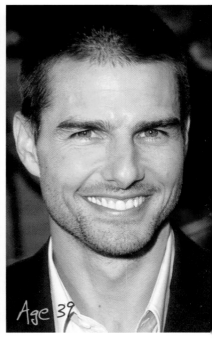

Age 39

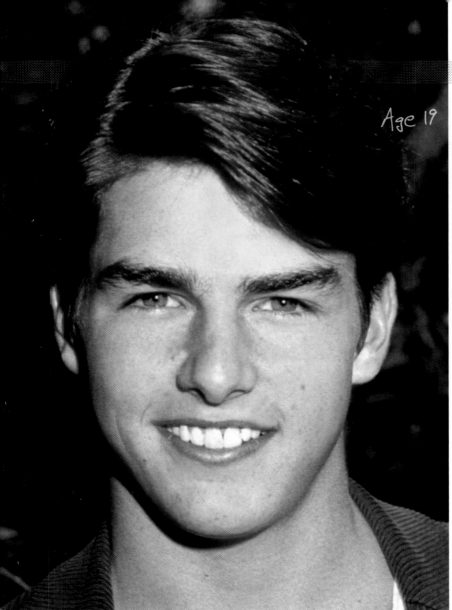

Age 19

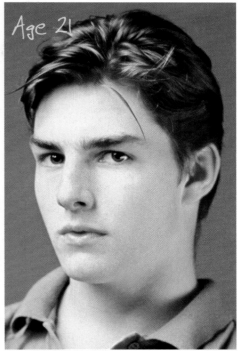

Age 21

As *Jerry Maguire* costar Jay Mohr put it, "There's only one thing you can do with a smile like that—become a movie star. You can't exactly fold sweaters at the Gap with that smile." Actually, Mark Johnson, Cruise's *Rain Man* producer, begged to differ: "His smile is just a little off, nose a little off," said Johnson. "But it's the sum total." *Rain Man* costar Valeria Golino focused on his eyes—"not their color. His regard—the way he looks with them. They're very alive."

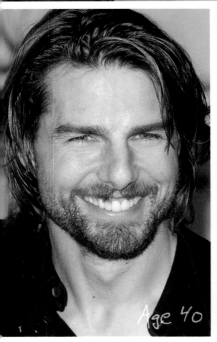

Age 40

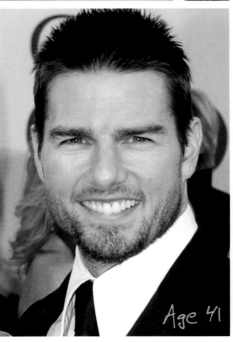

Age 41

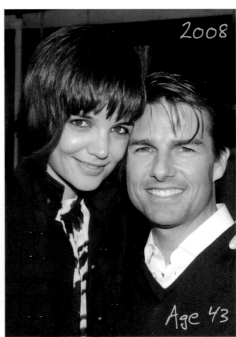

2008

Age 43

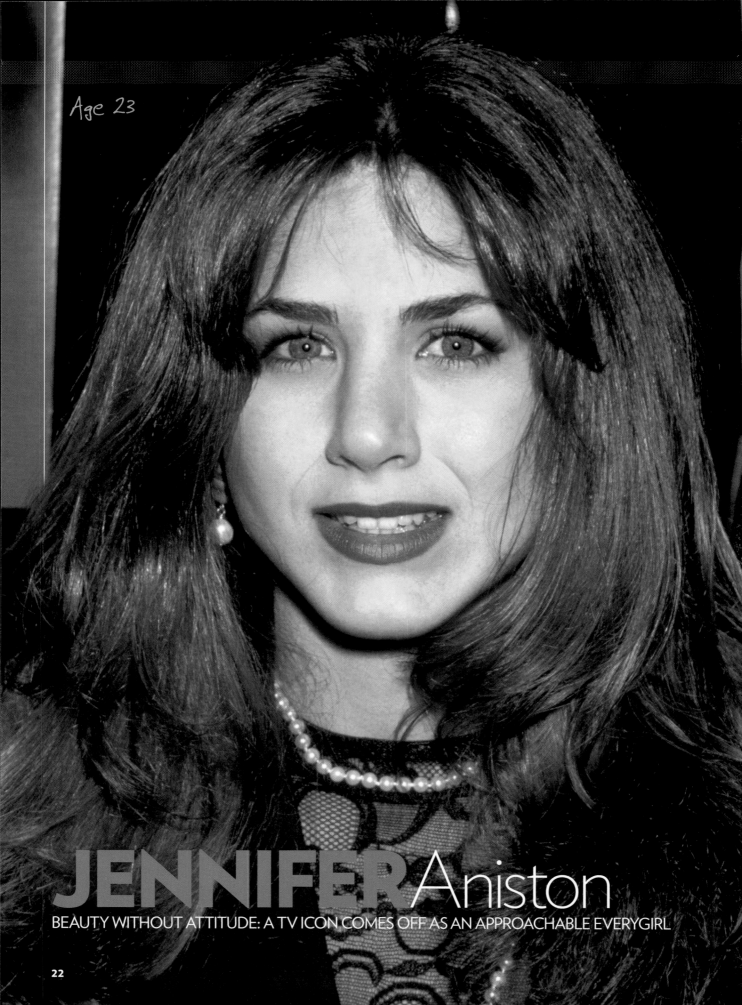

Age 23

JENNIFER Aniston
BEAUTY WITHOUT ATTITUDE: A TV ICON COMES OFF AS AN APPROACHABLE EVERYGIRL

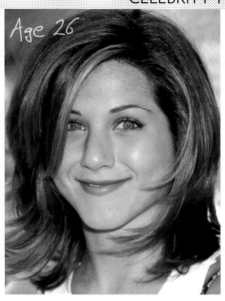

Age 18

Age 26

Age 38

2007

Age 21

Age 30

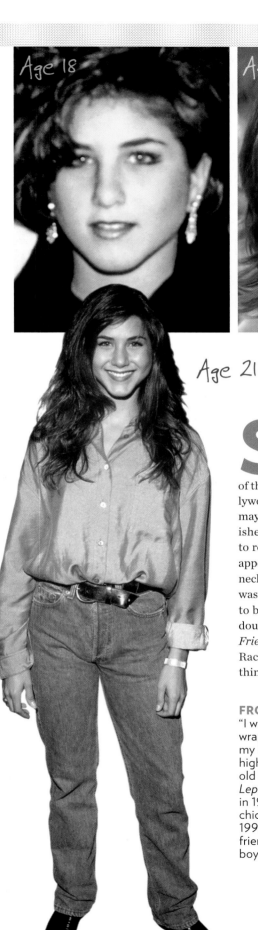

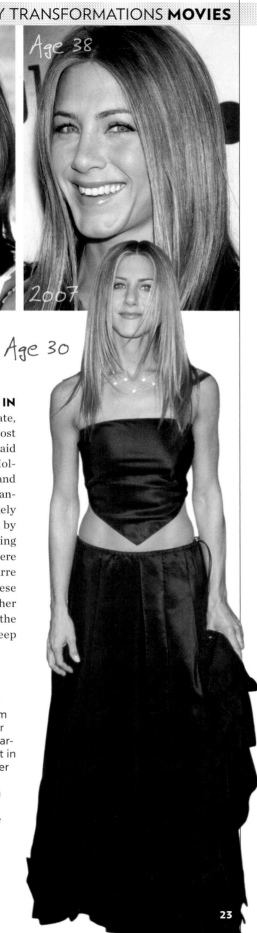

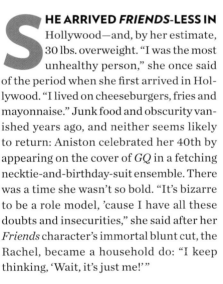

SHE ARRIVED *FRIENDS*-LESS IN Hollywood—and, by her estimate, 30 lbs. overweight. "I was the most unhealthy person," she once said of the period when she first arrived in Hollywood. "I lived on cheeseburgers, fries and mayonnaise." Junk food and obscurity vanished years ago, and neither seems likely to return: Aniston celebrated her 40th by appearing on the cover of *GQ* in a fetching necktie-and-birthday-suit ensemble. There was a time she wasn't so bold. "It's bizarre to be a role model, 'cause I have all these doubts and insecurities," she said after her *Friends* character's immortal blunt cut, the Rachel, became a household do: "I keep thinking, 'Wait, it's just me!'"

FROM *LEPRECHAUN* TO ICON
"I would spend each night desperately wrapping my bangs in pink curlers from my Barbie play set," Aniston said of her high school years (top left). The 23-year-old brunette, who made her film debut in *Leprechaun* (facing page, at the premier in 1993), was tanner, blonder, thinner, chicer at an L.A. awards bash (right) in 1999. But whatever, whenever, said a friend, "no matter how she looked, the boys loved her."

Age 12

Age 24

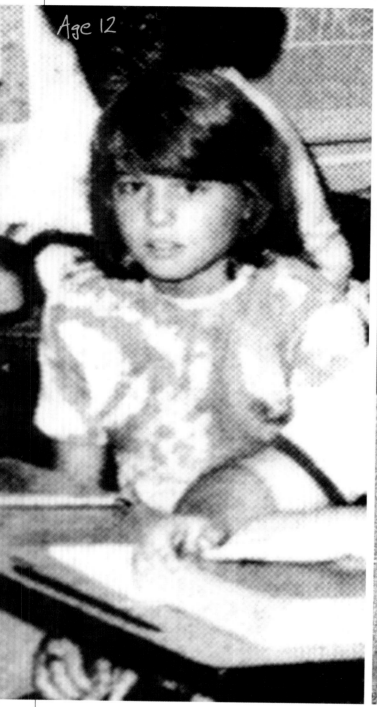
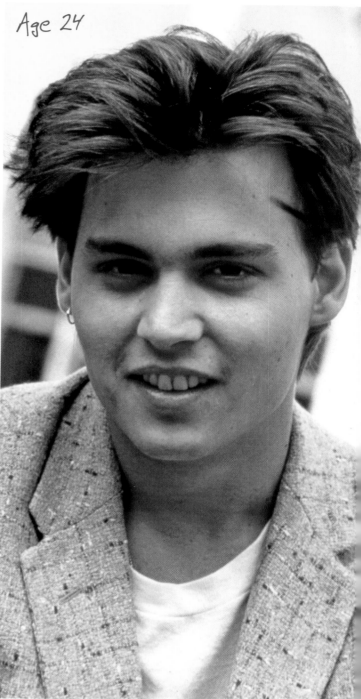

JOHNNYDepp

NOT SURPRISINGLY, HOLLYWOOD'S LIFELONG REBEL
GREW UP TO BE A VERY SUCCESSFUL PIRATE

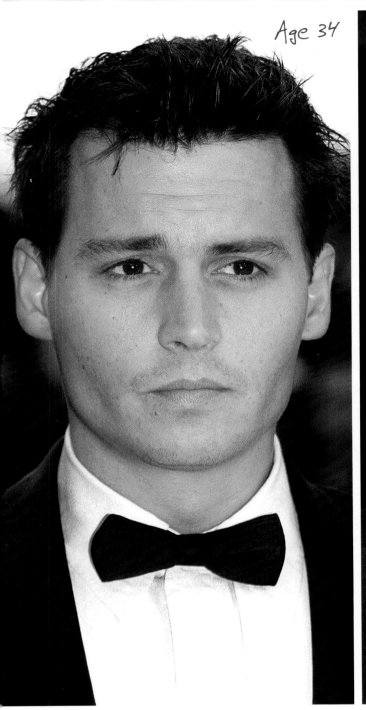

Age 34

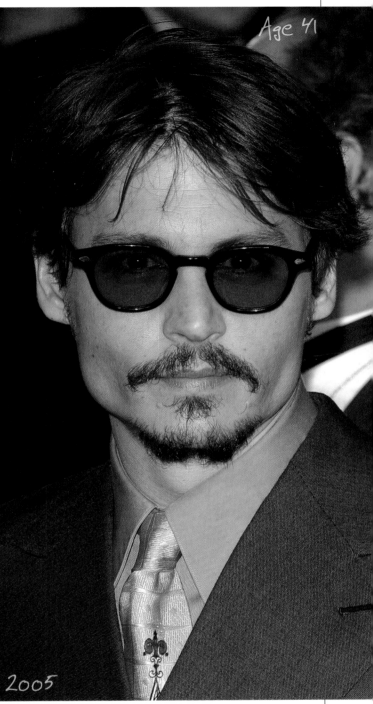

Age 41

2005

WHEN JOHNNY DEPP QUIT high school at 16 and moved to L.A., he was looking for a record deal, not a movie. But his first wife introduced him to Nicolas Cage, who introduced him to an agent, which led to a small part in *A Nightmare on Elm Street*. The teen TV hit *21 Jump Street* brought stardom—and discomfort.

"Some people, when they get attention in the public eye, they stand a bit taller," he said. "I shrink and kind of hide." He stuck to quirky, often critically lauded roles for decades—until scoring a monster commercial success with the *Pirates of the Caribbean* films. "Johnny," joked a director friend, "told me that selling out was really quite pleasurable."

DEPP PERCEPTION
The actor (from left) as a way-cute Florida seventh grader; as *21 Jump Street*'s tween heartthrob; a portrait of the artist as a young man at Cannes, age 33; and, in an updated zoot suit, viewing the Golden Globes through a purple haze.

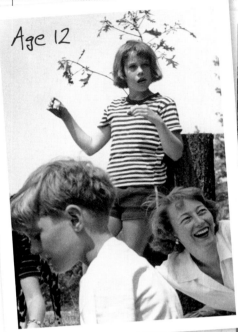

Age 12

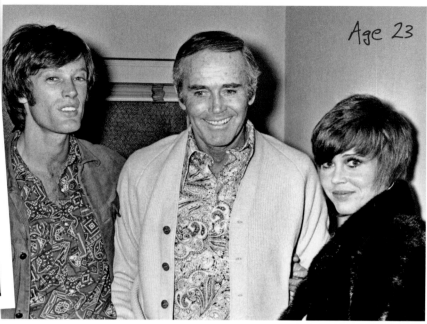

Age 23

Jane**FONDA** SEVEN DECADES IN THE SPOTLIGHT AS DAUGHTER, ACTRESS, WIFE AND ACTIVIST

WITH HER FAMOUS FAMily, three marriages and more than 40 films, **Jane Fonda**'s life has been outrageous, inspiring and controversial—but *never* predictable. The actress, now 71, says her life has unfolded in acts. Act I: an actress desperately seeking approval from the men in her life, including dad Henry. Act II: a woman taking control of her own destiny through her career, political activism and a killer workout. After splitting from Ted Turner in 2000, she became a born-again Christian and began Act III: pursuing good works—including a campaign against teen pregnancy—close to her heart.

Fonda's mother, Frances (with Jane and brother Peter, top), battled mental illness. "She came out of an institution for this phony picnic for some family magazine," Fonda recalls. "She killed herself six months later." Right: "There are some things . . . that I would do over if I could," says Fonda, who has apologized to veterans for visiting Hanoi during the Vietnam War.

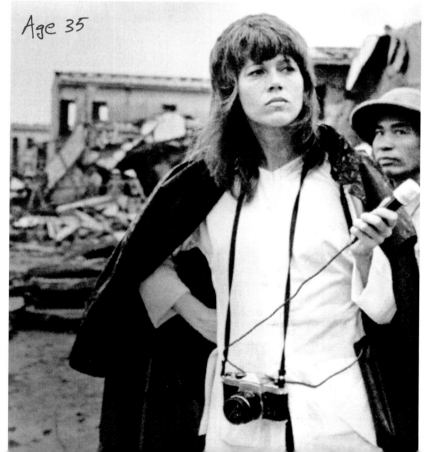

Age 35

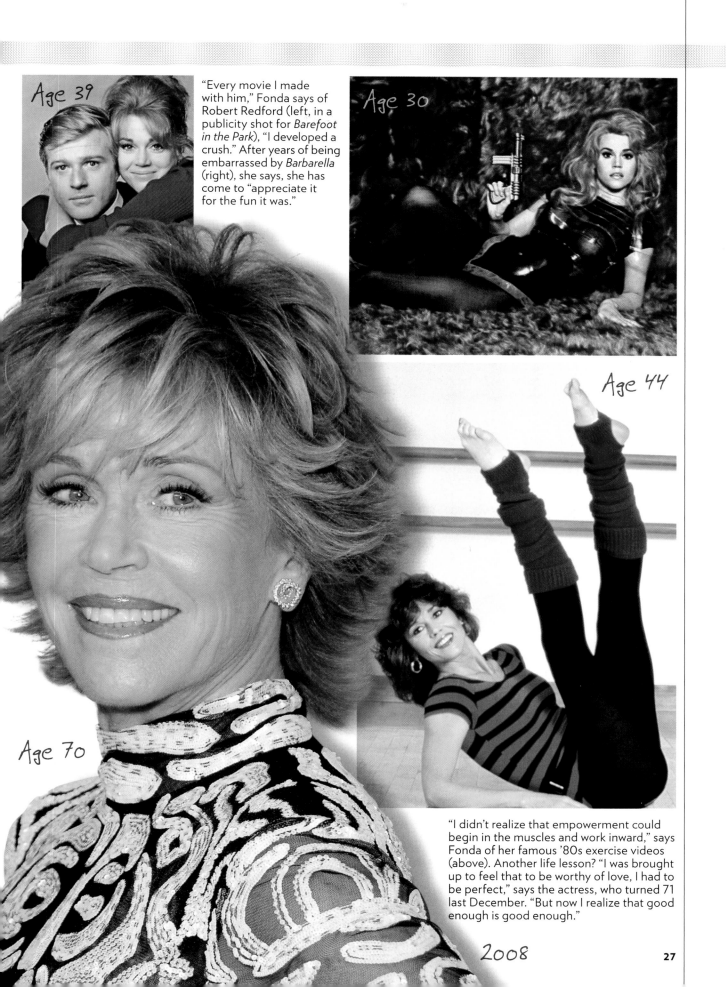

Age 39

"Every movie I made with him," Fonda says of Robert Redford (left, in a publicity shot for *Barefoot in the Park*), "I developed a crush." After years of being embarrassed by *Barbarella* (right), she says, she has come to "appreciate it for the fun it was."

Age 30

Age 44

Age 70

"I didn't realize that empowerment could begin in the muscles and work inward," says Fonda of her famous '80s exercise videos (above). Another life lesson? "I was brought up to feel that to be worthy of love, I had to be perfect," says the actress, who turned 71 last December. "But now I realize that good enough is good enough."

2008

"We just drove off into the desert and said, 'Let's shoot some stuff,'" says Gere of this 1978 image, by photographer pal Herb Ritts, that helped make him famous. The car? "I think it belonged to a girlfriend of mine."

Age 28

Richard GERE

LOOK BACK IN WONDER: THE UNLIKELY ARC OF A BUDDHIST SEX SYMBOL

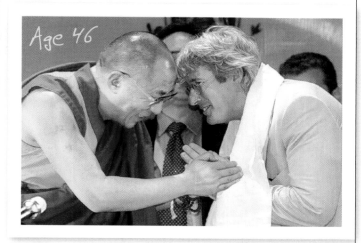

Age 17

Age 46

Age 30

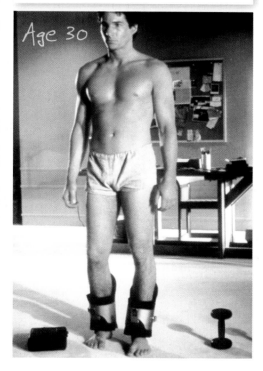

"My mother made that costume!" says Gere of the regal outfit (left) he wore to star in a high school production of *The King and I* in 1967. "I felt a sense of self-worth being onstage." Of his *American Gigolo* self (lower left), "That was a hundred years ago," he sighs. "I never saw the [gravity] boots again, but people come up to me and say they actually use them." At their first meeting, the Dalai Lama (above, with Gere in Italy), now a longtime friend, told him that "laughter, sadness, jealousy, hatred . . . all our emotions are in a sense acting."

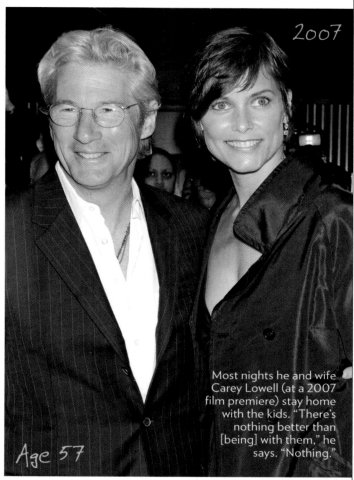

2007

Age 57

NEARLY 30 YEARS AGO, A RELA-tively unknown **Richard Gere**—taut, tanned and definitely trouble—strutted across the screen in *American Gigolo*, sending hearts aflutter (and Armani suit sales booming). A philosophy major at the University of Massachusetts Amherst and a Buddhist since his early 20s, the actor, now 59, silver-haired and bespectacled, is bemused by, and grateful for, his unusual adventure. "I don't think the slightest bit of me," he says, "imagined this would be my life."

Most nights he and wife Carey Lowell (at a 2007 film premiere) stay home with the kids. "There's nothing better than [being] with them," he says. "Nothing."

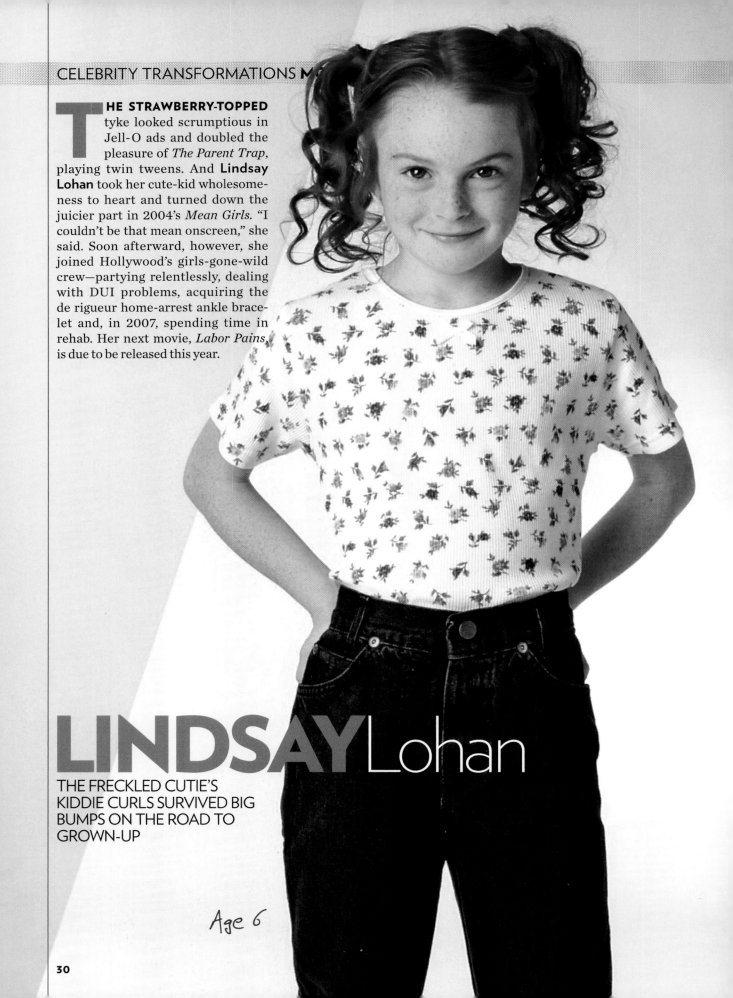

THE STRAWBERRY-TOPPED tyke looked scrumptious in Jell-O ads and doubled the pleasure of *The Parent Trap*, playing twin tweens. And **Lindsay Lohan** took her cute-kid wholesomeness to heart and turned down the juicier part in 2004's *Mean Girls.* "I couldn't be that mean onscreen," she said. Soon afterward, however, she joined Hollywood's girls-gone-wild crew—partying relentlessly, dealing with DUI problems, acquiring the de rigueur home-arrest ankle bracelet and, in 2007, spending time in rehab. Her next movie, *Labor Pains,* is due to be released this year.

LINDSAY Lohan

THE FRECKLED CUTIE'S KIDDIE CURLS SURVIVED BIG BUMPS ON THE ROAD TO GROWN-UP

Age 6

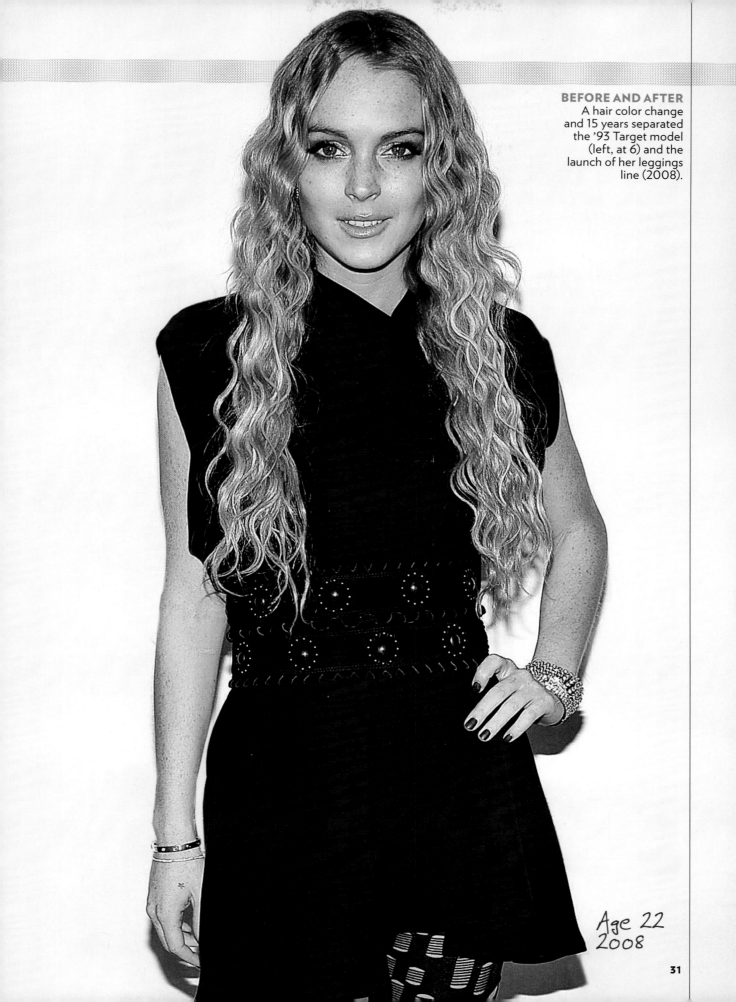

Age 22
2008

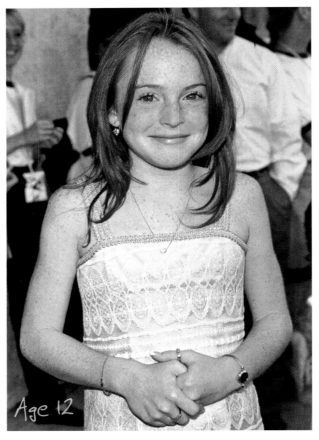

Age 12

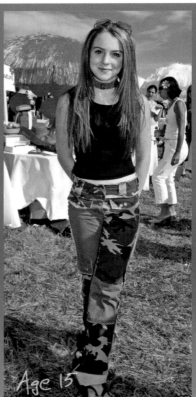

Age 15

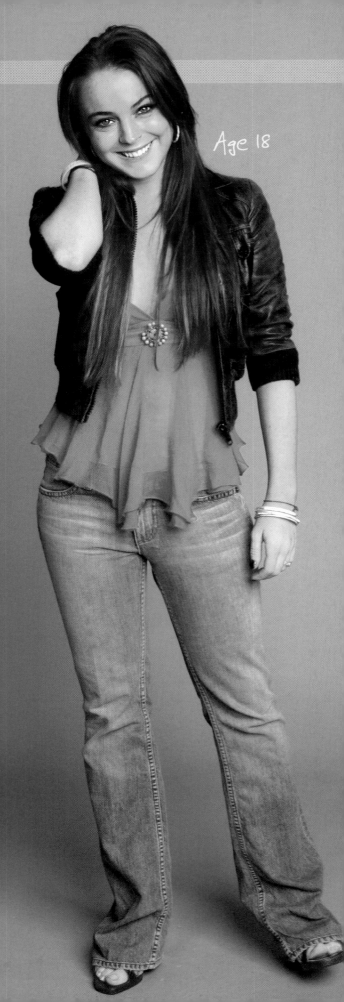

Age 18

LIVING DOLL
Hollywood's latest leading young lady lit up the red carpet at the 1998 premiere of *The Parent Trap* (above). Three years later she was appearing at charity events (left) and launching a music career. She had two more film hits, *Freaky Friday* and *Mean Girls,* to her credit by the time she attended the Teen Choice Awards (right) in 2004. "She's full of life," said music mentor Tommy Mottola. "She is becoming a real woman."

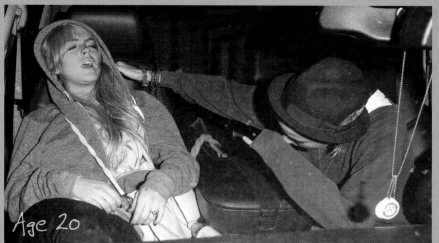

Age 20

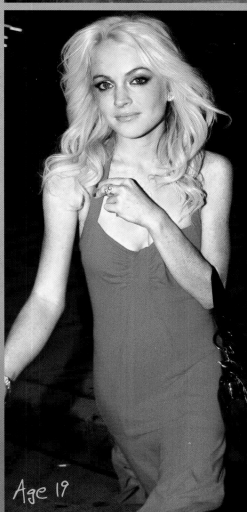

Age 19

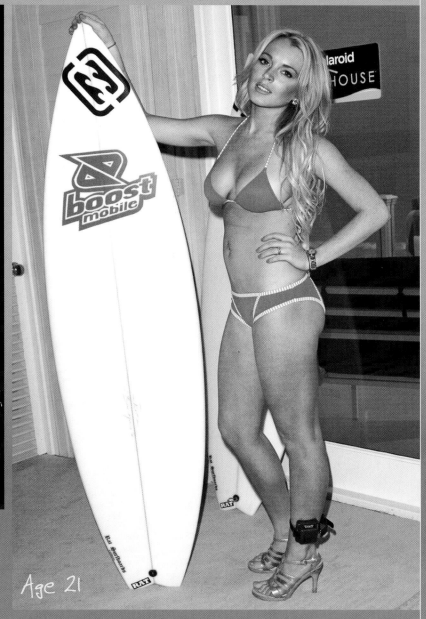

Age 21

FROM WASTE CASE TO GO FIGURE
"When I lost weight everything reduced and changed," Lindsay told *Allure* of her startling 2005 shrinking act (above) and her 2007 look (with sobriety monitor ankle bracelet, right). "Then I gained weight again and I was like, 'Wow, the breasts are really back.'"

Age 30

CLINT Eastwood

STILL A STAR SIX DECADES AFTER HE ARRIVED IN HOLLYWOOD, LEAN, HUNGRY AND HOT

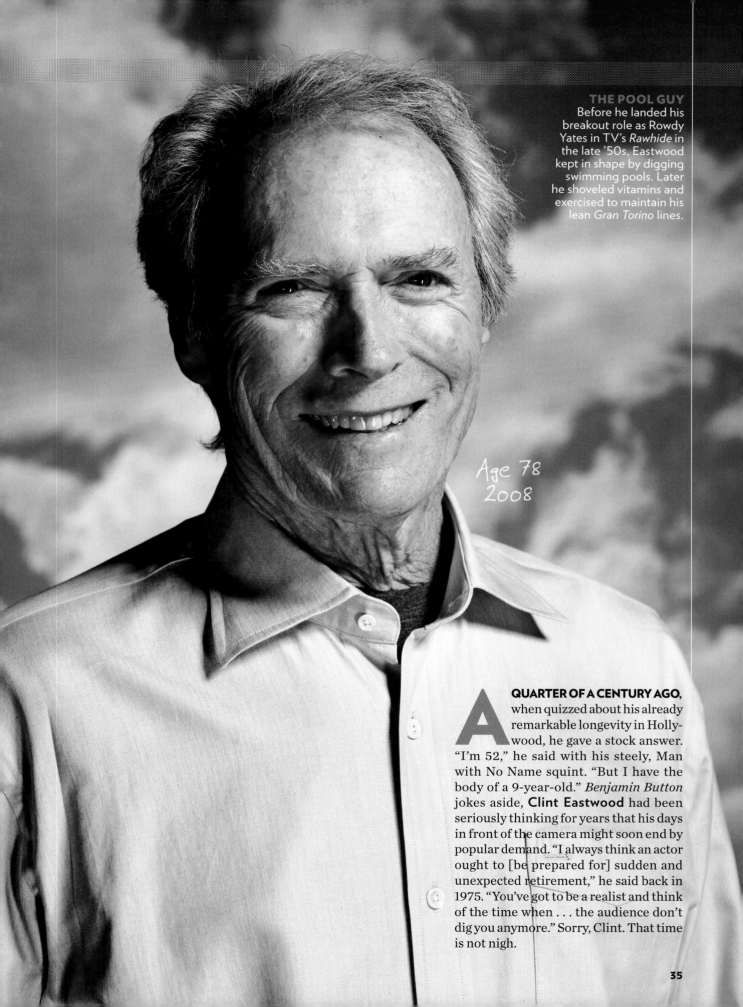

Age 78
2008

A QUARTER OF A CENTURY AGO, when quizzed about his already remarkable longevity in Hollywood, he gave a stock answer. "I'm 52," he said with his steely, Man with No Name squint. "But I have the body of a 9-year-old." *Benjamin Button* jokes aside, **Clint Eastwood** had been seriously thinking for years that his days in front of the camera might soon end by popular demand. "I always think an actor ought to [be prepared for] sudden and unexpected retirement," he said back in 1975. "You've got to be a realist and think of the time when . . . the audience don't dig you anymore." Sorry, Clint. That time is not nigh.

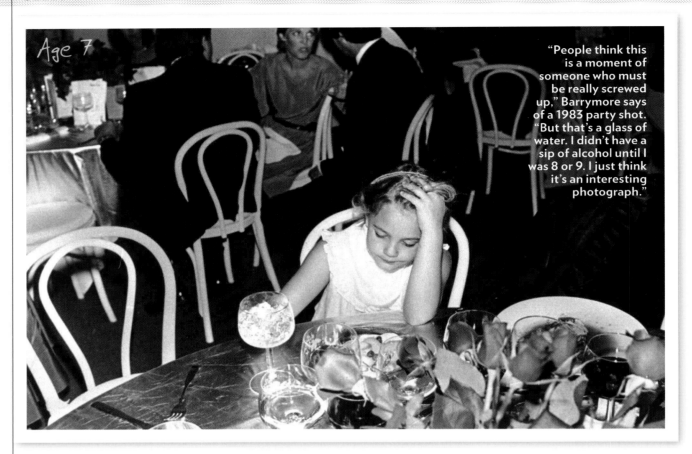

Age 7

"People think this is a moment of someone who must be really screwed up," Barrymore says of a 1983 party shot. "But that's a glass of water. I didn't have a sip of alcohol until I was 8 or 9. I just think it's an interesting photograph."

Drew**BARRYMORE**

USING THE DRAMA IN HER GENES, LEARNING FROM THE DRAMA IN HER LIFE

T'S QUITE A BIO, OF COURSE. STARdom in *E.T.* by 9; drinking and drug rehab at 13; a harrowing autobiography, *Little Girl Lost*, published in her teens; posing for *Playboy* at 19; a string of hit movies; two divorces by 28—and, facing 35, a sense, perhaps, of relief. "I'm happy with my age," **Drew Barrymore** said in 2004. "I've made mistakes that I don't have to make anymore."

She had also made peace with *perceived* personal imperfections. "For the next lifetime, I've put in a bid for the long thin arms, perfectly small, gorgeous boobs [and] tall thin legs," she said. "But every once in a while, if I'm lucky and good to myself, I can feel beautiful on the inside— and I can tell that shows on the outside. It's amazing to me."

Age 7

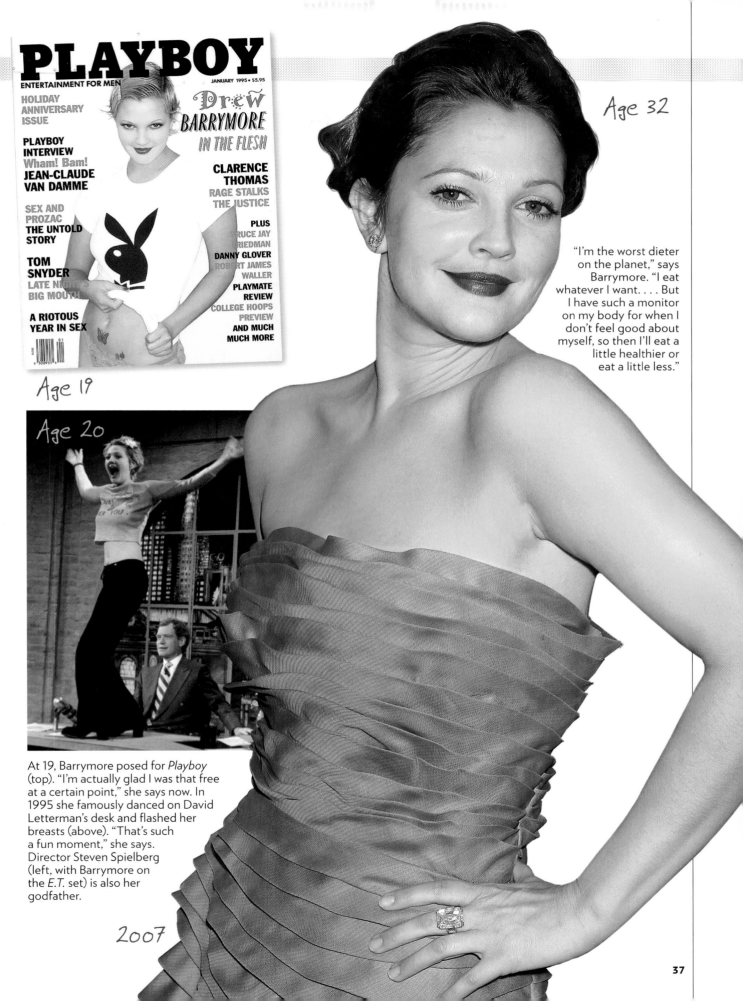

Age 32

Age 19

Age 20

"I'm the worst dieter on the planet," says Barrymore. "I eat whatever I want. . . . But I have such a monitor on my body for when I don't feel good about myself, so then I'll eat a little healthier or eat a little less."

At 19, Barrymore posed for *Playboy* (top). "I'm actually glad I was that free at a certain point," she says now. In 1995 she famously danced on David Letterman's desk and flashed her breasts (above). "That's such a fun moment," she says. Director Steven Spielberg (left, with Barrymore on the *E.T.* set) is also her godfather.

2007

Age 24

JENNIFER Lopez

"JENNY FROM THE BLOCK" GROWS UP,
GLAMS UP AND SHAKES UP SHOWBIZ ON TWO FRONTS

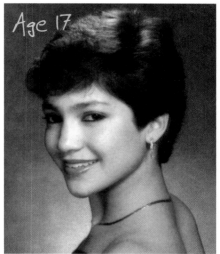

Age 17

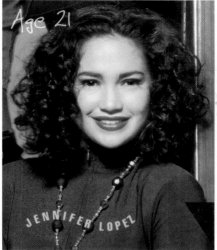

Age 21

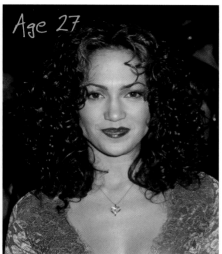

Age 27

Age 31

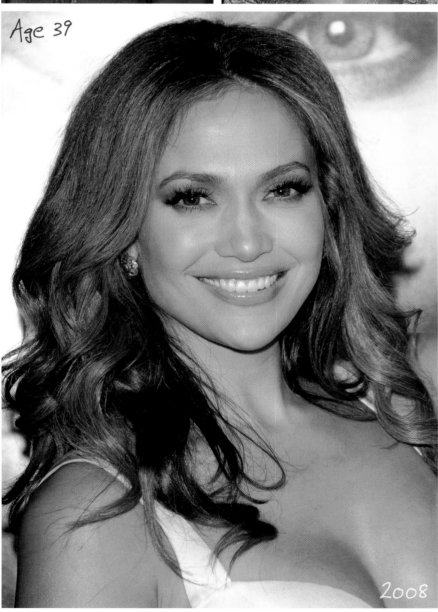

Age 39

2008

HER FIRST ROLE? *MY LITTLE Girl* (1987) with Mary Stuart Masterson and James Earl Jones. The first one most people remember? As a "Fly Girl" on TV's *In Living Color* in the early 1990s. "She had ambition written all over her," says an actor who knew her then. "She looked like a person who intended to make the most of her talents."

No kidding. In short order, **Jennifer Lopez** ate up a breakthrough role in the biopic *Selena* and moved up an order of magnitude with a great performance opposite George Clooney in *Out of Sight*. She has stayed in the headlines ever since, thanks to albums, romances, divorces, perfume, movies, marriage and—as of February 2008—twins.

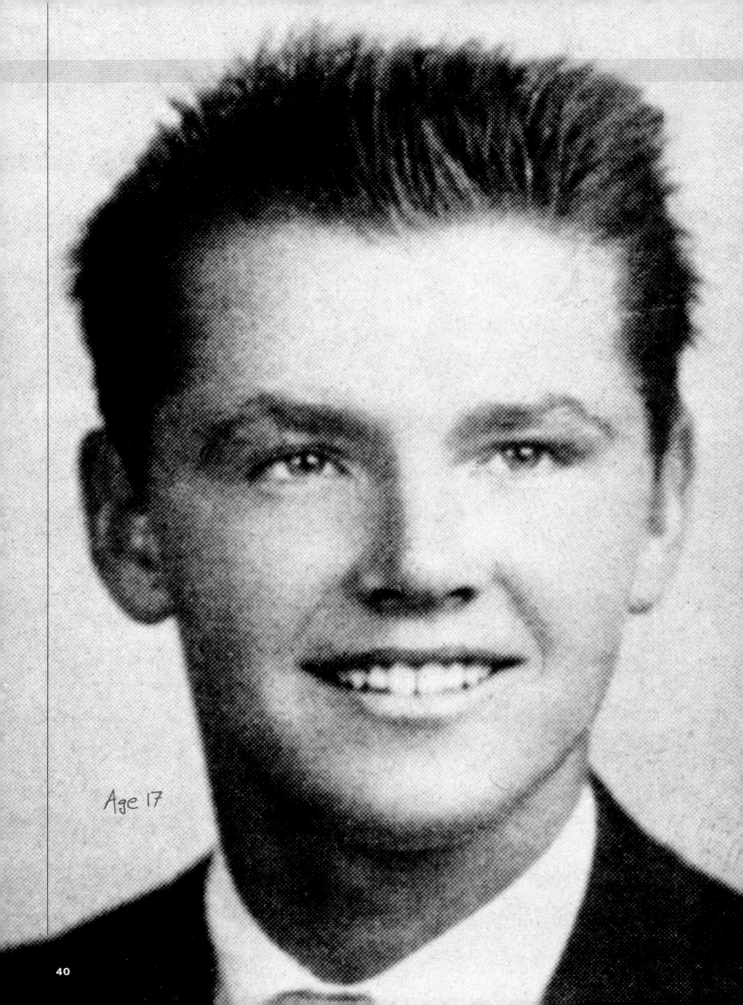

Age 17

Smilin' JACK

TIME MARCHES ON, AND HAIRLINES RETREAT, BUT THE GRIN REMAINS THE SAME

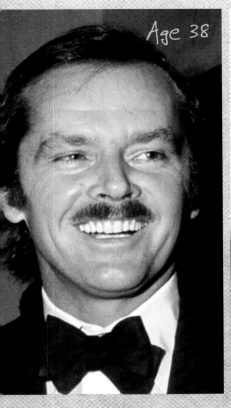

Age 38

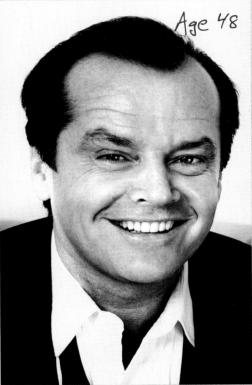

Age 48

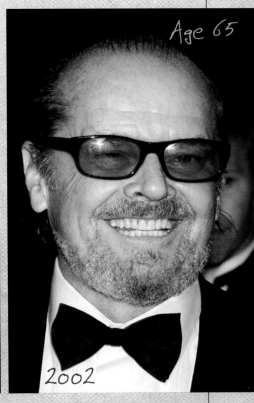

Age 65

2002

HEEERE'S JACK!
"I'm ridin' high now, but it could all crumble," Nicholson said after his burst of success in the early '70s. "I'll be ready if it does. In New York you have to make $50 a week to keep from freezing to death, but in California you can sleep on the ground. I may be doing that yet."

LIVE WITH ANJELICA [HUSTON], AND THERE ARE OTHER women in my life who are simply friends of mine," **Jack Nicholson** said in a 1980 PEOPLE interview, by way of explaining his romantic situation. "Most of the credit for our wonderfully successful relationship has to do with [Anjelica's] flexibility." Drugs? "I still love to get high, I'd say, about four days a week," said Jack. "Last year on a raft trip I had a little flavor of the season—peach mescaline. But I don't advocate anything for anybody."

Outrageous, quotable, honest, maybe just a little dangerous—that's been Nicholson's winning formula for more than 40 years. A lack of vanity hasn't hurt either. "I got my first pair of reading glasses this year!" he announced at the end of the 1980 interview. "Time marches on." Luckily, he added, "my life has always gotten better as I've gotten older."

Age: unknown

Age: unknown

Age: unknown

NICOLE Kidman

PORCELAIN SKIN, GREAT HAIR AND, FRIENDS SAY, A LAUGH THAT COULD STOP TRAFFIC

EVERYONE IN SYDNEY LOOKS like a California beach girl," says actress Naomi Watts, who has known **Nicole Kidman** since they were teens. "[But] she looked like someone who belonged in another time." It was a mixed blessing: Kidman says she "hated being pale as a kid" and that her mop top made her feel "awkward and repulsive." Still, she notes, "there's something you hate about looking different and then there's something that it gives you. It makes you develop your personality." And maybe your laugh? "She's this really Aussie girl who's full of life and has this loud, honking laugh," notes director Baz Luhrmann. Adds actor Simon Baker, a pal: "[It's] definitely more mule than human."

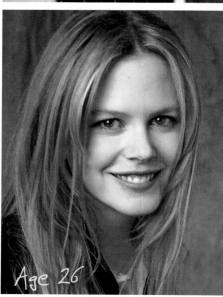

Age 26

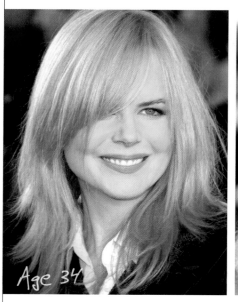

Age 34

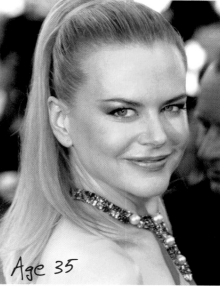

Age 35

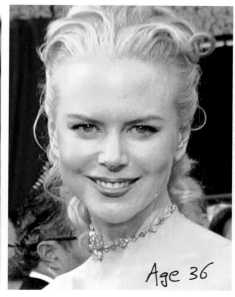

Age 36

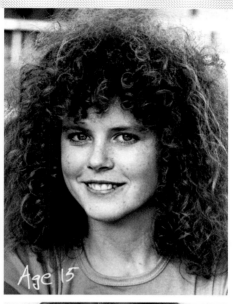

Age 15

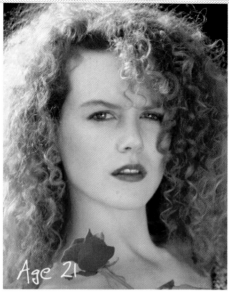

Age 21

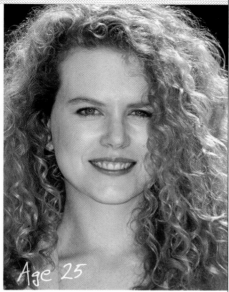

Age 25

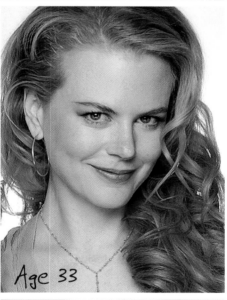

Age 33

2008

or

Klei

Age 38

Age 40

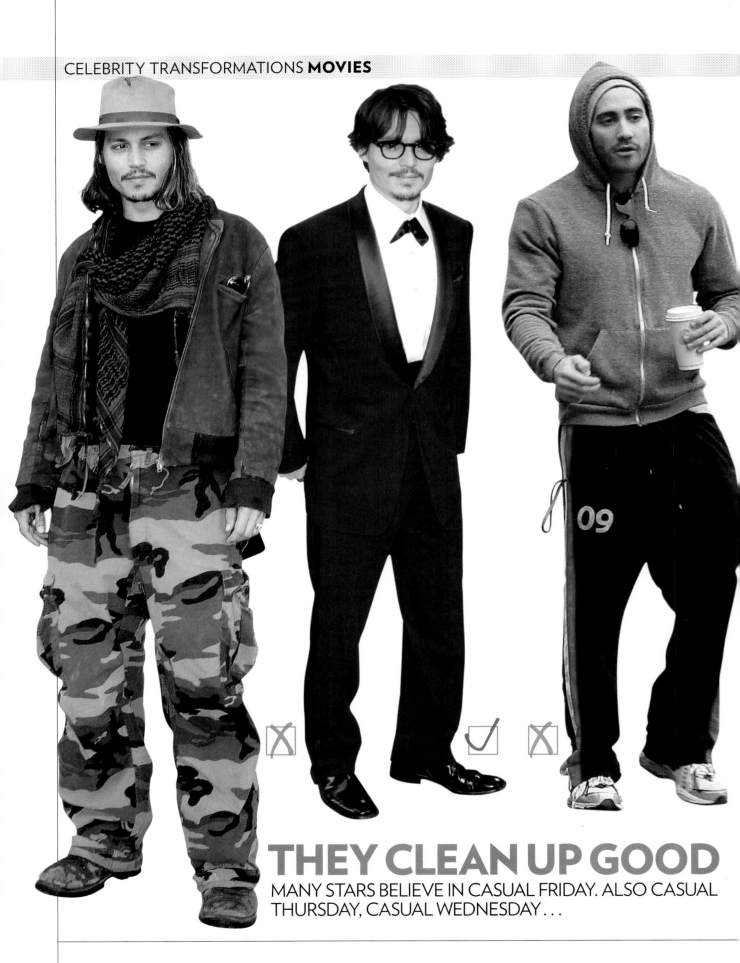

THEY CLEAN UP GOOD
MANY STARS BELIEVE IN CASUAL FRIDAY. ALSO CASUAL
THURSDAY, CASUAL WEDNESDAY . . .

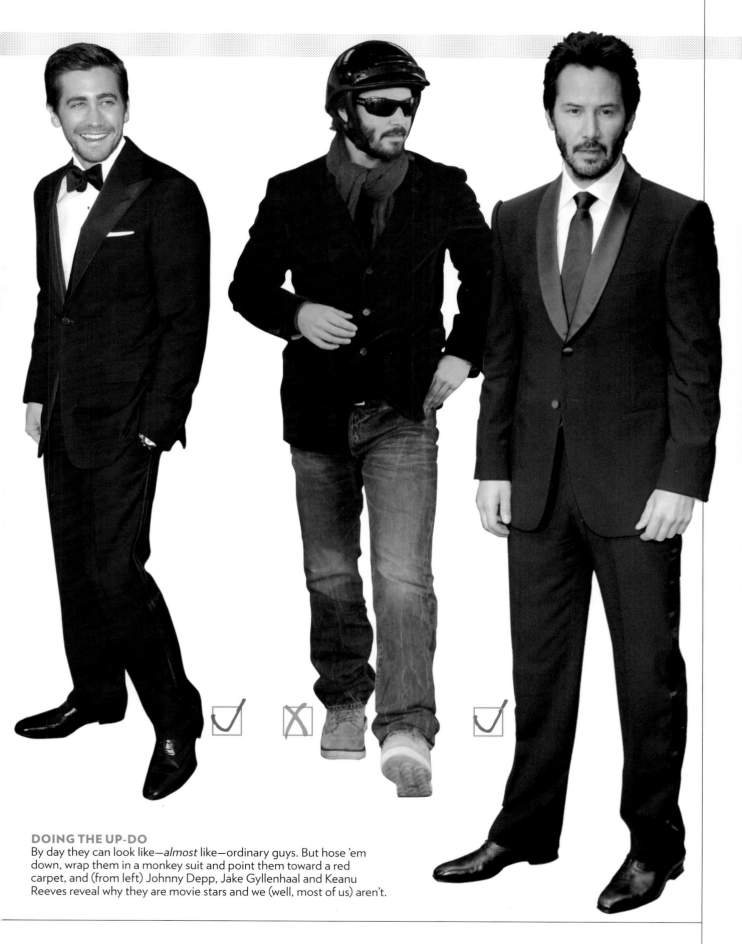

DOING THE UP-DO

By day they can look like—*almost* like—ordinary guys. But hose 'em down, wrap them in a monkey suit and point them toward a red carpet, and (from left) Johnny Depp, Jake Gyllenhaal and Keanu Reeves reveal why they are movie stars and we (well, most of us) aren't.

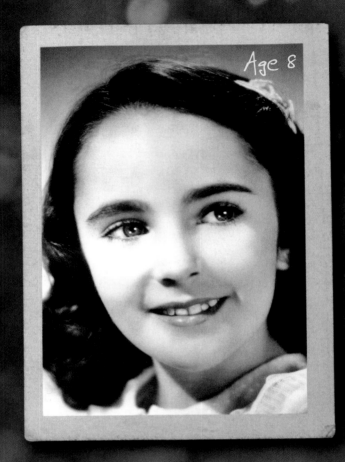

Age 8

SCREEN
GODDESSES

LAUREN BACALL LOOKS BACK, AND WHY THE CAMERA LOVED
ELIZABETH TAYLOR, "THE MOST BEAUTIFUL WOMAN IN THE WORLD"

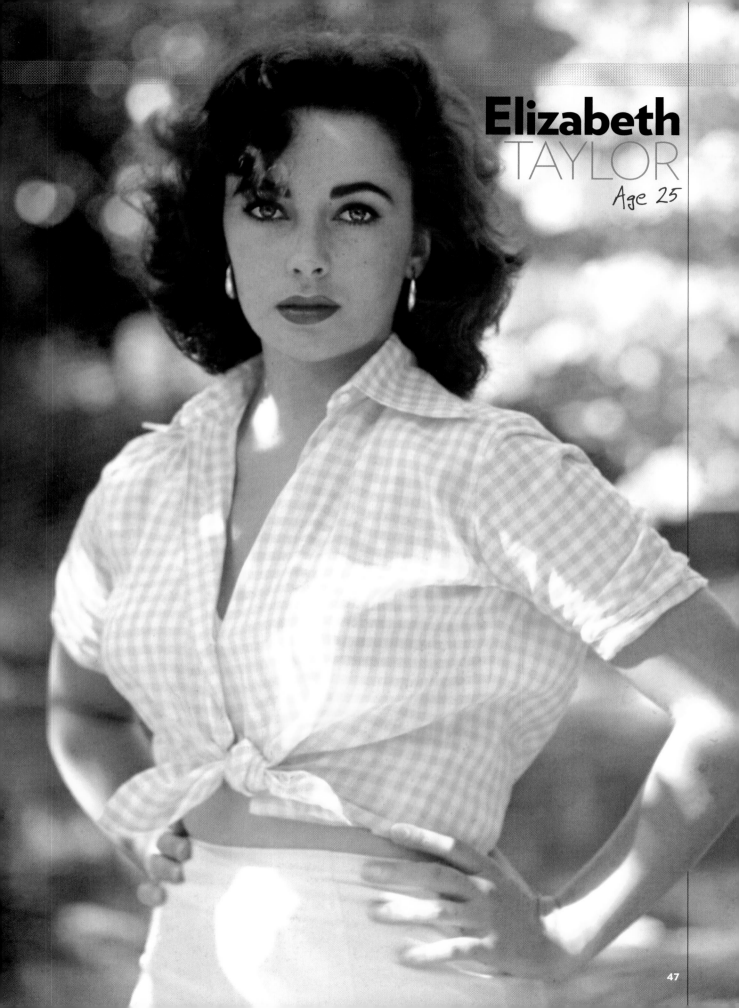

Elizabeth
TAYLOR
Age 25

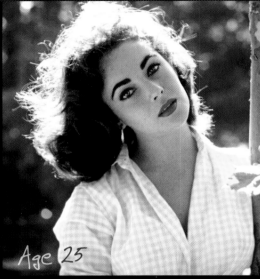

Age 25

Age 15

COME HITHER...
She was so beautiful, said one friend, that "it was like a punch in the stomach to see her for the first time." *National Velvet* made her a child star at 12, but Taylor wanted more and went after it. By 17, she said, she had "learned how to look sultry and pose provocatively."

ELIZABETHTaylor

BIGGER THAN MOVIES, BIGGER THAN HOLLYWOOD; IN THE END,
HER GREATEST PERFORMANCE IS A LIFE LIKE NO OTHER

IN HER PRIME SHE WAS CALLED THE MOST beautiful woman in the world—but her allure went far, far beyond surface glamour. One man called her "an erotic legend"; another claimed that "every minute this broad spends outside of bed is a waste of time." And those were two of her *husbands.*

Pretty hot stuff for a woman whose own mother once described her as "the funniest-looking baby I ever saw. Her nose looked like a tilt-tipped button, and her tiny face was so tightly closed, it looked

as if it would never unfold." It did, revealing violet eyes that made strangers stop and stare. So, from early on, did an earthiness that could both shock and charm: When an MGM casting director doubted that the 11-year-old Taylor was physically ready to play the lead in *National Velvet*, Taylor promised, "Don't worry, you'll have your breasts!"

The world cast Taylor as the beautiful, irresistible, dangerous siren, and she wore the role like the diamonds she loves. As Taylor once told L_IFE_ magazine, "I sashay up to men. I walk up to women."

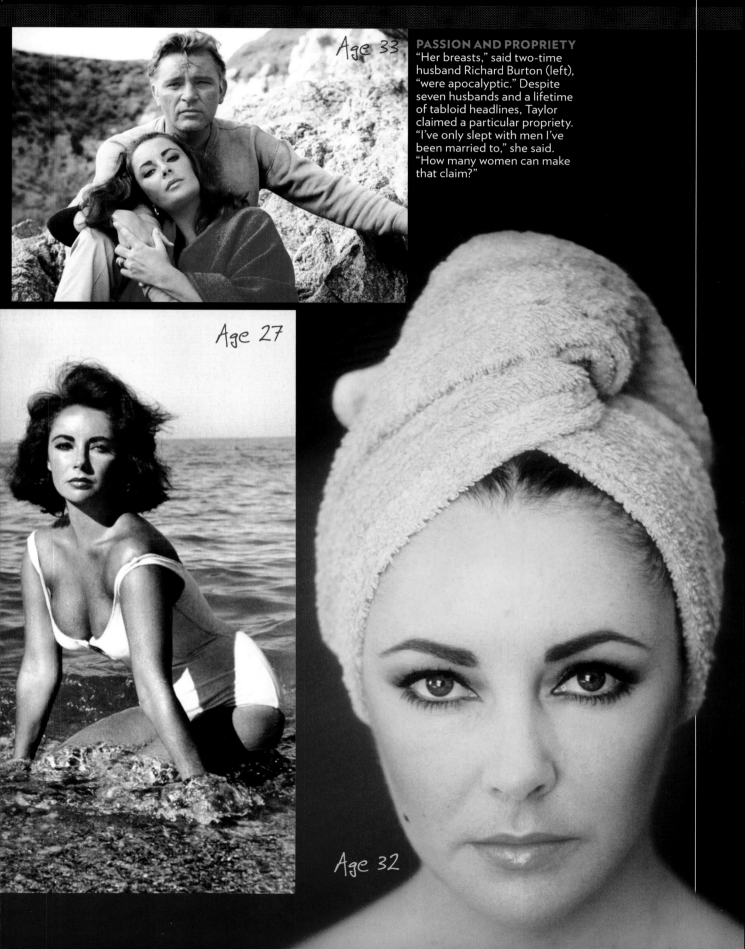

Age 33

PASSION AND PROPRIETY
"Her breasts," said two-time husband Richard Burton (left), "were apocalyptic." Despite seven husbands and a lifetime of tabloid headlines, Taylor claimed a particular propriety. "I've only slept with men I've been married to," she said. "How many women can make that claim?"

Age 27

Age 32

Age 2

Age: unknown

Age 13

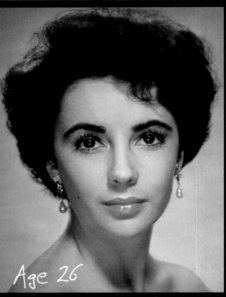

Age 26

"SHE LOOKS AT YOU WITH THOSE EYES," RICHARD BURTON SAID, "AND YOUR HEART CHURNS." TRUMAN CAPOTE THOUGHT HER "A PRISONER'S DREAM, A SECRETARY'S SELF-FANTASY; UNREAL, UNATTAINABLE."

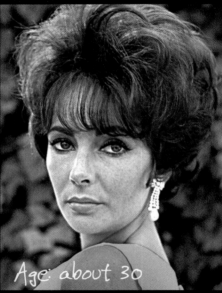

Age: about 30

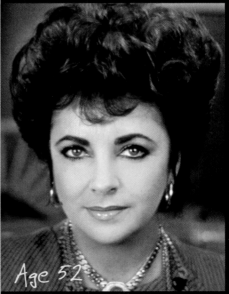

Age 52

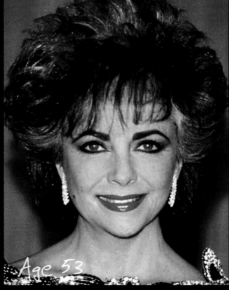

Age 53

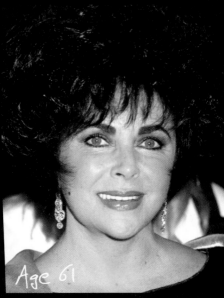

Age 61

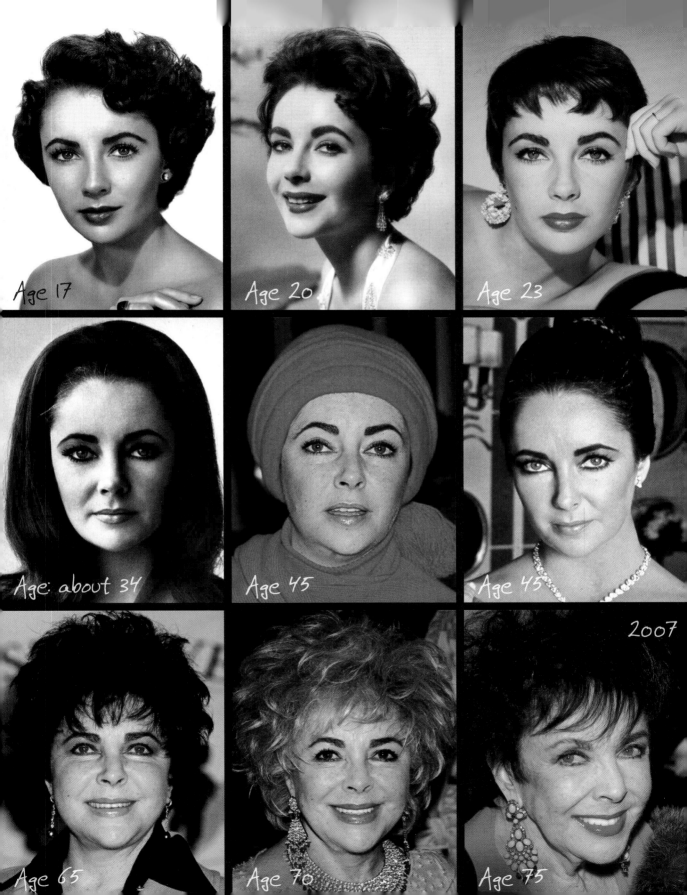

Age 17

Age 20

Age 23

Age: about 34

Age 45

Age 45

2007

Age 65

Age 70

Age 75

Lauren BACALL

IN AN EXCEPTIONAL LIFE, A HOLLYWOOD LEGEND HAS SEEN—AND LIVED—IT ALL

ABOVE: A very young Bacall (ca. 1933).

Age 19

RIGHT: With Humphrey Bogart in a publicity pic for her first movie, 1944's *To Have and Have Not*. They fell in love on-set ("You can't beat chemistry," she says) but Bogart was married. "I was miserable," she says. After he divorced in '45, Bogie and Bacall wed. They would make three more movies together.

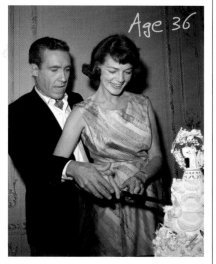

Age 36

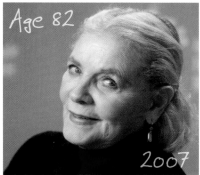

Age 82 · 2007

TOP: When she married Jason Robards in 1961, Bacall was pregnant with their son Sam (now an actor on *Gossip Girl*). She worried about Robards' drinking from the beginning, but "I was trying to have a life—what can I tell you?" **ABOVE:** The legend in 2007.

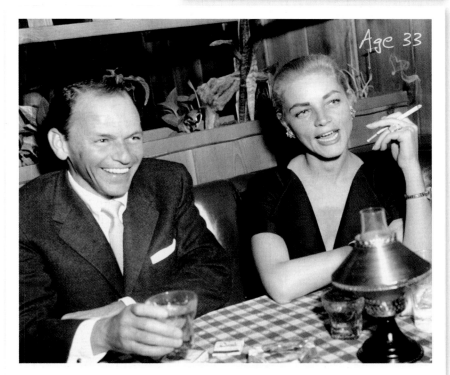

Age 33

Bacall and Sinatra (in 1957 in Hollywood) dated after Bogie died, even discussed marriage, but "he felt trapped," Bacall wrote in her 1978 autobiography *By Myself*. When the press reported their impending engagement, Sinatra blamed her for leaking the story and abruptly ended the affair. "To be rejected is hell," she wrote. "He behaved like a complete s---."

LAUREN BACALL HAS BEEN a star for more than six decades, first as a ravishing '40s ingenue, a brainy beauty with a purring voice and captivating eyes. Then she became Hollywood royalty as Mrs. Humphrey Bogart, marrying a man 25 years her senior. By 32, she was a widow and a single mom. "I didn't know what the hell I was doing," she says of that period. "If I hadn't had those two little children"—Steve and Leslie—"I don't know what I would have done." At 84, the six-time grandmother is still sharp, still grand and still, charmingly, blunt about things that matter.

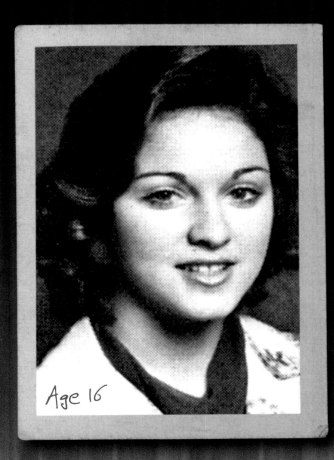

Age 16

MUSIC

NECESSITY—AS BEYONCE, MICHAEL JACKSON, MILEY AND MADONNA WELL KNOW—IS THE MOTHER OF POP REINVENTION

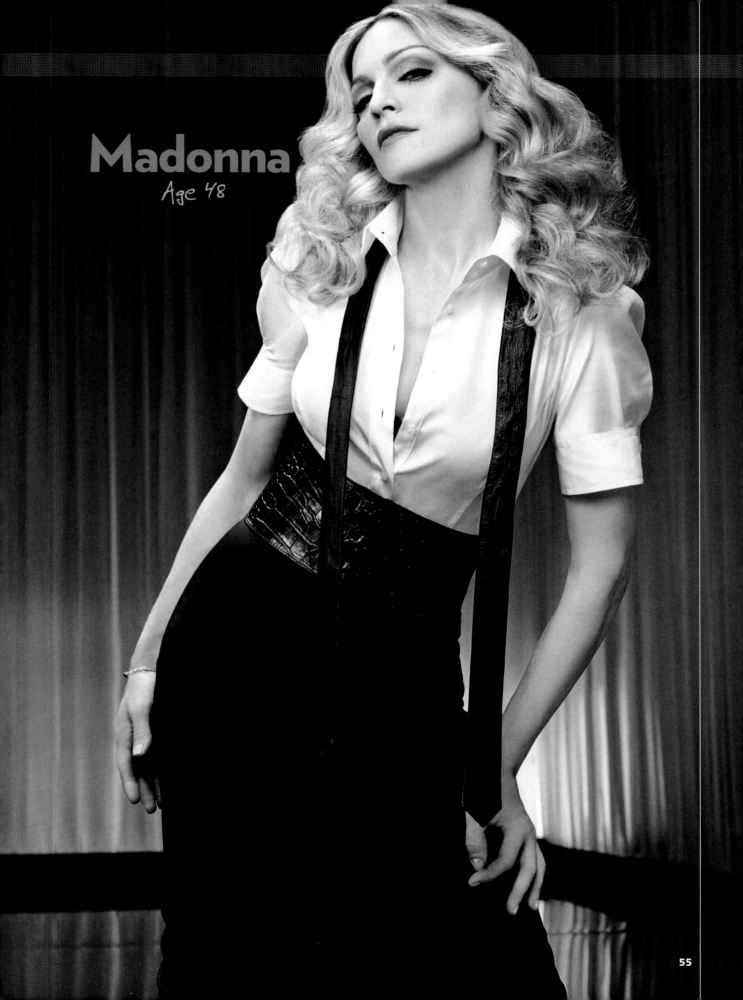

Madonna
Age 48

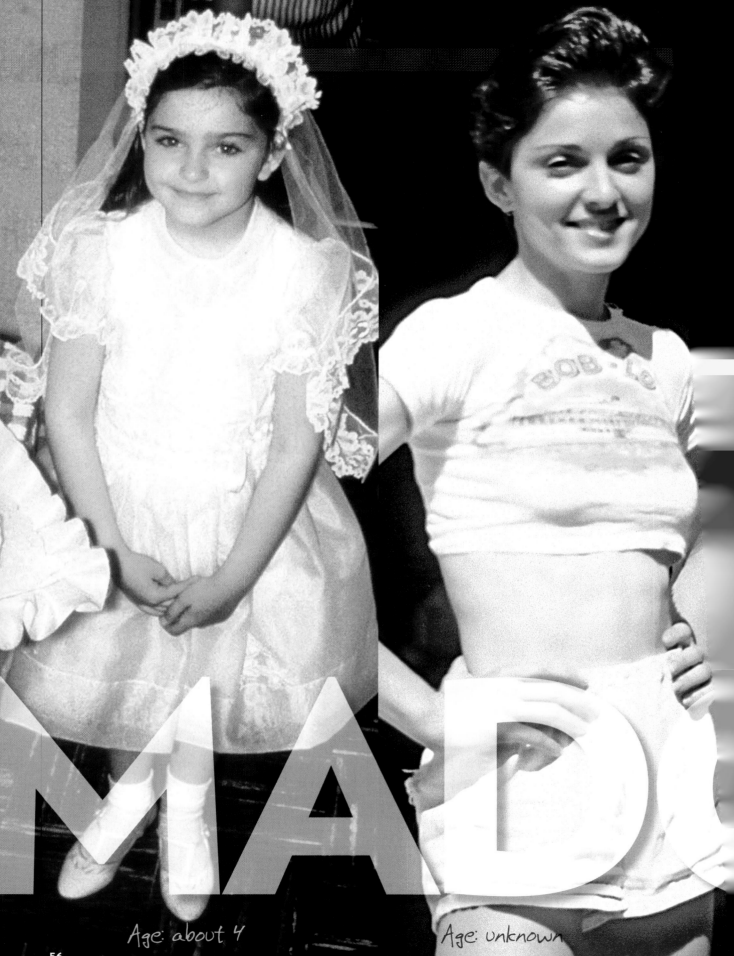

MAD

Age: about 4

Age: unknown

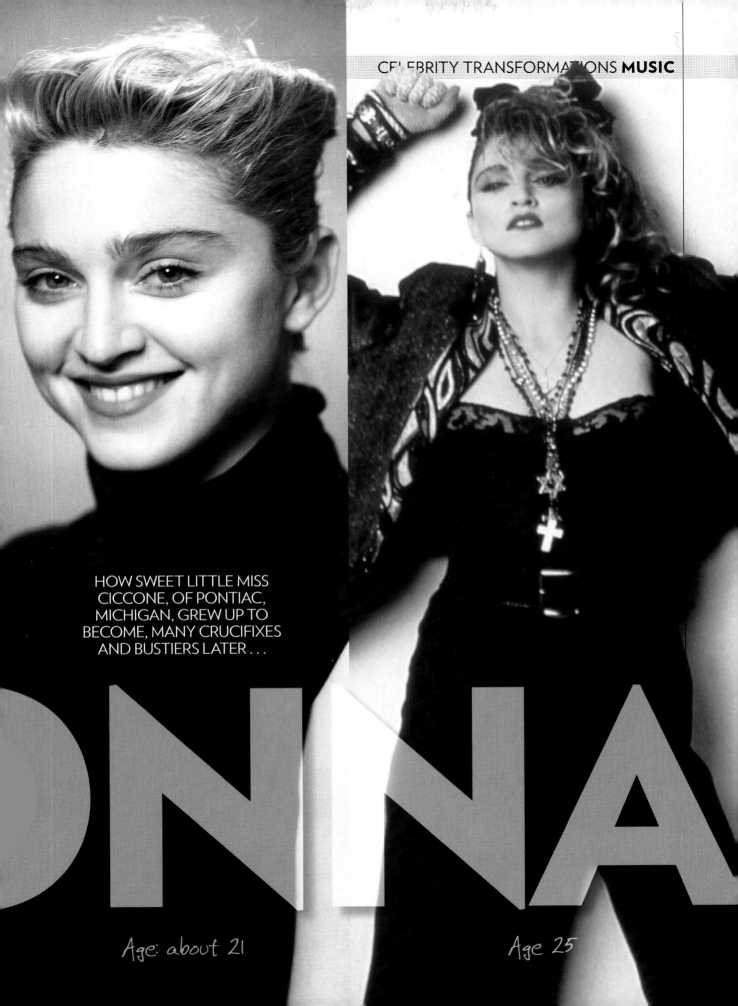

HOW SWEET LITTLE MISS
CICCONE, OF PONTIAC,
MICHIGAN, GREW UP TO
BECOME, MANY CRUCIFIXES
AND BUSTIERS LATER . . .

ONNA

Age: about 21

Age 25

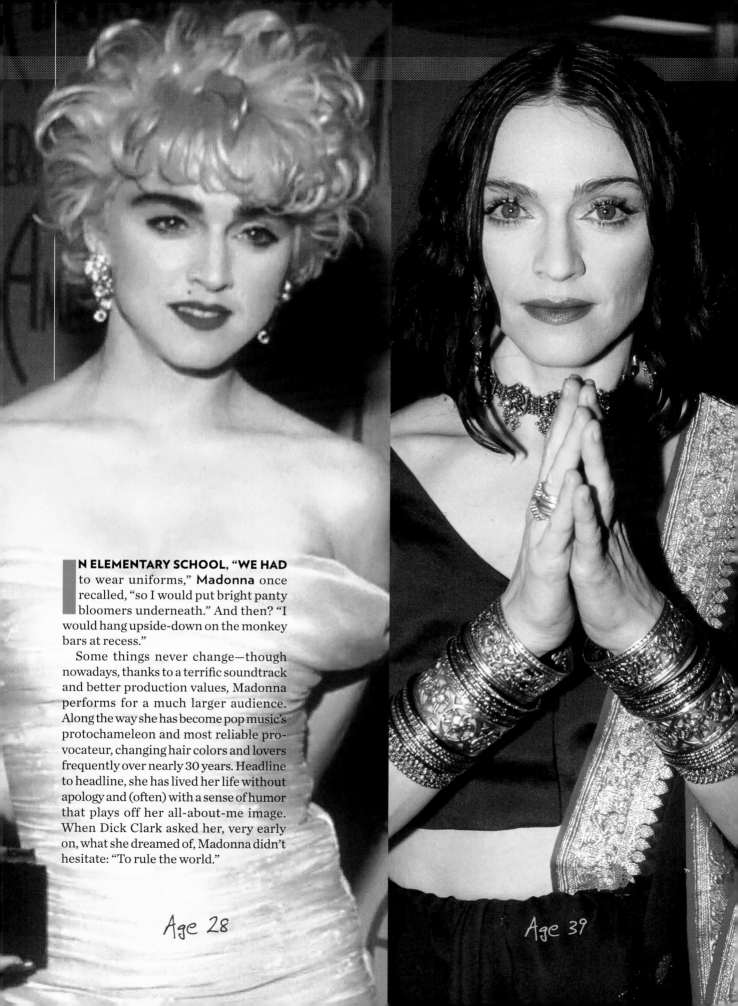

IN ELEMENTARY SCHOOL, "WE HAD to wear uniforms," **Madonna** once recalled, "so I would put bright panty bloomers underneath." And then? "I would hang upside-down on the monkey bars at recess."

Some things never change—though nowadays, thanks to a terrific soundtrack and better production values, Madonna performs for a much larger audience. Along the way she has become pop music's protochameleon and most reliable provocateur, changing hair colors and lovers frequently over nearly 30 years. Headline to headline, she has lived her life without apology and (often) with a sense of humor that plays off her all-about-me image. When Dick Clark asked her, very early on, what she dreamed of, Madonna didn't hesitate: "To rule the world."

Age 28

Age 39

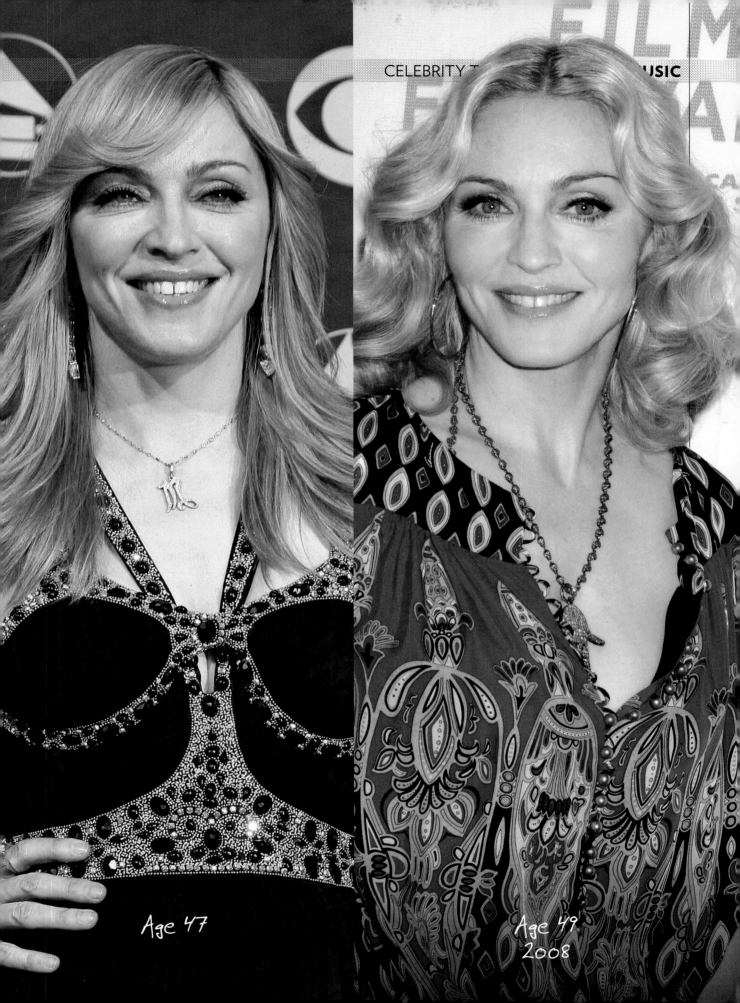

CELEBRITY T... ...USIC

Age 47

Age 49
2008

MICHAEL Jackson

FOUR DECADES IN, THE KING OF POP IS—NO KIDDING—A CHANGED MAN

Age: about 12

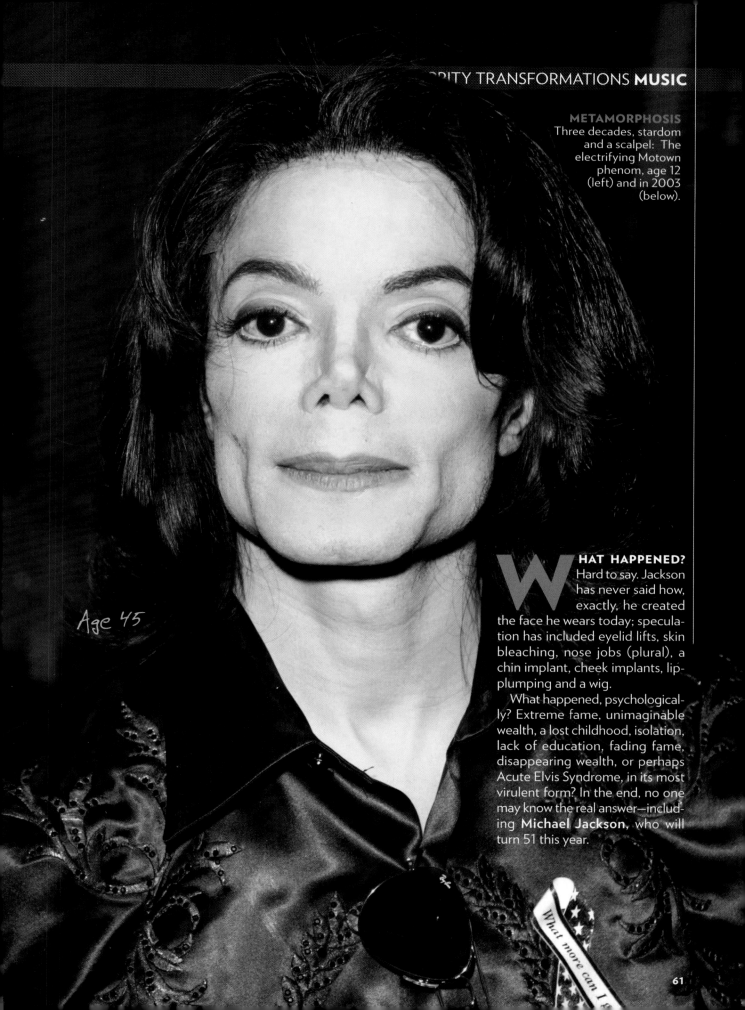

METAMORPHOSIS
Three decades, stardom and a scalpel: The electrifying Motown phenom, age 12 (left) and in 2003 (below).

Age 45

WHAT HAPPENED?
Hard to say. Jackson has never said how, exactly, he created the face he wears today; speculation has included eyelid lifts, skin bleaching, nose jobs (plural), a chin implant, cheek implants, lip-plumping and a wig.

What happened, psychologically? Extreme fame, unimaginable wealth, a lost childhood, isolation, lack of education, fading fame, disappearing wealth, or perhaps Acute Elvis Syndrome, in its most virulent form? In the end, no one may know the real answer—including **Michael Jackson,** who will turn 51 this year.

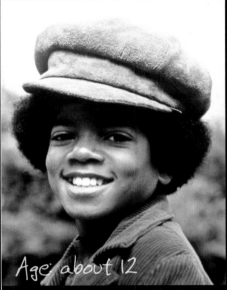

Age: about 12

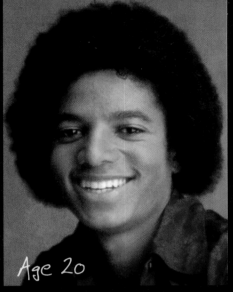

Age 20

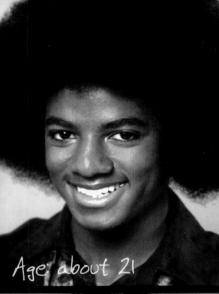

Age: about 21

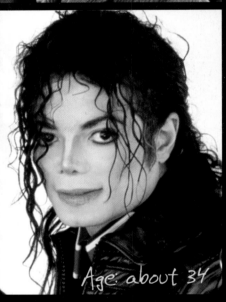

Age: about 34

'I'VE NEVER HAD MY
CHEEKBONES DONE,
NEVER HAD MY EYES
DONE, NEVER HAD MY
LIPS DONE . . . [BUT] I'M
NEVER PLEASED
WITH ANYTHING. . . .
I TRY NOT TO LOOK
IN THE MIRROR"
—MICHAEL JACKSON,
1993

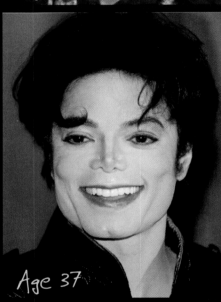

Age 37

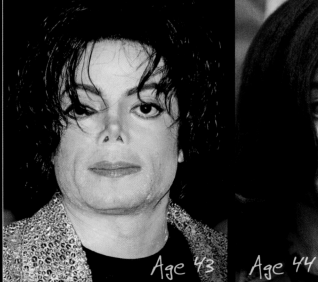

Age 43

Age 44

Age 46

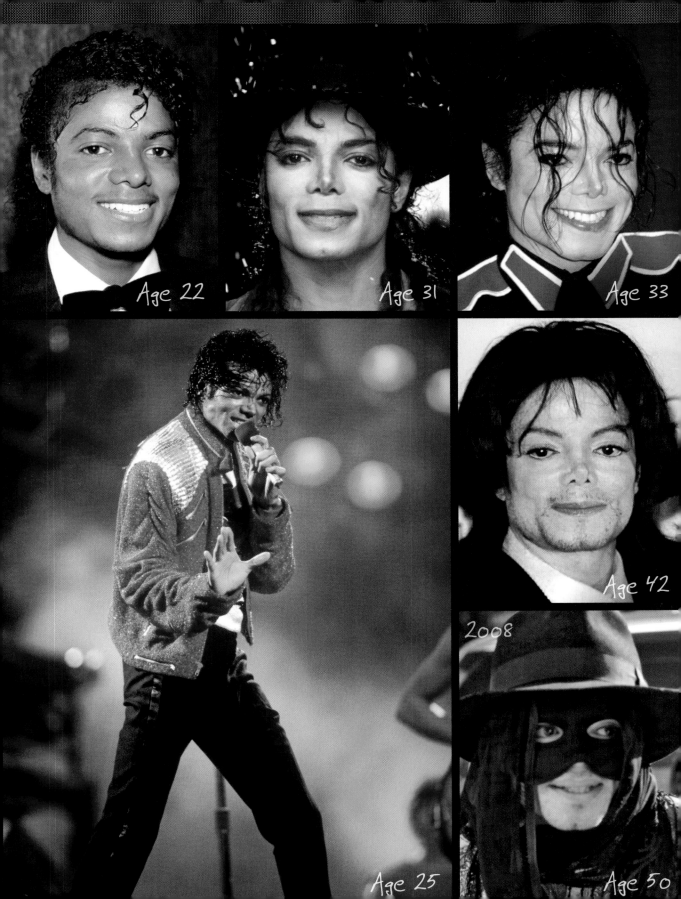

Age 22

Age 31

Age 33

Age 42

2008

Age 25

Age 50

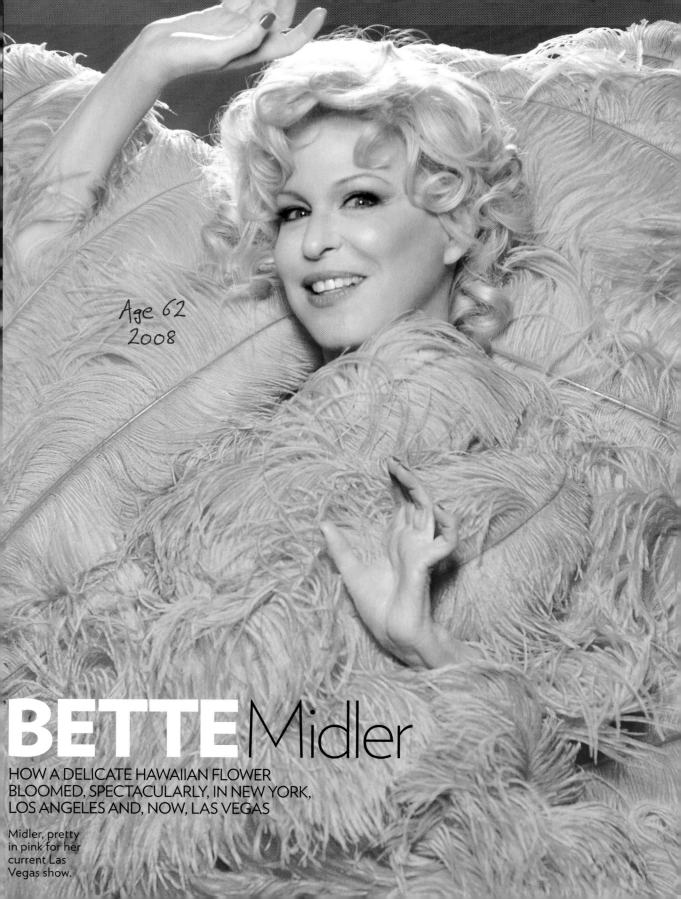

Age 62
2008

BETTE Midler

HOW A DELICATE HAWAIIAN FLOWER BLOOMED, SPECTACULARLY, IN NEW YORK, LOS ANGELES AND, NOW, LAS VEGAS

Midler, pretty in pink for her current Las Vegas show.

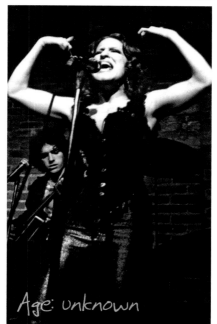

Age: unknown

LEFT "That's me in my corset!" says Midler (at Manhattan's Bitter End) in the early '70s). Starting out, Midler was in Broadway's *Fiddler on the Roof* and developed a nightclub act. "That was the beginning of everything," she says. "I look back and say, 'Oh, boy, it could've gone either way.'"

RIGHT Midler (striking a pose next to her tour truck in Atlanta in 1973, right) has always mixed sass and showwomanship. Planning her Las Vegas act, she promised, "I will be very blonde, and I will be dressed up like a Christmas goose!"

BELOW "Here we are as the trashy ladies," says Midler, who performed on Cher's variety show in 1975. "I kept that costume. I adore her."

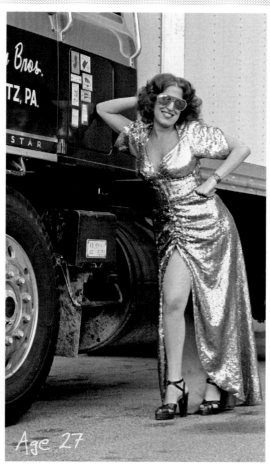

Age 27

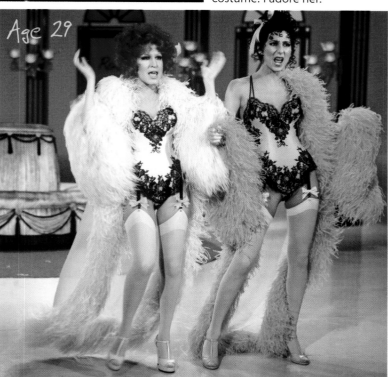

Age 29

BELOW Midler says that her daughter Sophie, 22, a Yale grad, and husband, artist Martin von Haselberg, were even more excited than she was about her temporary move to Vegas: "They get to have fun, and I have to do the work!"

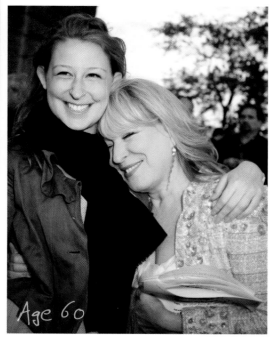

Age 60

A HOUSEPAINTER'S DAUGHTER WHO FELL IN LOVE with showbiz at 14, **Bette Midler** performed in gay bathhouses and on Broadway before becoming a movie star. "My dreams came true," she says. "It's been quite a ride." And it continues: Last year, Midler, now 63, replaced Celine Dion at Caesars Palace in Las Vegas. Backed by 18 dancers (the Caesar Salad Girls) and three backup singers (the Staggering Harlettes), Midler sings her classics and, effectively, blows her fans a big, campy kiss. "Come back and see us," she says at the end of the show. "We'll be here forever!"

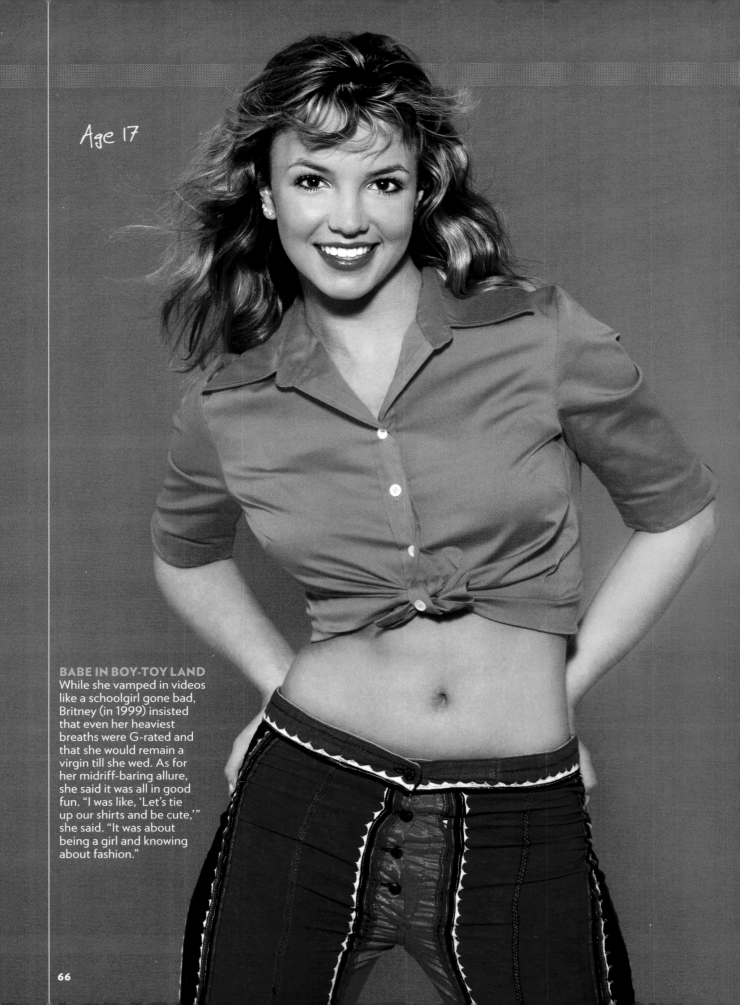

Age 17

BABE IN BOY-TOY LAND
While she vamped in videos like a schoolgirl gone bad, Britney (in 1999) insisted that even her heaviest breaths were G-rated and that she would remain a virgin till she wed. As for her midriff-baring allure, she said it was all in good fun. "I was like, 'Let's tie up our shirts and be cute,'" she said. "It was about being a girl and knowing about fashion."

BRITNEY Spears

IN HER JOURNEY FROM CRAYONS TO PERFUME, THE LOUISIANA LASSIE
LANDED IN LOLITALAND, SOJOURNING IN BARE BELLY ALONG THE WAY

Age unknown

Age 4

Age 14

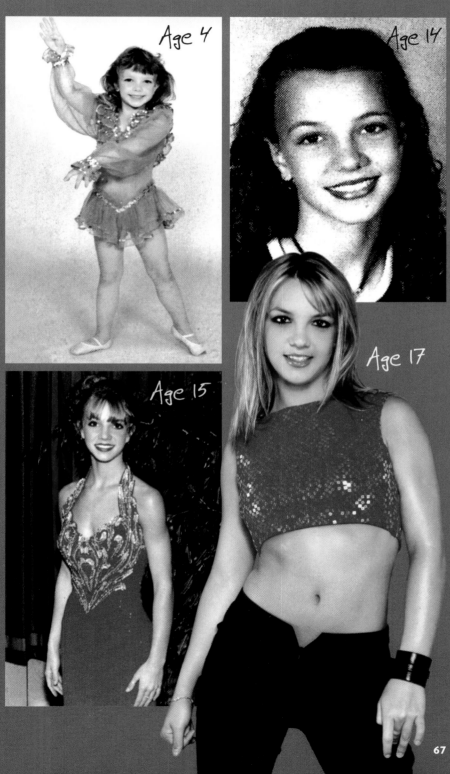

Age 15

Age 17

EVEN AS A TINY TOT SHE WAS so precocious, "I would get on my mom's nerves," said the girl who toddled to the name of Brit-Brit as a singing, dancing, Madonna-channeling child. Recalled her brother Bryan: "She would put on makeup and sing to herself in the bathrooom mirror." Years before she starred in the Disney Channel's *The New Mickey Mouse Club* with incubating talents Justin Timberlake and Christina Aguilera, Brit networked with a future coworker (at Disney World, above). By 1985 she was performing in dance pageants (center) and was a seasoned TV veteran by the time she reached eighth grade (above right). Classmates didn't have much time to admire their school's 1997 Freshman Maid beauty queen (right). Two years later she released her . . . *Baby One More Time* debut LP, which sold 25 million copies and Brit-Brit (far right) was a star-star.

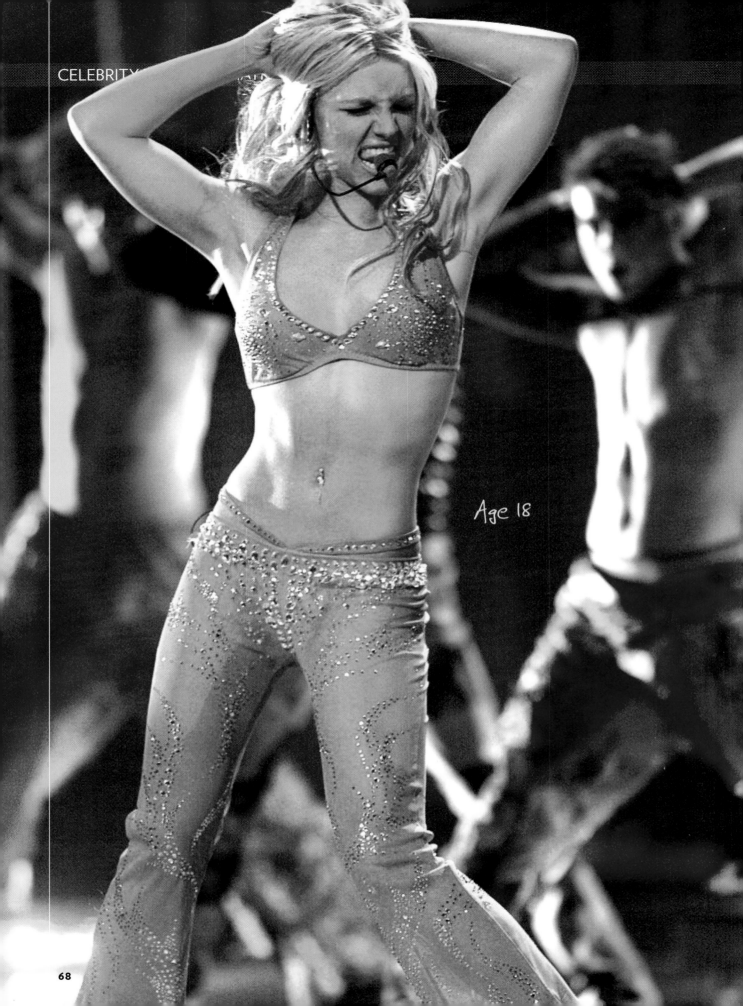

Age 18

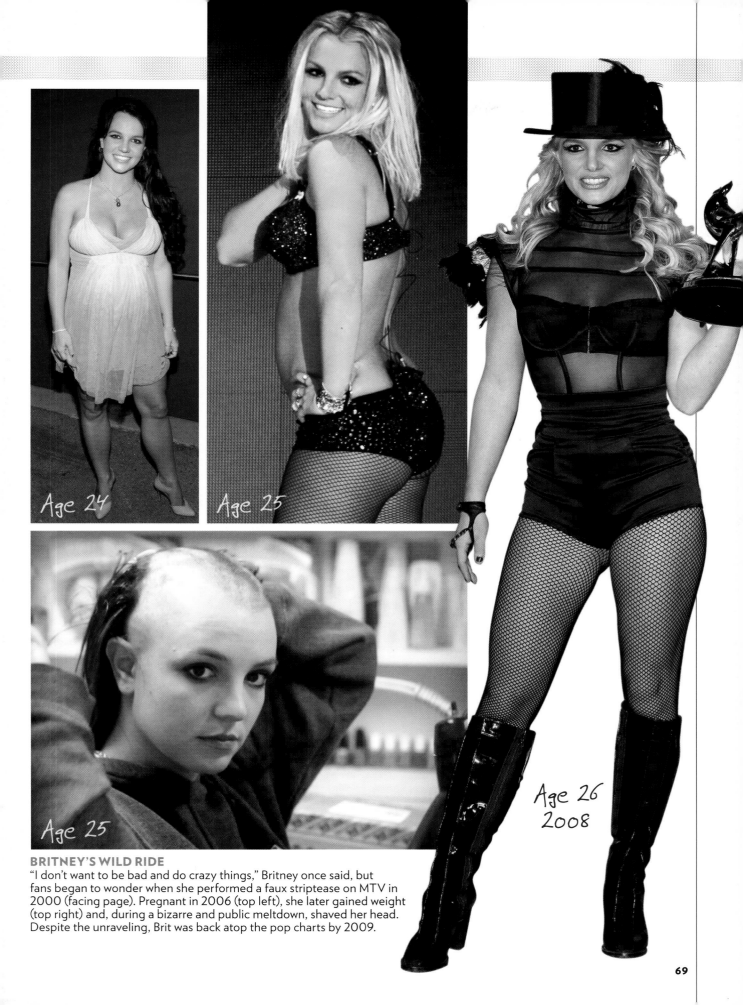

Age 24

Age 25

Age 25

Age 26
2008

BRITNEY'S WILD RIDE
"I don't want to be bad and do crazy things," Britney once said, but fans began to wonder when she performed a faux striptease on MTV in 2000 (facing page). Pregnant in 2006 (top left), she later gained weight (top right) and, during a bizarre and public meltdown, shaved her head. Despite the unraveling, Brit was back atop the pop charts by 2009.

Age 4

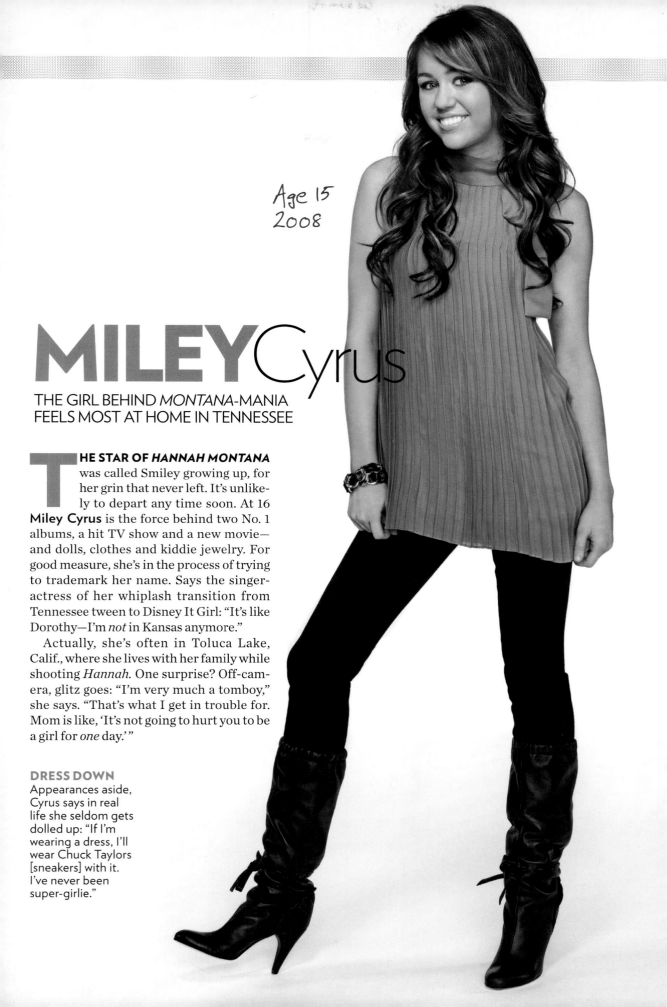

Age 15
2008

MILEY Cyrus

THE GIRL BEHIND *MONTANA*-MANIA FEELS MOST AT HOME IN TENNESSEE

THE STAR OF *HANNAH MONTANA* was called Smiley growing up, for her grin that never left. It's unlikely to depart any time soon. At 16 **Miley Cyrus** is the force behind two No. 1 albums, a hit TV show and a new movie—and dolls, clothes and kiddie jewelry. For good measure, she's in the process of trying to trademark her name. Says the singer-actress of her whiplash transition from Tennessee tween to Disney It Girl: "It's like Dorothy—I'm *not* in Kansas anymore."

Actually, she's often in Toluca Lake, Calif., where she lives with her family while shooting *Hannah*. One surprise? Off-camera, glitz goes: "I'm very much a tomboy," she says. "That's what I get in trouble for. Mom is like, 'It's not going to hurt you to be a girl for *one* day.'"

DRESS DOWN
Appearances aside, Cyrus says in real life she seldom gets dolled up: "If I'm wearing a dress, I'll wear Chuck Taylors [sneakers] with it. I've never been super-girlie."

The JONAS BROTHERS

FROM NEW JERSEY THEY CAME, SELLING RECORDS AND STEALING HEARTS

IF YOU'RE AN 11-YEAR-OLD GIRL, THE parent of an 11-year-old girl or have in the past year spent five minutes within earshot of an 11-year-old girl, the boys from Wyckoff, N.J., need no introduction. For anyone else: The **Jonas Brothers**—Kevin, Joe and Nick—sons of a former Assembly of God minister and his wife, are America's Boy Band du jour, the Monkees of the moment, 'NSYNC for the New Millennium. Their most recent album, *A Little Bit Longer*, debuted at No. 1, and their Disney TV movie, *Camp Rock*, attracted nearly 9 million viewers.

They seem to be surfing the wave of frenetic teen mania with bemused aplomb. And, so far, a complete absence of scandal: None of the boys drink or smoke, and all wear "purity rings" signifying their pledge to stay pure until marriage. "Some people are like, 'Whoa!'—taken aback," says Nick. "Why is the world so freaked out that we have standards?"

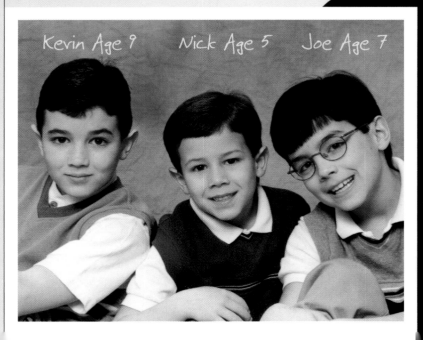

Kevin Age 9 Nick Age 5 Joe Age 7

MEET THE CUTES
As kids, Kevin (the oldest, above) was "the talkative one," Joe (middle) the quiet one and Nick (the youngest, right) "very serious," says their dad.

Kevin Age 21

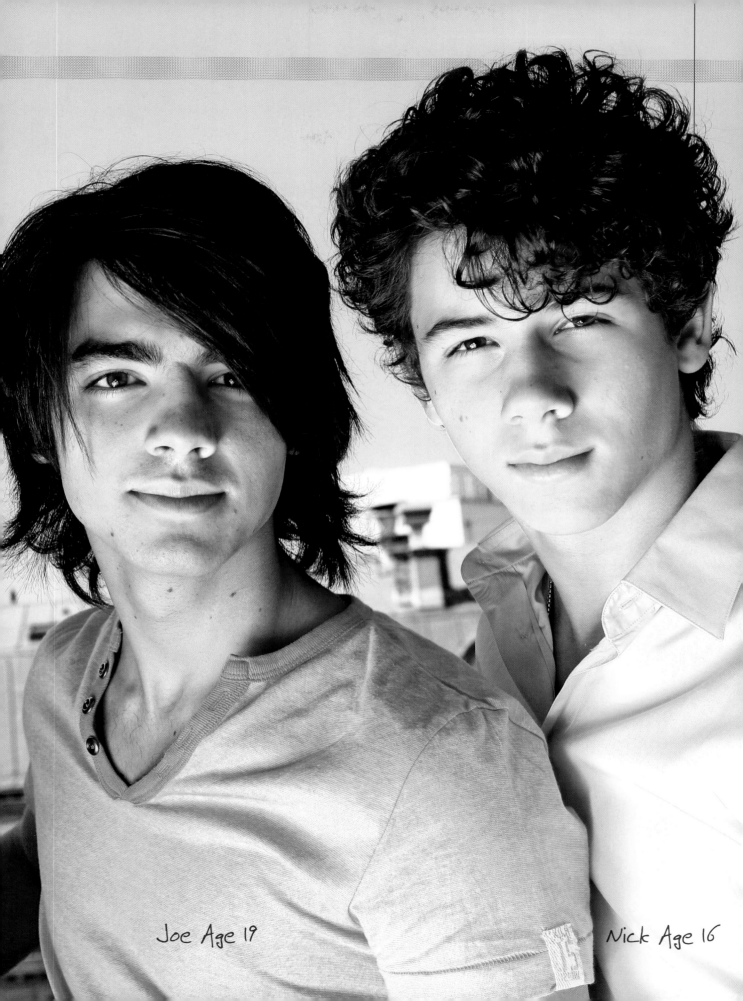

Joe Age 19 Nick Age 16

ELTON John

POP'S PEACOCK SHEDS THE OUTLANDISH FEATHERS OF YOUTH TO EMERGE, AT 61, HAPPIER, MELLOWER AND MARRIED

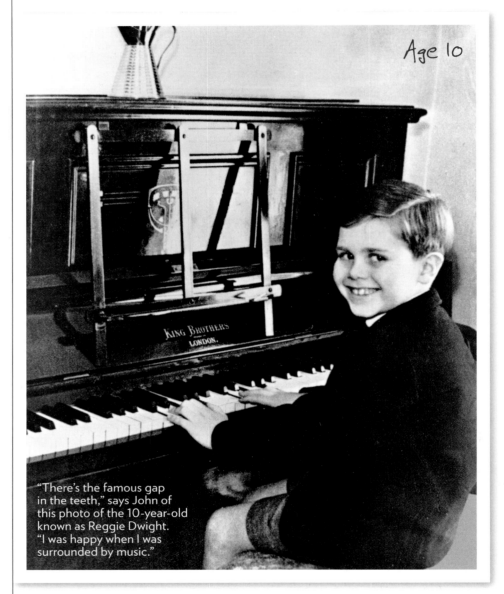

Age 10

"There's the famous gap in the teeth," says John of this photo of the 10-year-old known as Reggie Dwight. "I was happy when I was surrounded by music."

ONE OF ELTON JOHN'S MOST recent projects was creating the music for the Broadway hit *Billy Elliot,* about a boy whose father doesn't want him to study ballet. The story struck close to John's heart. "I never had his approval," says John of his dad, Stanley Dwight, an air force officer.

"My mother had letters from [my father] saying, 'He'll never become a star.'" John did, of course—and says he was thrilled that, in the end, his father, who died in 1991, "was proud of me." Despite the initial discouragement, John says his father also gave him a great gift: "He instilled in me the drive to become who I am."

"I was stuck behind a piano. I wanted to express myself through my outfits," explains pop's premier popinjay. He wore this one while singing "Don't Go Breaking My Heart" to Miss Piggy. "I couldn't stop laughing," he says. "She flounced off going, 'I'm fed up with working with amateurs!'"

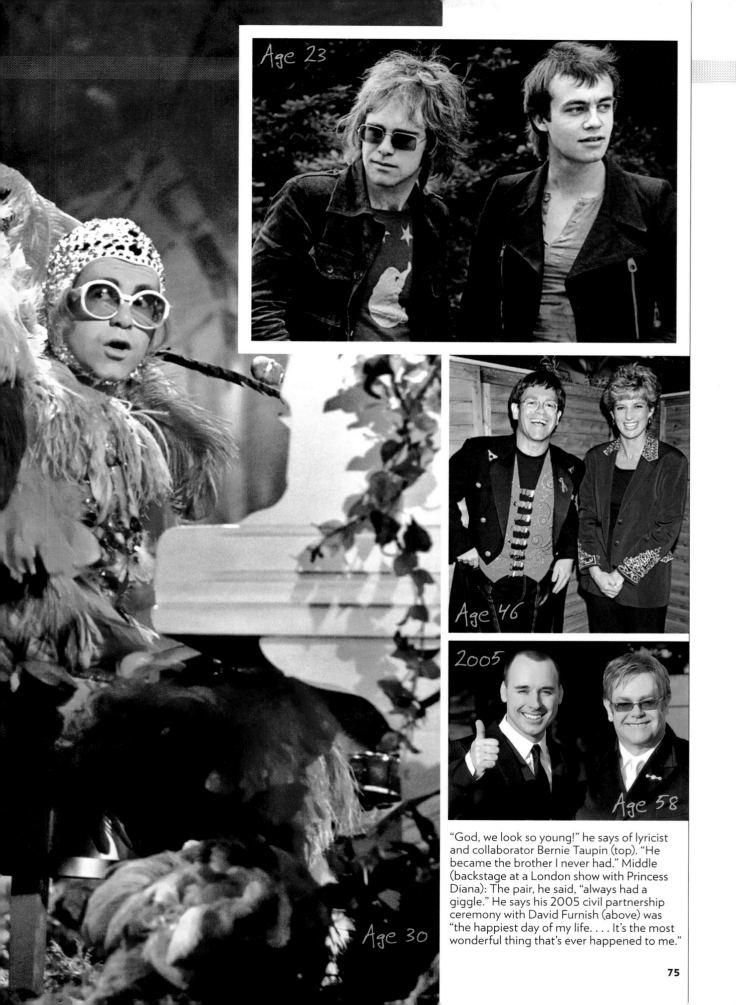

Age 23

Age 46

2005

Age 58

Age 30

"God, we look so young!" he says of lyricist and collaborator Bernie Taupin (top). "He became the brother I never had." Middle (backstage at a London show with Princess Diana): The pair, he said, "always had a giggle." He says his 2005 civil partnership ceremony with David Furnish (above) was "the happiest day of my life. . . . It's the most wonderful thing that's ever happened to me."

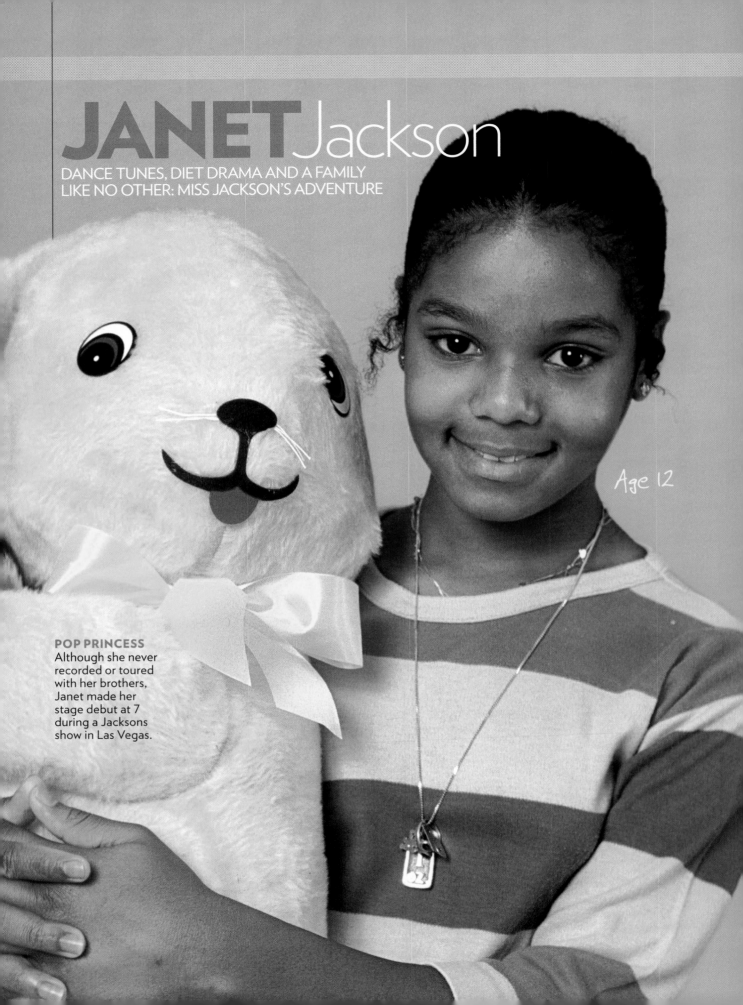

JANET Jackson

DANCE TUNES, DIET DRAMA AND A FAMILY LIKE NO OTHER: MISS JACKSON'S ADVENTURE

Age 12

POP PRINCESS
Although she never recorded or toured with her brothers, Janet made her stage debut at 7 during a Jacksons show in Las Vegas.

Age 6

Age 14

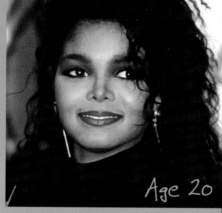

Age 20

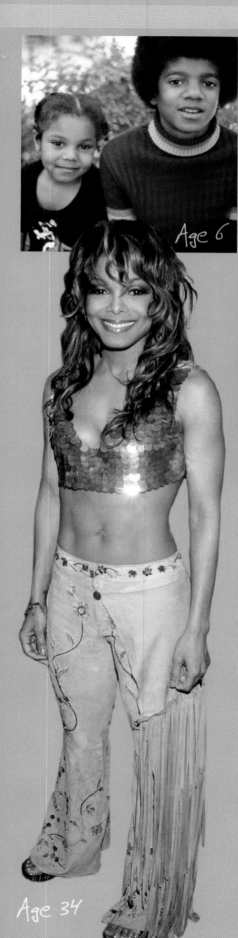

Age 34

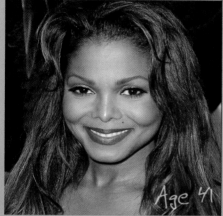

Age 39

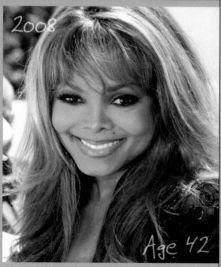

Age 41

2008

Age 42

AS THE KING OF POP'S BABY sister, she grew up in Michael Jackson's long—if very thin—shadow. "Michael and I were like this," she told PEOPLE, holding up crossed fingers. "If you saw Michael, you knew that I would be somewhere close." The youngest of the nine Jackson siblings leaped into the spotlight with her 1986 hit, "Nasty," and album, *Control.* "Now," she said then, "it's my turn." Her trajectory soared until 2004, when she and Justin Timberlake brought a tad too much sexy back during the Super Bowl halftime show. A Timberlake dance move exposed the nipple that launched a government investigation, immortalized a euphemism ("wardrobe malfunction") and, it seems, initiated a career slump. Her most recent album, *Discipline,* sold poorly, and she has lately canceled numerous concert dates—and a *Saturday Night Live* appearance—citing health problems.

OUT OF HER CONTROL
Plagued since childhood by fluctuating weight (brother Michael teasingly called her Dunk, short for "donkey," because of her size), Janet had ballooned by January 2006 (center) but shed the weight a few months later. By 2008 (above) she was hitting the Paris fashion shows.

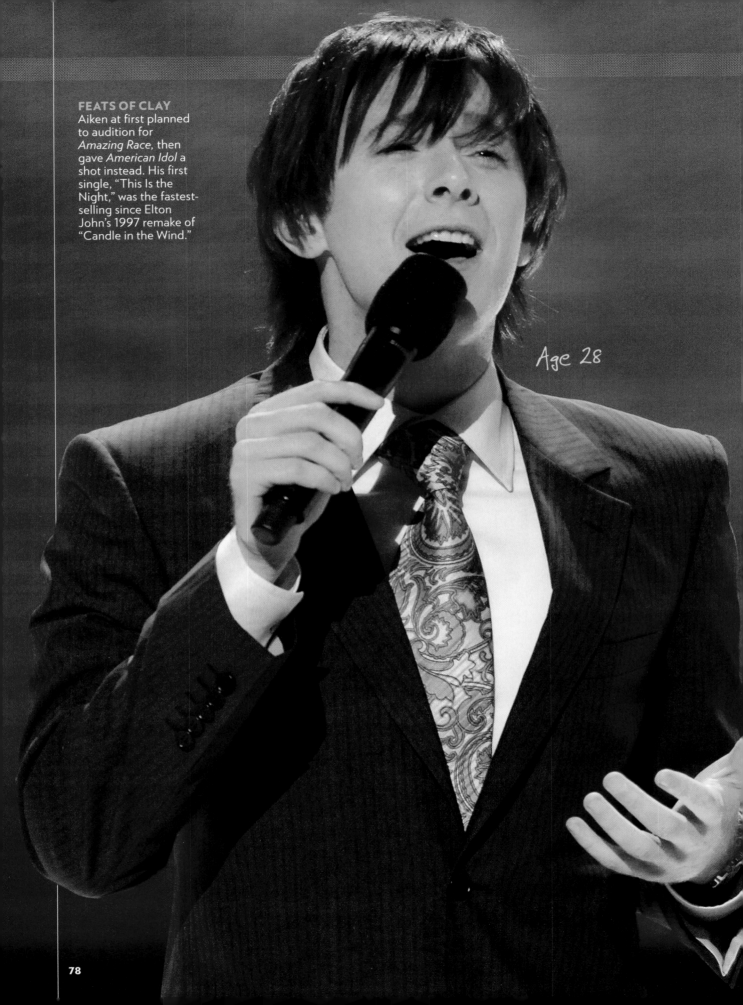

FEATS OF CLAY
Aiken at first planned to audition for *Amazing Race,* then gave *American Idol* a shot instead. His first single, "This Is the Night," was the fastest-selling since Elton John's 1997 remake of "Candle in the Wind."

Age 28

CLAYAiken

IT TOOK A VILLAGE OF STYLISTS TO COMPLETE *AMERICAN IDOL*'S MOST FAMOUS MAKEOVER

HIS GEEKY CHARM WON HIM LEGIONS OF FANS on *American Idol*; the honesty he displayed last year—when, shortly after becoming a dad, he announced he was gay—may have won him more. "It was the first decision I made as a father," Aiken said. "I cannot raise a child to lie." He realized his son, Parker, may get teased when he's older. "But I got picked on more than he'll ever get picked on, I guarantee you," he said. "And you know what? No matter what situation you're in, if you're raised in a loving environment, that's the most important thing."

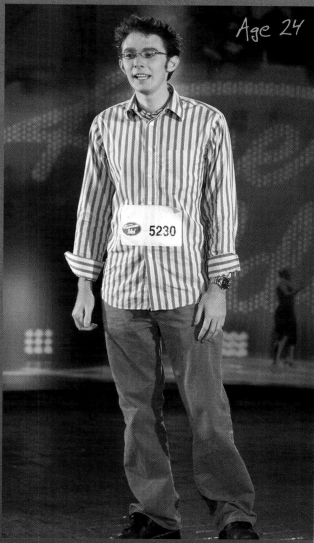

Age 24

5230

Age: unknown

Age 18

Age 24

Age 26

Age 29

2008

MOLDING CLAY
"You don't look like a pop star," Simon Cowell said at Aiken's 2003 audition (above). Born theatrical, Aiken made his singing debut at age 5 and starred in a school production of *Oklahoma!* at 16.

BEYONCÉ

THE HIP-POP-POP GODDESS FINDS FLAWS WHERE OTHERS CAN'T (BIG *EARS*?!?)

Age: about 13

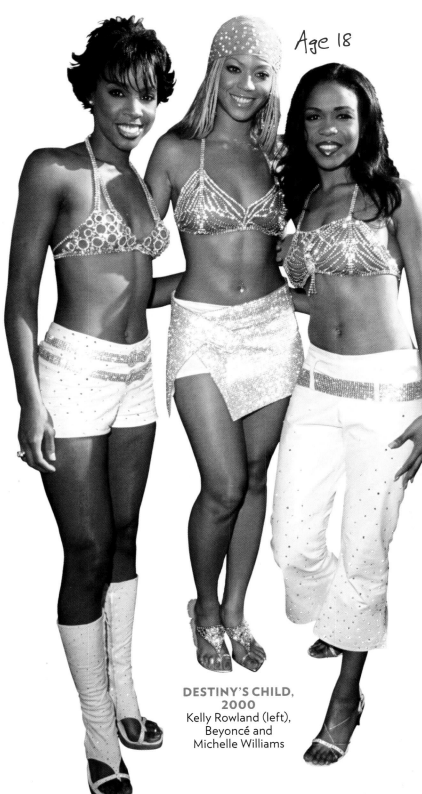

Age 18

DESTINY'S CHILD, 2000
Kelly Rowland (left), Beyoncé and Michelle Williams

TALENTS AS MANY-SPLENDORED have come before. But how many singer-actress-dancer-designer-model-songwriters live to see a word they popularized enshrined in the *Oxford English Dictionary*? Perhaps none as "bootylicious" (*adj.*, from the song of the same title, used, according to the *OED*, "often with reference to the buttocks; sexually attractive, sexy, shapely") as **Beyoncé**. Early in a career remarkable for its nonstop upward trajectory and the preservation of a public image as unblemished as her perfect, magazine-cover-shoot-ready skin, Beyoncé (her family name, Knowles, has long been superfluous) claimed her looks were nothing to sing about. "Every day I find something wrong," the then-19-year-old Destiny's Child leader said in 2001. "If I could make changes, my legs would be more muscular, I'd have a six-pack, and my waist would be smaller." Oh—and those ears! "I used to get teased because they were bigger than my head," she said. "I have many insecurities," she added. "I think they keep you humble." Add wisdom to the résumé.

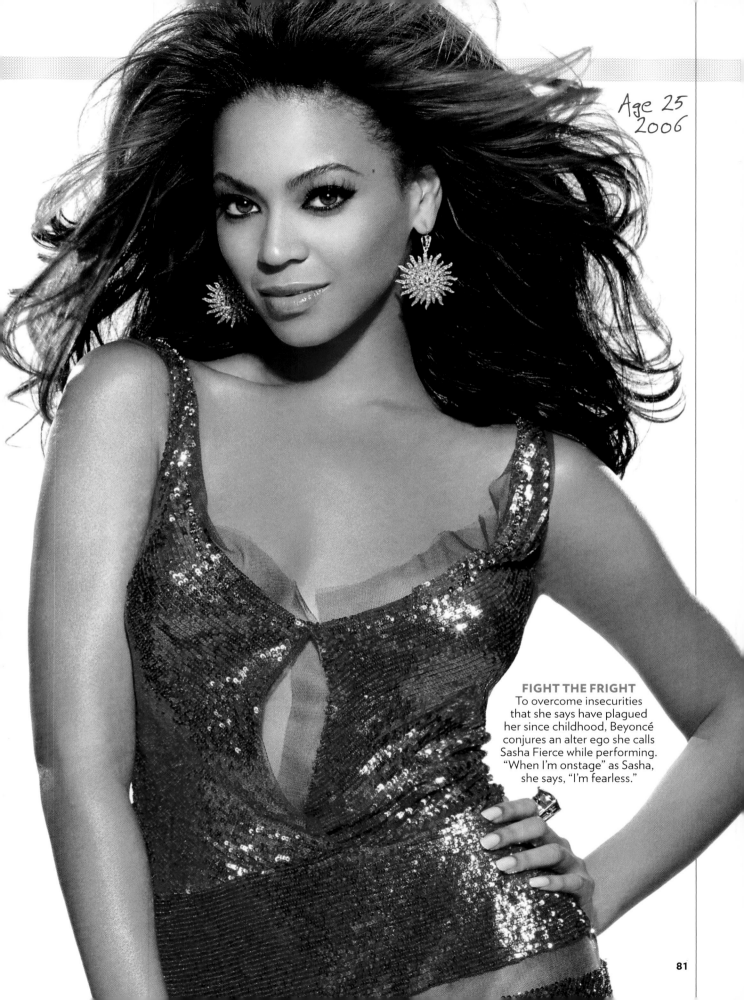

Age 25
2006

FIGHT THE FRIGHT
To overcome insecurities that she says have plagued her since childhood, Beyoncé conjures an alter ego she calls Sasha Fierce while performing. "When I'm onstage" as Sasha, she says, "I'm fearless."

81

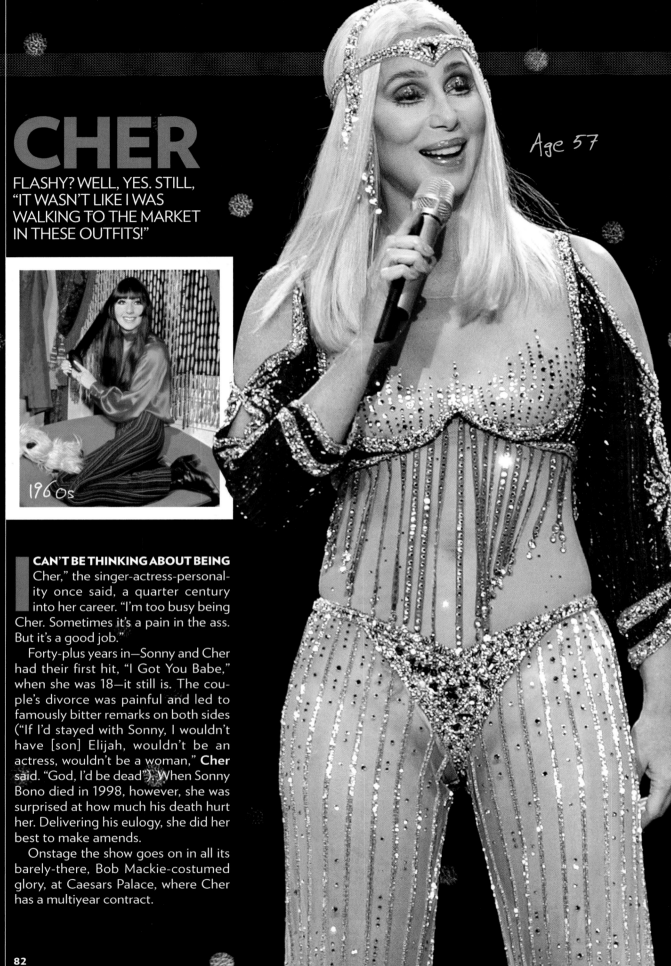

CHER

FLASHY? WELL, YES. STILL, "IT WASN'T LIKE I WAS WALKING TO THE MARKET IN THESE OUTFITS!"

Age 57

1960s

I **CAN'T BE THINKING ABOUT BEING** Cher," the singer-actress-personality once said, a quarter century into her career. "I'm too busy being Cher. Sometimes it's a pain in the ass. But it's a good job."

Forty-plus years in—Sonny and Cher had their first hit, "I Got You Babe," when she was 18—it still is. The couple's divorce was painful and led to famously bitter remarks on both sides ("If I'd stayed with Sonny, I wouldn't have [son] Elijah, wouldn't be an actress, wouldn't be a woman," **Cher** said. "God, I'd be dead"). When Sonny Bono died in 1998, however, she was surprised at how much his death hurt her. Delivering his eulogy, she did her best to make amends.

Onstage the show goes on in all its barely-there, Bob Mackie-costumed glory, at Caesars Palace, where Cher has a multiyear contract.

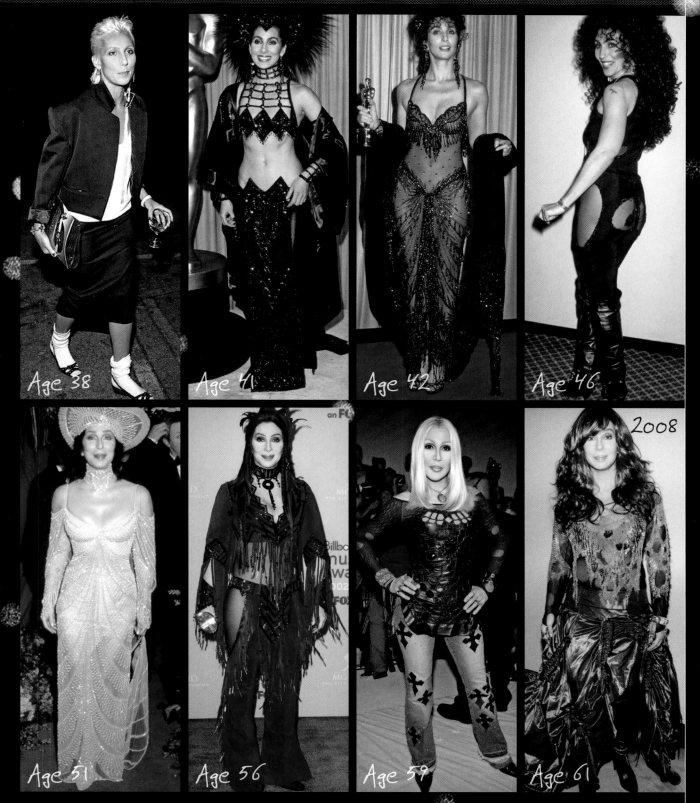

Age 38

Age 41

Age 42

Age 46

Age 51

Age 56

Age 59

2008

Age 61

TIME MARCHES ON, IN RHINESTONES & LEATHER

"Mom once told her, 'Someday you'll be really glad you look different and are different,'" Cher's sister Georgeanne Bartylak once recalled. "'You're going to have your time.'" That time has so far spanned four decades. Designer Bob Mackie said of his muse, "She was never intimidated by anything I put on her."

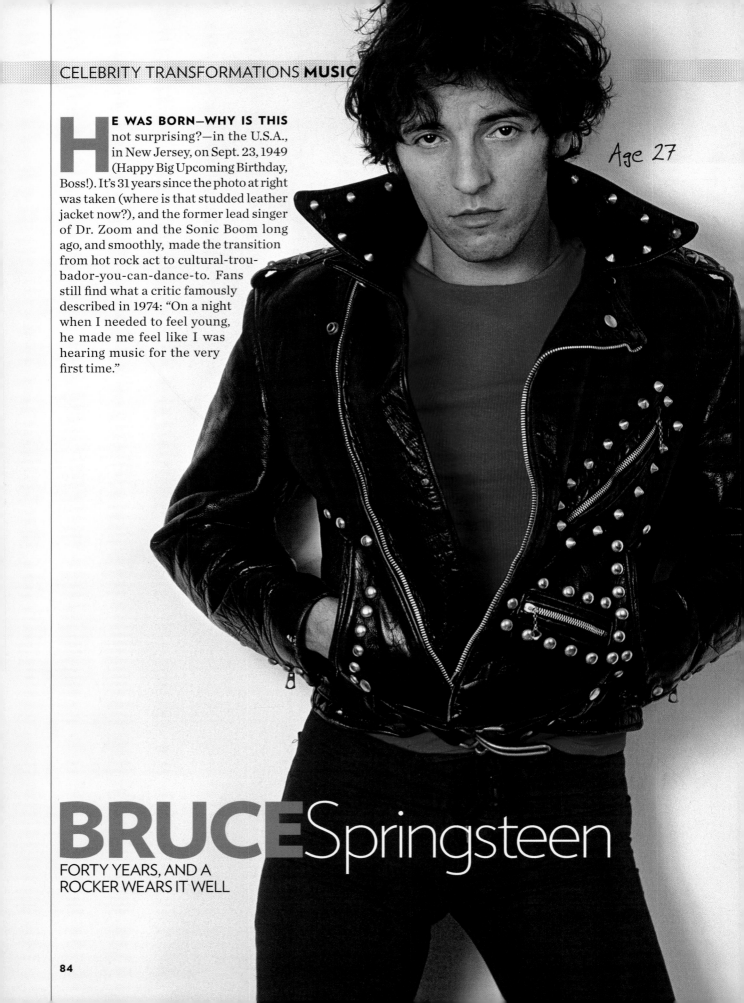

HE WAS BORN—WHY IS THIS not surprising?—in the U.S.A., in New Jersey, on Sept. 23, 1949 (Happy Big Upcoming Birthday, Boss!). It's 31 years since the photo at right was taken (where is that studded leather jacket now?), and the former lead singer of Dr. Zoom and the Sonic Boom long ago, and smoothly, made the transition from hot rock act to cultural-trou-bador-you-can-dance-to. Fans still find what a critic famously described in 1974: "On a night when I needed to feel young, he made me feel like I was hearing music for the very first time."

Age 27

BRUCE Springsteen
FORTY YEARS, AND A ROCKER WEARS IT WELL

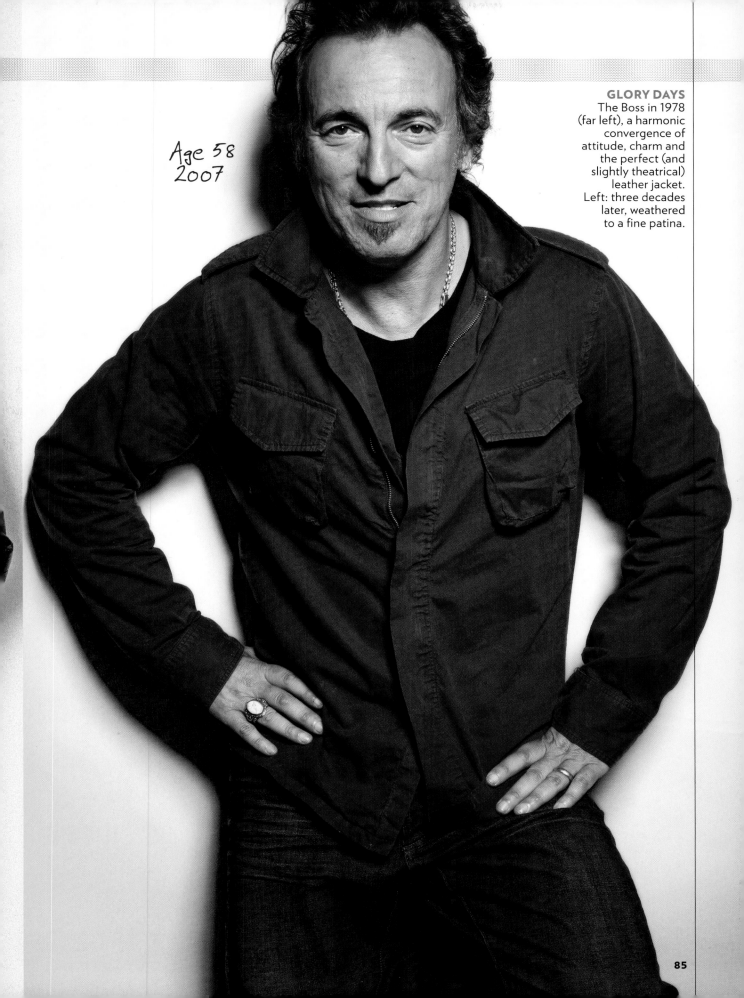

Age 58
2007

GLORY DAYS
The Boss in 1978
(far left), a harmonic
convergence of
attitude, charm and
the perfect (and
slightly theatrical)
leather jacket.
Left: three decades
later, weathered
to a fine patina.

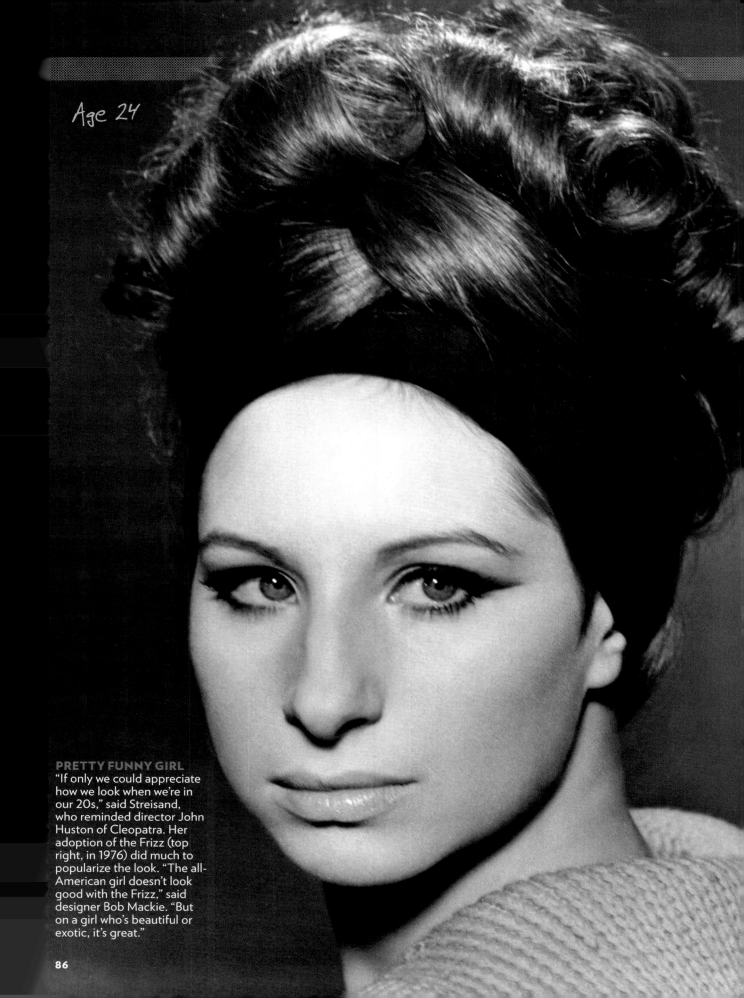

Age 24

PRETTY FUNNY GIRL
"If only we could appreciate how we look when we're in our 20s," said Streisand, who reminded director John Huston of Cleopatra. Her adoption of the Frizz (top right, in 1976) did much to popularize the look. "The all-American girl doesn't look good with the Frizz," said designer Bob Mackie. "But on a girl who's beautiful or exotic, it's great."

Barbra STREISAND

WHEN HER STAR WAS BORN, CRITICS DIDN'T KNOW WHAT TO MAKE OF HER EXOTIC BEAUTY; HER FANS HAVE BEEN VERKLEMPT EVER SINCE

MOM WAS, TO SAY THE LEAST, NOT always her biggest cheerleader. "'You'll never make it,'" **Barbra Streisand** recalled her mother saying. "'You're not pretty enough.'" (For good measure, Streisand's mother also told her that her voice was too weak.) The ferocious drive to prove her mother wrong helped make Streisand one of the most successful singers in history, a Broadway star and an Oscar-winning actress. "I was proving to my mother that this skinny little girl, you know, unconventional-looking, I suppose, could be a movie star," she told PEOPLE in 2008. While Streisand's voice made the likes of classical pianist Glenn Gould swoon ("one of the natural wonders of the age," he judged it), her looks did not conform to Hollywood conventions of beauty. "How can she be the leading lady?" costar Omar Sharif reportedly wondered after he was introduced to Streisand on the set of *Funny Girl*. But within a week he praised her as "the most gorgeous girl I'd ever seen in my life. I was madly in love with her."

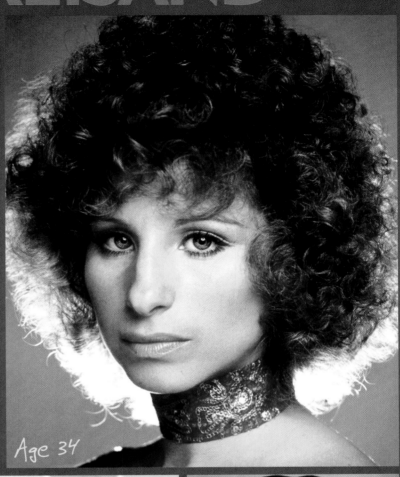

Age 34

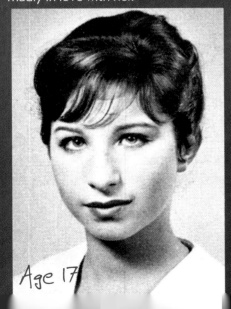

Age 17

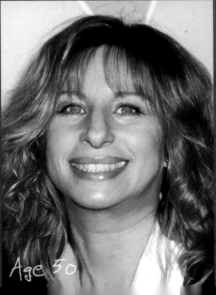

Age 50

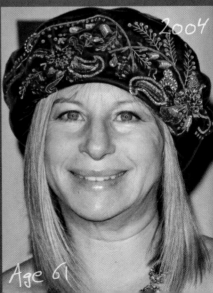

2004

Age 61

Starting out

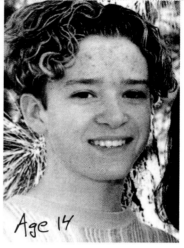

Age 14

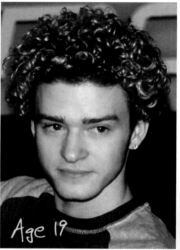

Age 19

SOON, I WILL GET BOOTS
A portrait of the artist as a very young cowpoke (left). At 11, Timberlake performed the Alan Jackson song "Love's Got a Hold on You" on the TV talent show *Star Search*. And, alas, lost.

JUSTIN Timberlake

BYE, BYE, BYE? HARDLY; WHEN THE BOY GROUP 'NSYNC FOLDED,
ONE MEMBER BECAME A BREAKOUT SOLO ACT

IT STARTED LIKE THIS: AS THE WARM-UP ACT at a lip-synching contest, **Justin Timberlake**, age 8, sang a New Kids on the Block song. And? "Little girls in the sixth grade . . . just surrounded him," recalled Timberlake's stepdad. "It was like something out of a Beatles movie. They had him pinned against a wall. Some wanted to get his autograph; some tried to give him money."

Twenty years later, the girls are older, but not much else has changed. Though still not yet 30, the ex-Mouseketeer, who rocketed to fame with 'Nsync, has romanced Britney and Cameron and, as a solo act in 2006, famously brought (as the song proclaimed) "Sexy Back"—which earned him a Grammy but, inexplicably, no recognition from the United Nations.

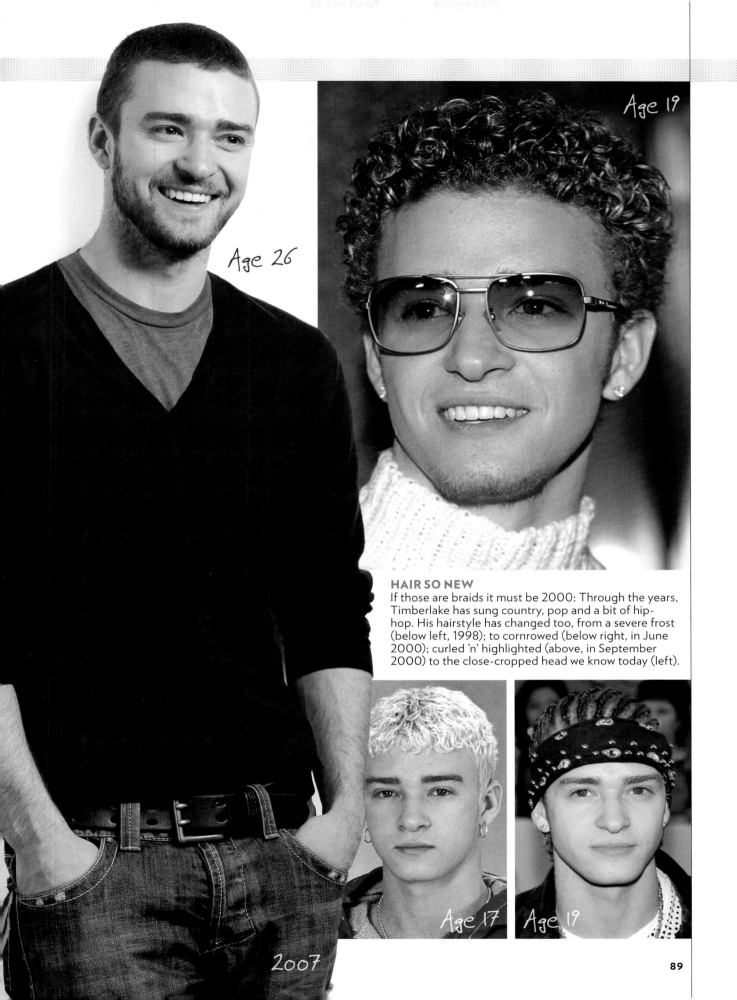

Age 26

Age 19

Age 17

Age 19

2007

HAIR SO NEW
If those are braids it must be 2000: Through the years, Timberlake has sung country, pop and a bit of hip-hop. His hairstyle has changed too, from a severe frost (below left, 1998); to cornrowed (below right, in June 2000); curled 'n' highlighted (above, in September 2000) to the close-cropped head we know today (left).

KEITHUrban

COUNTRY'S DOWN UNDER WONDER HEATS UP HEARTSTRINGS

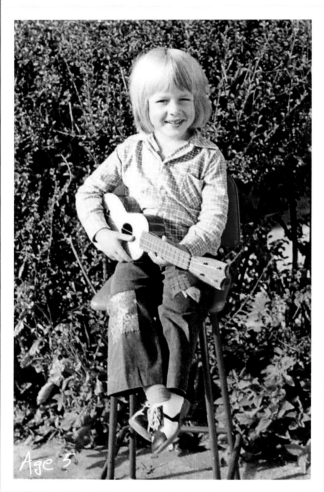

Age 5

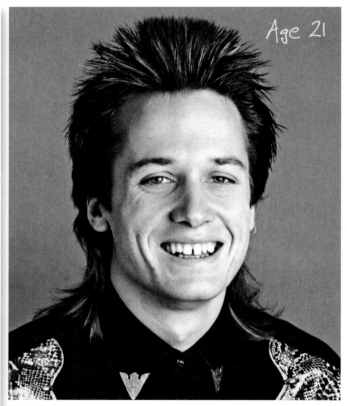

Age 21

Age: unknown

WHAT IS THE KIWI COWBOY'S SECRET? "Besides the fact that he's hot and speaks with an accent," opined tour mate Miranda Lambert, "he's vulnerable yet mysterious and smells really good." Born in Whangarei, New Zealand, and raised in Caboolture, Australia—where, besides having fun with phonics, he milked cows and was taught to twang by his music-loving parents—**Keith Urban** was more than a little bit country when he moved to Nashville in 1992. Even so, he said, "I knew I would be a little fish in a big sea." He eventually made his splash with his music, of course. But when he guested on an album by his childhood hero Dolly Parton, she sensed something more: "The longer I was with him, the sexier he got. I couldn't keep my mind on my business."

HUMAN UKE BOX
Strumming since he was a tyke (left), Urban joined his parents on stage at 8 and formed his own band at 14. He was a star in Australia with four No. 1 country hits by the time he moved to Nashville.

LOCKS ON FAME
Stardom, a nude appearance in *Playgirl* and his natural color were in the future when he posed in 2001. That same year he was called the "male . . . Faith Hill." Urban hoped his "girlfriend doesn't look like Tim McGraw."

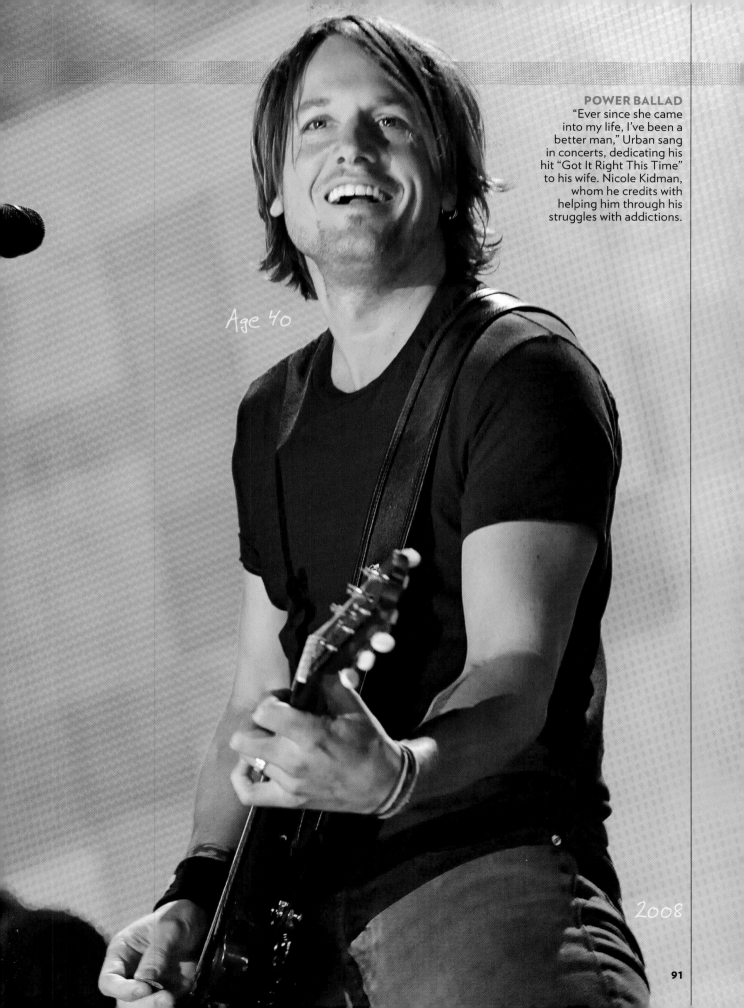

POWER BALLAD
"Ever since she came into my life, I've been a better man," Urban sang in concerts, dedicating his hit "Got It Right This Time" to his wife. Nicole Kidman, whom he credits with helping him through his struggles with addictions.

Age 40

2008

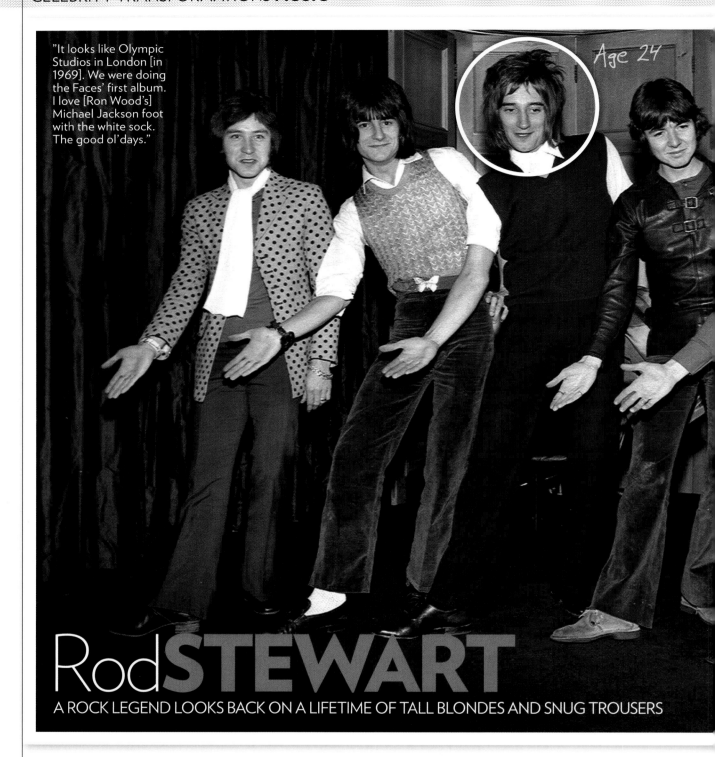

"It looks like Olympic Studios in London [in 1969]. We were doing the Faces' first album. I love [Ron Wood's] Michael Jackson foot with the white sock. The good ol' days."

Age 24

Rod STEWART

A ROCK LEGEND LOOKS BACK ON A LIFETIME OF TALL BLONDES AND SNUG TROUSERS

T SEEMS LIKE ONLY YESTERDAY HE WAS A ROOSTER-coiffed lad, swept into America by "Maggie May" and the last wave of the British Invasion. And now . . . he's a rooster-coiffed 64-year-old living in Beverly Hills with longtime girlfriend Penny Lancaster, 38, and still producing hits (*Still the Same . . . Great Rock Classics of Our Time* debuted at No. 1 on *Billboard*'s album chart in 2006). Success as a sexagenarian is "absolutely sweeter," says **Rod Stewart.** "I've been written off so many bloody times, it's like I've had the last laugh." One curious fact: Stewart's passion for models extends beyond the runway. A model-railroad fanatic, he filled an entire floor of his home with a spectacularly detailed track setup—which landed the proud hobbyist on the cover of the December 2007 *Model Railroader* magazine.

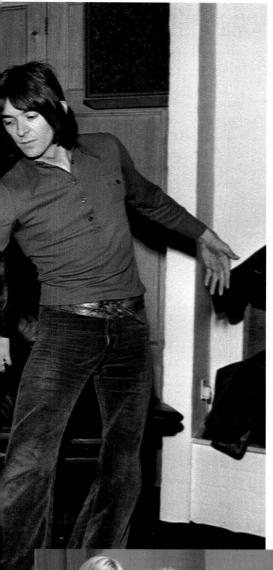

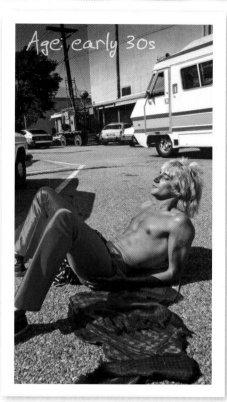
Age: early 30s

Age 31

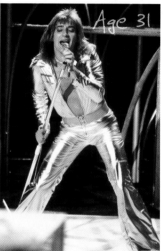
Age 31

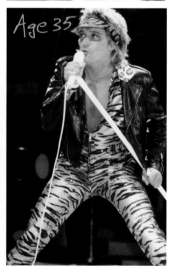
Age 35

ABOVE: "I've always been a bit of a bronzer. That's the bottom half of whatever I was going to wear" in Los Angeles ca. 1978.

BELOW: "That's all the kids; a handsome bunch they are. That's Sean on the right, then there's Kimberly, Renee, then Ruby, Old Dad, then Liam in the front and my lovely girlfriend Penny at the end. A family turnout at the American Music Awards" in 2003.

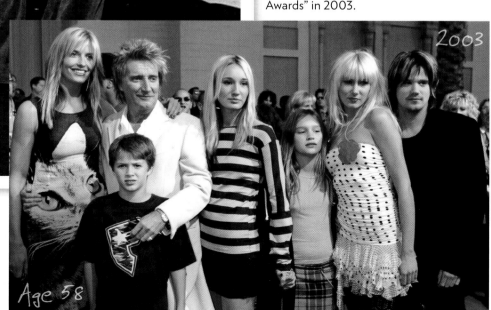
2003

Age 58

Do you think I'm sexy: The classic years, onstage. "It's a lovely figure of a man, you must admit. Can you imagine I used to wear this and then go play [soccer] on Saturday?"

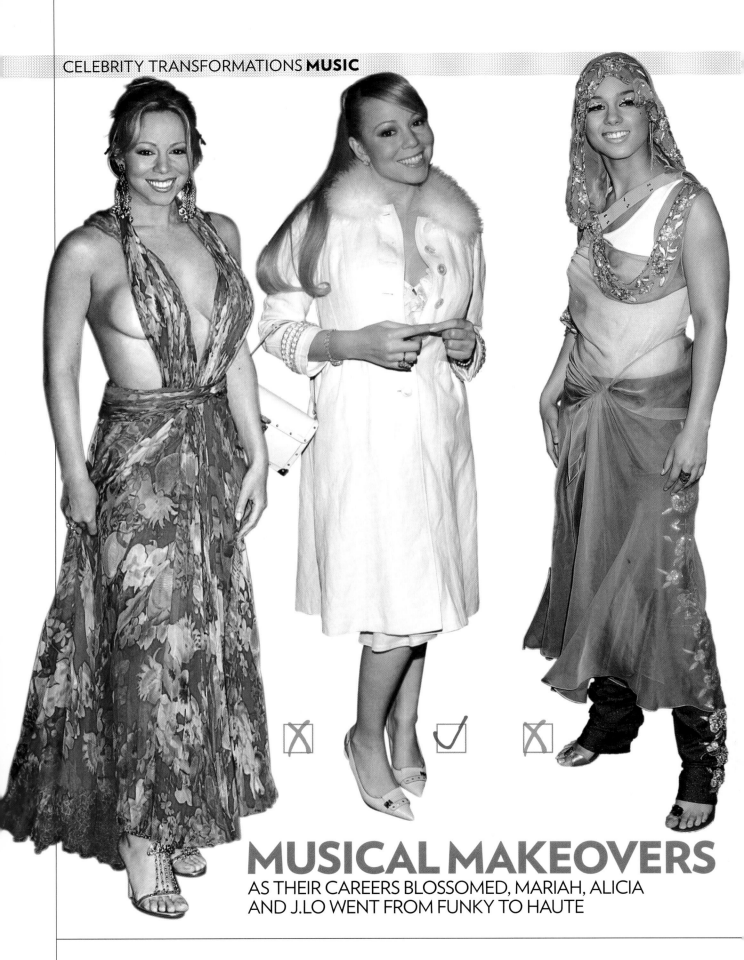

MUSICAL MAKEOVERS
AS THEIR CAREERS BLOSSOMED, MARIAH, ALICIA
AND J.LO WENT FROM FUNKY TO HAUTE

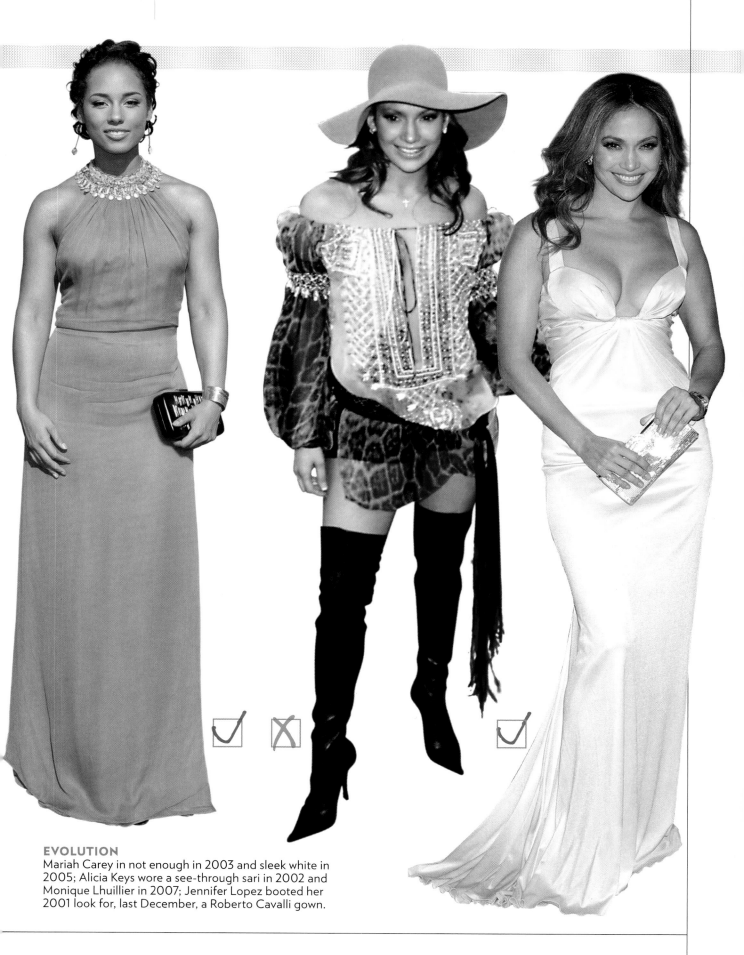

EVOLUTION
Mariah Carey in not enough in 2003 and sleek white in
2005; Alicia Keys wore a see-through sari in 2002 and
Monique Lhuillier in 2007; Jennifer Lopez booted her
2001 look for, last December, a Roberto Cavalli gown.

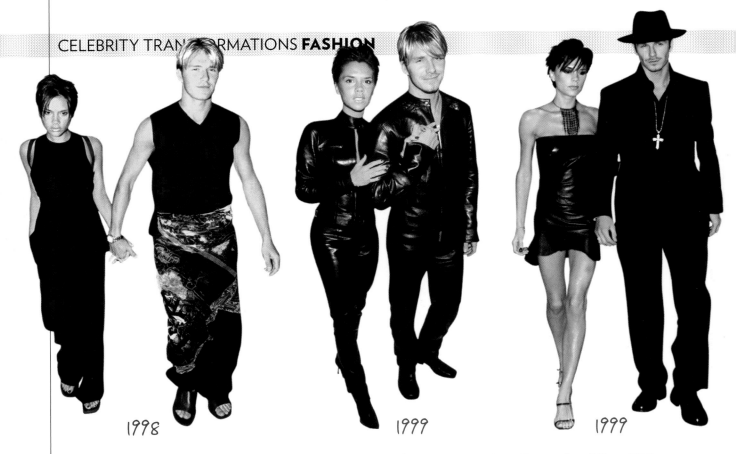

1998 1999 1999

BECKHAMS ON PARADE

FROM ENGLAND THEY CAME, A PAIR WITH FLAIR (AND *NO* FEAR OF FLASHBULBS)

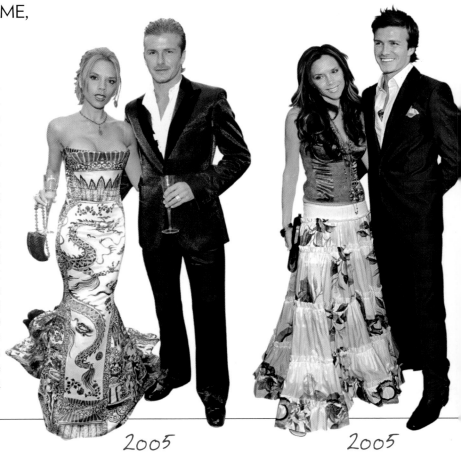

2005 2005

MANY WOMEN ARE FASH-ionable. Some men are fashionable. But there may be no celebrity *couple* as fashion-focused as **Victoria "Posh Spice" Beckham,** 34, and her soccer-star husband, **David,** 33. Formal or casual, in argyle, matching leathers or skirt (his) and pants (hers), they are—at the very least—never dull. Which raises an obvious question: Who spends more time in front of the mirror? "It would definitely be me," says Victoria. "But I don't think it's as much time as people assume. Obviously, with the [three] kids running around, I can't afford to be high-maintenance." Though she does reserve the right to make her own decisions: "I've always found it quite weird when people have stylists. . . . I'm way too much of a control freak."

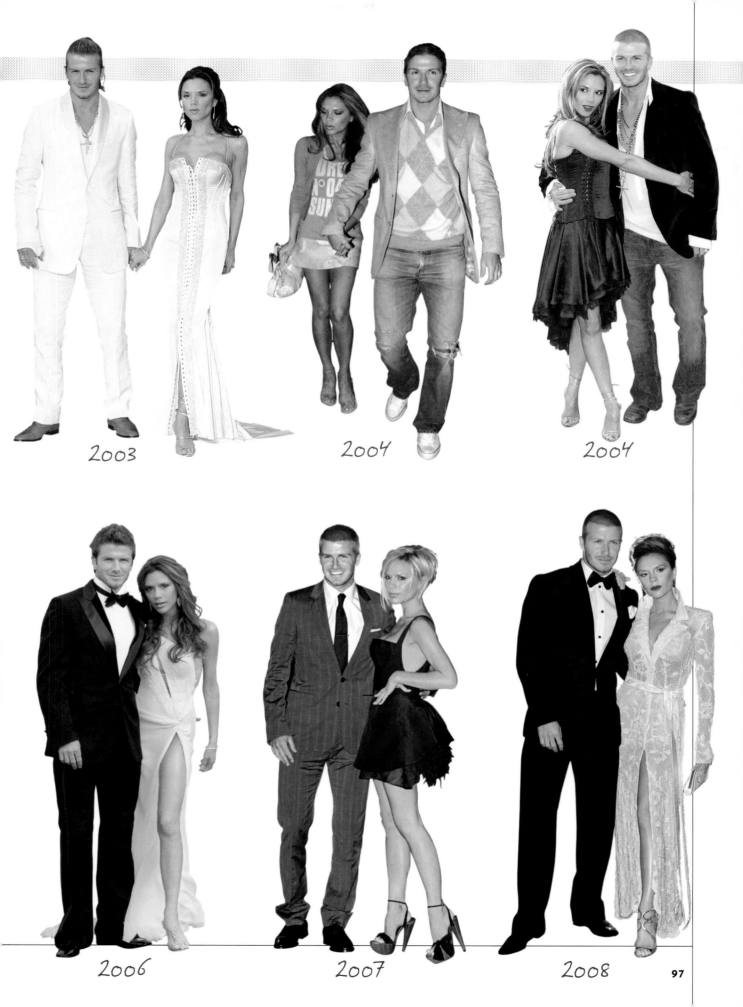

2003

2004

2004

2006

2007

2008

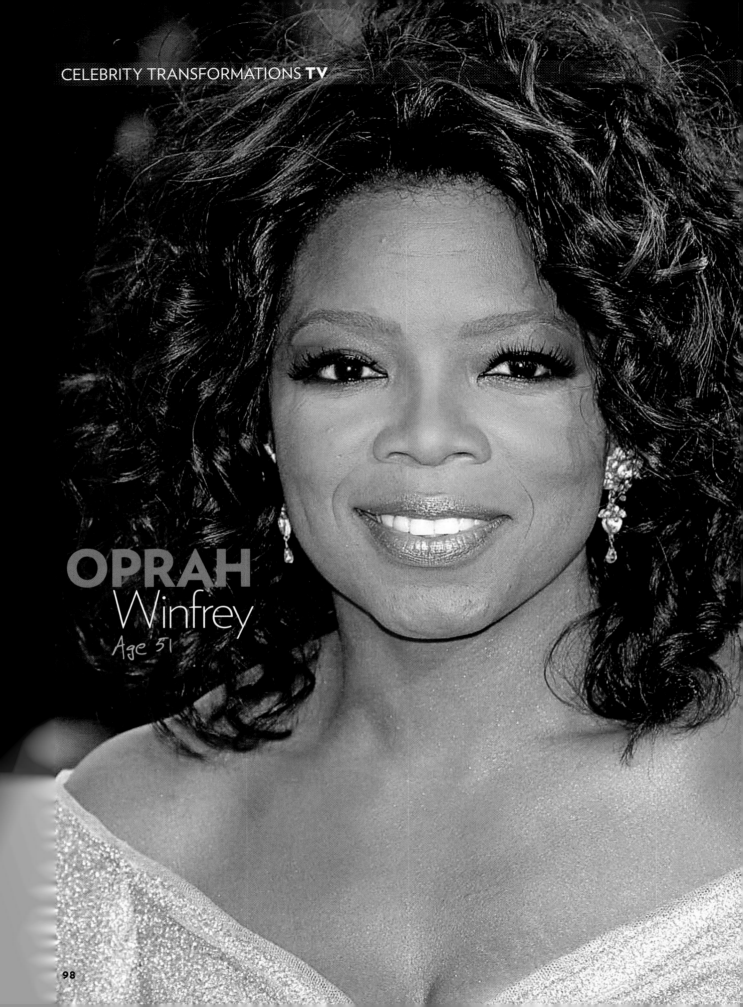

OPRAH
Winfrey
Age 51

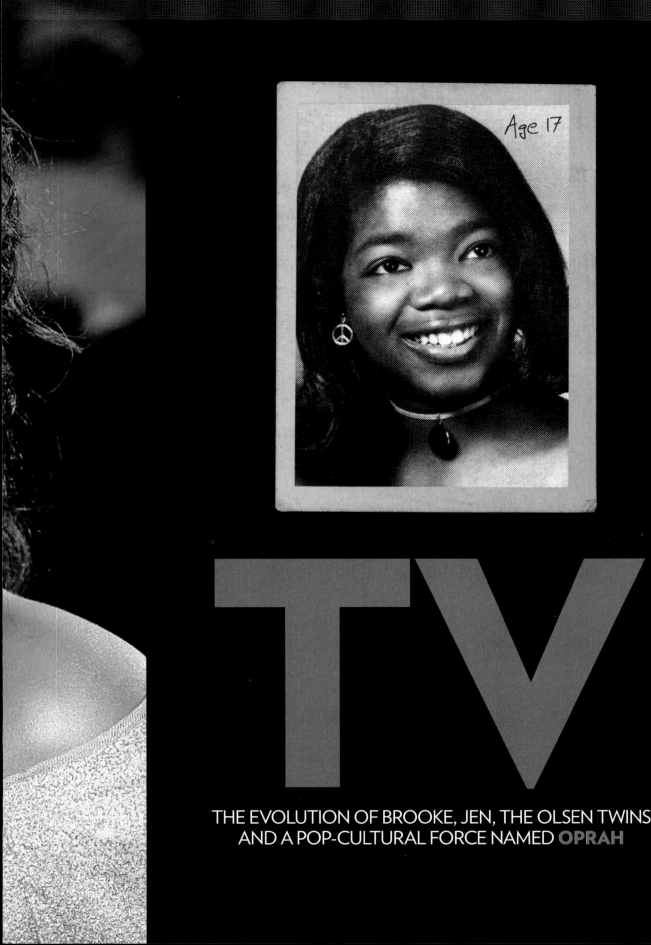

Age 17

TV

THE EVOLUTION OF BROOKE, JEN, THE OLSEN TWINS
AND A POP-CULTURAL FORCE NAMED **OPRAH**

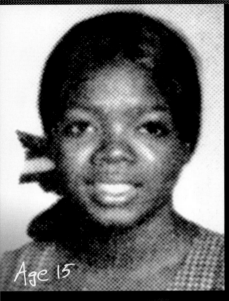

Age 15

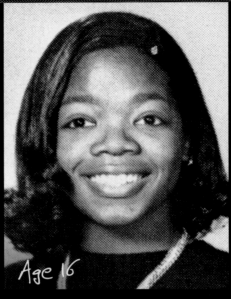

Age 16

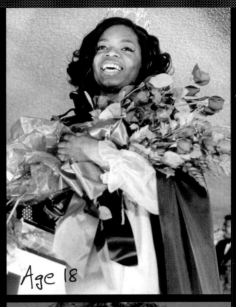

Age 18

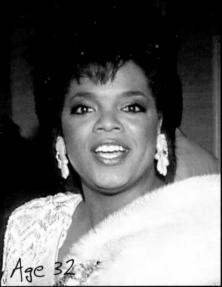

Age 32

"SHE MAKES PEOPLE CARE BECAUSE SHE CARES. THAT IS WINFREY'S GENIUS, AND WILL BE HER LEGACY, AS THE CHANGES SHE HAS WROUGHT . . . PERMEATE OUR CULTURE AND SHAPE OUR LIVES"
—TIME MAGAZINE, 1998

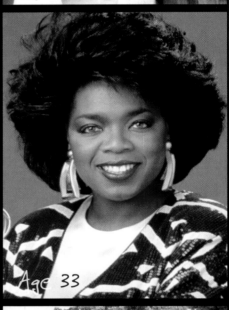

Age 33

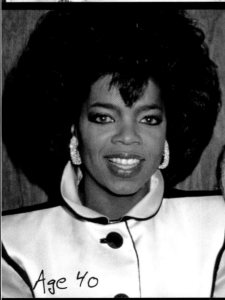

Age 40

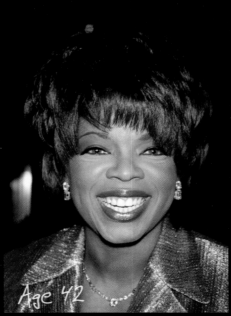

Age 42

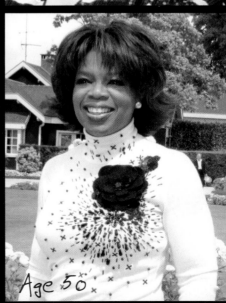

Age 50

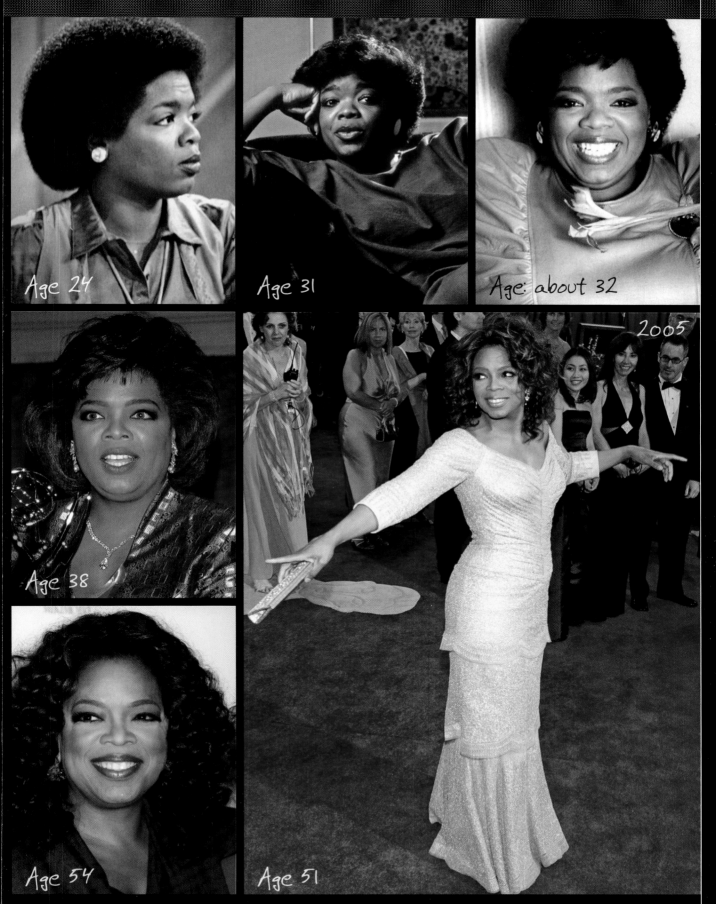

Age 24

Age 31

Age: about 32

2005

Age 38

Age 54

Age 51

Age 8

Age 17

SARAH JESSICA Parker

STARDOM? SURE. GLAMOUR QUEEN? THAT, FOR SJP, WAS A HAPPY SURPRISE

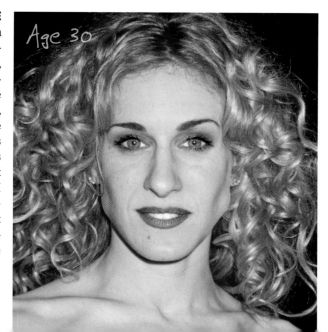

Age 30

HER STANDING IN THE PANTHEON OF STYLE was cemented when Manolo Blahnik, the design house she helped lionize in *Sex and the City,* christened a new shoe the SJP. Not bad for an actress who, after starring in *Annie* on Broadway at age 12, spent a frustrating decade in Hollywood. Cast in a series of what she felt were ugly duckling roles, **Sarah Jessica Parker** came to believe, she told IN STYLE, that she was "not pretty enough to play the lead" in a major Hollywood movie. "For many years she was always surprised whenever she or a character she played was considered sexy," director David Frankel told PEOPLE. That changed big-time in 1998. "Sarah Jessica has the biting wit I wanted the character to have, but she is also extremely sympathetic," said Darren Star, producer of the HBO series that made SJP household initials. And when she won the 2004 Emmy for best lead comedy actress, she exulted, "This is the biggest celebration I've had in a long time!"

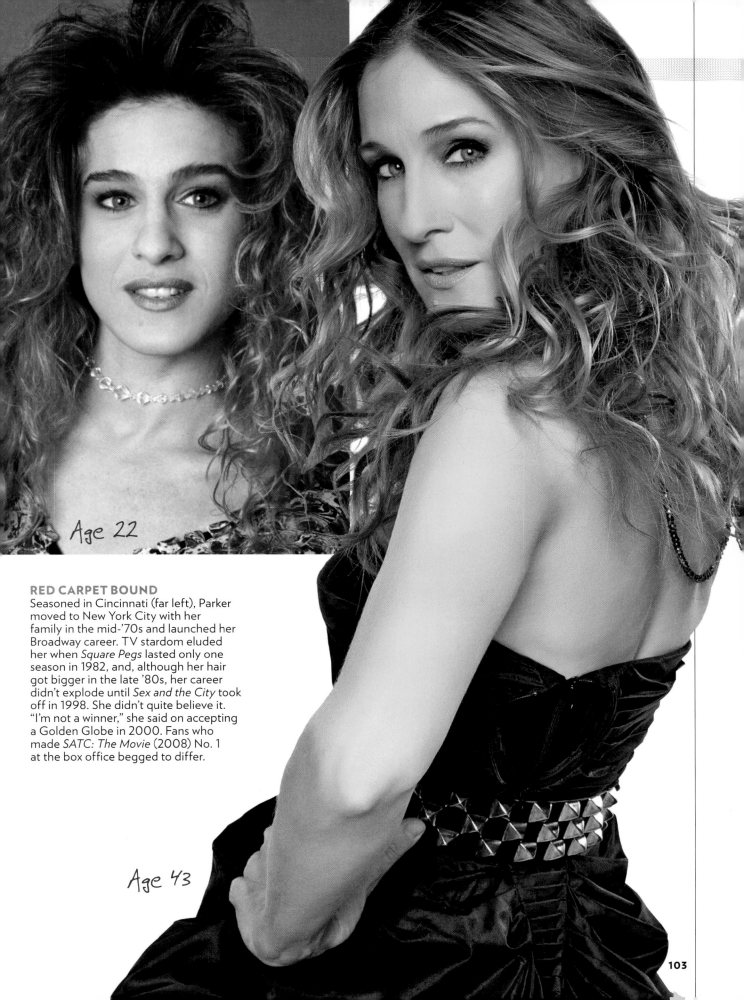

Age 22

RED CARPET BOUND
Seasoned in Cincinnati (far left), Parker
moved to New York City with her
family in the mid-'70s and launched her
Broadway career. TV stardom eluded
her when *Square Pegs* lasted only one
season in 1982, and, although her hair
got bigger in the late '80s, her career
didn't explode until *Sex and the City* took
off in 1998. She didn't quite believe it.
"I'm not a winner," she said on accepting
a Golden Globe in 2000. Fans who
made *SATC: The Movie* (2008) No. 1
at the box office begged to differ.

Age 43

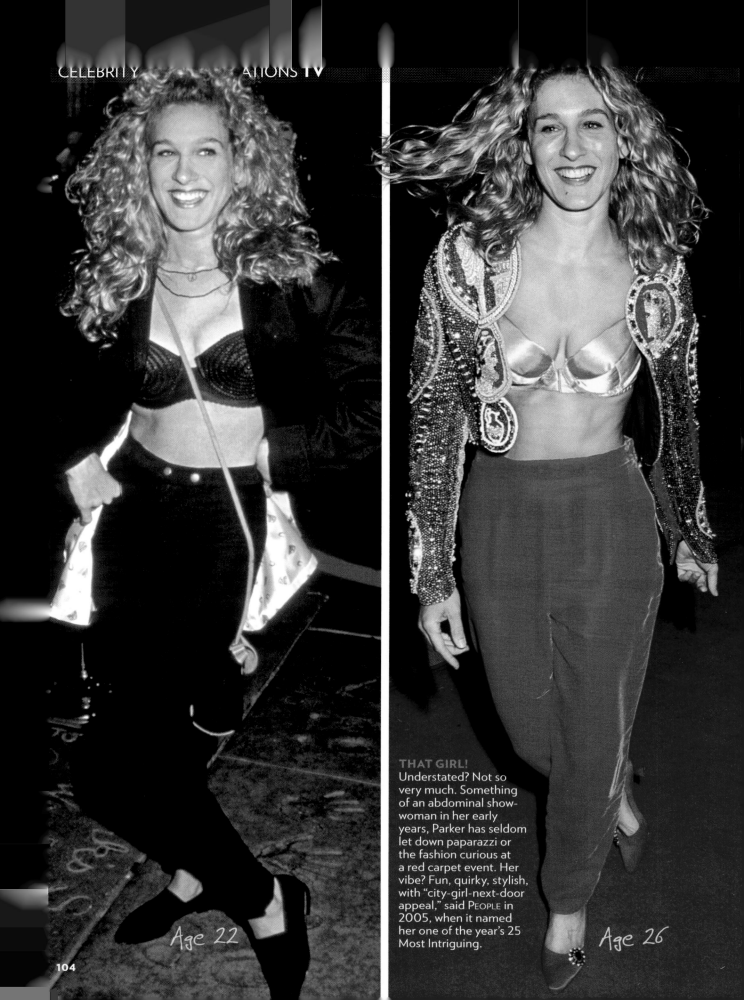

THAT GIRL!
Understated? Not so very much. Something of an abdominal show-woman in her early years, Parker has seldom let down paparazzi or the fashion curious at a red carpet event. Her vibe? Fun, quirky, stylish, with "city-girl-next-door appeal," said PEOPLE in 2005, when it named her one of the year's 25 Most Intriguing.

Age 22

Age 26

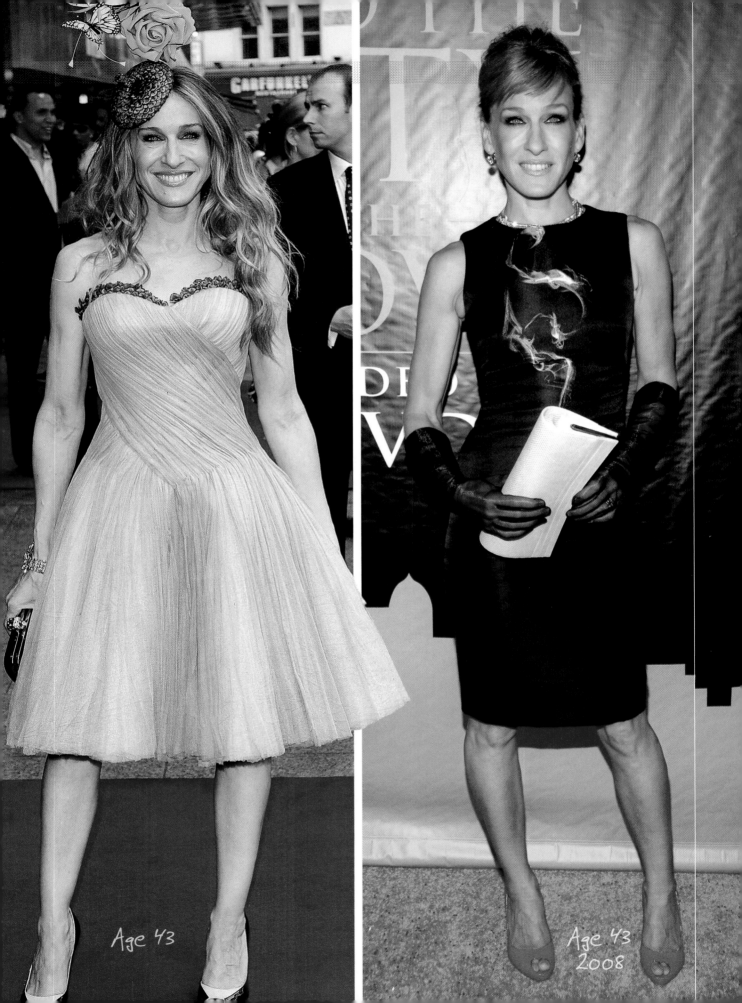

Age 43

Age 43
2008

Age 13

BROOKEShields

AN IVORY SOAP MODEL BEFORE SHE TURNED 1, SHE HAS BEEN
LOOKING BACK AT THE CAMERA ALL HER LIFE

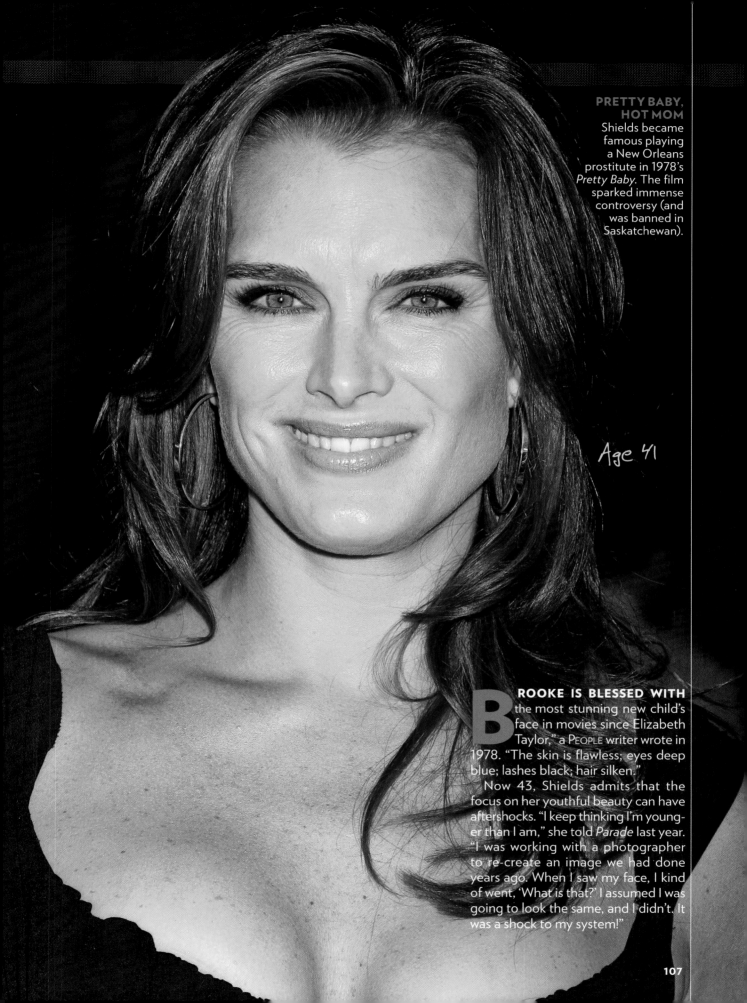

Age 41

BROOKE IS BLESSED WITH the most stunning new child's face in movies since Elizabeth Taylor," a PEOPLE writer wrote in 1978. "The skin is flawless; eyes deep blue; lashes black; hair silken."

Now 43, Shields admits that the focus on her youthful beauty can have aftershocks. "I keep thinking I'm younger than I am," she told *Parade* last year. "I was working with a photographer to re-create an image we had done years ago. When I saw my face, I kind of went, 'What is that?' I assumed I was going to look the same, and I didn't. It was a shock to my system!"

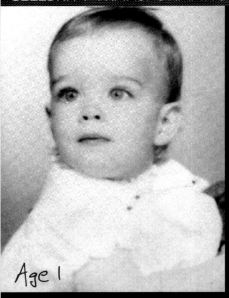

Age 1

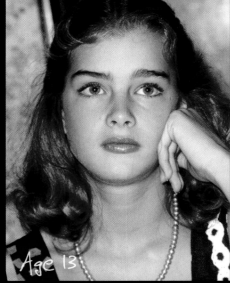

Age 13

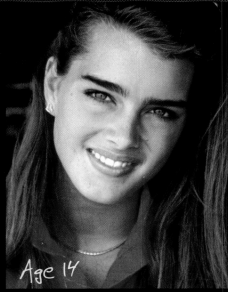

Age 14

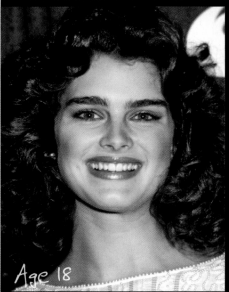

Age 18

TERI SHIELDS,
BROOKE'S MOM
AND MANAGER,
CALLED HER
PRECOCIOUSLY
BEAUTIFUL
DAUGHTER
"A GIFT FROM
GOD"

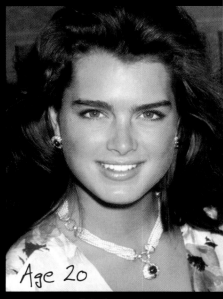

Age 20

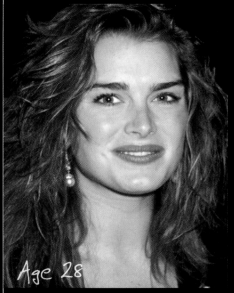

Age 28

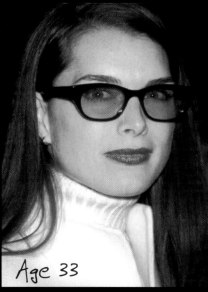

Age 33

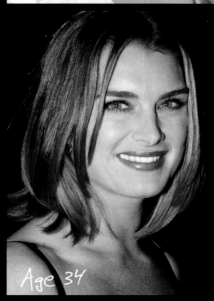

Age 34

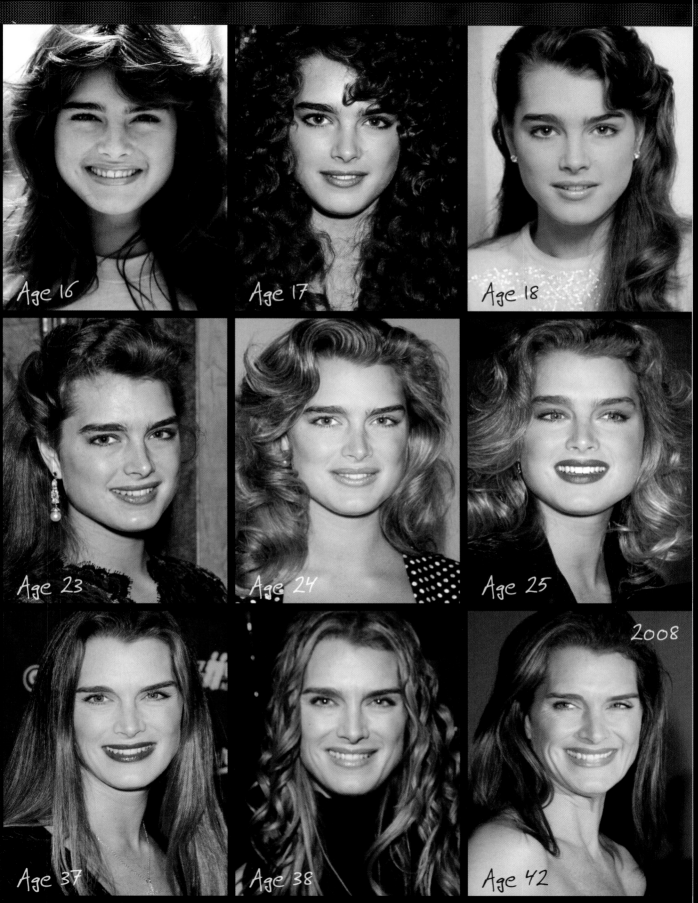

Age 16

Age 17

Age 18

Age 23

Age 24

Age 25

2008

Age 37

Age 38

Age 42

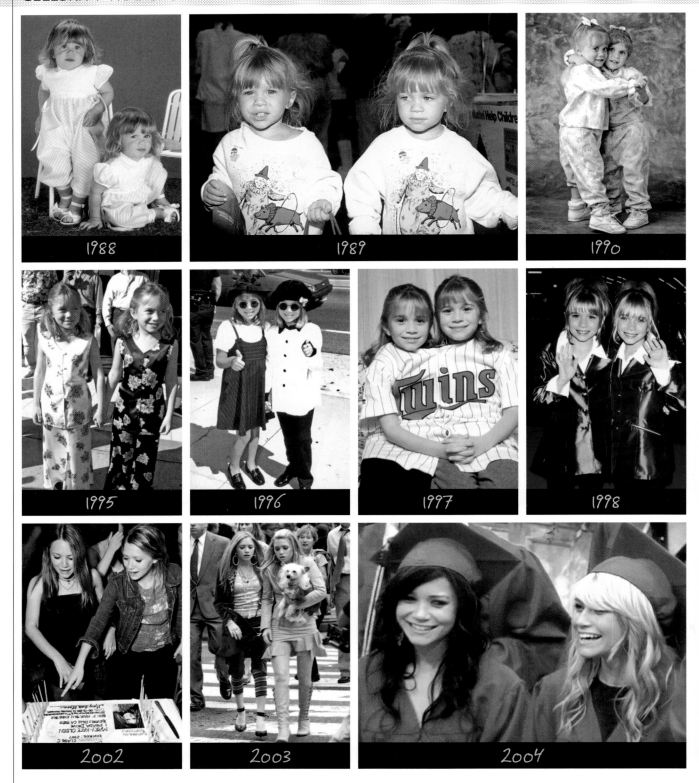

1988

1989

1990

1995

1996

1997

1998

2002

2003

2004

The**OLSEN TWINS**

MINIMOGULS MARY-KATE AND ASHLEY TACKLE THEIR NEXT PROJECT: ADULTHOOD

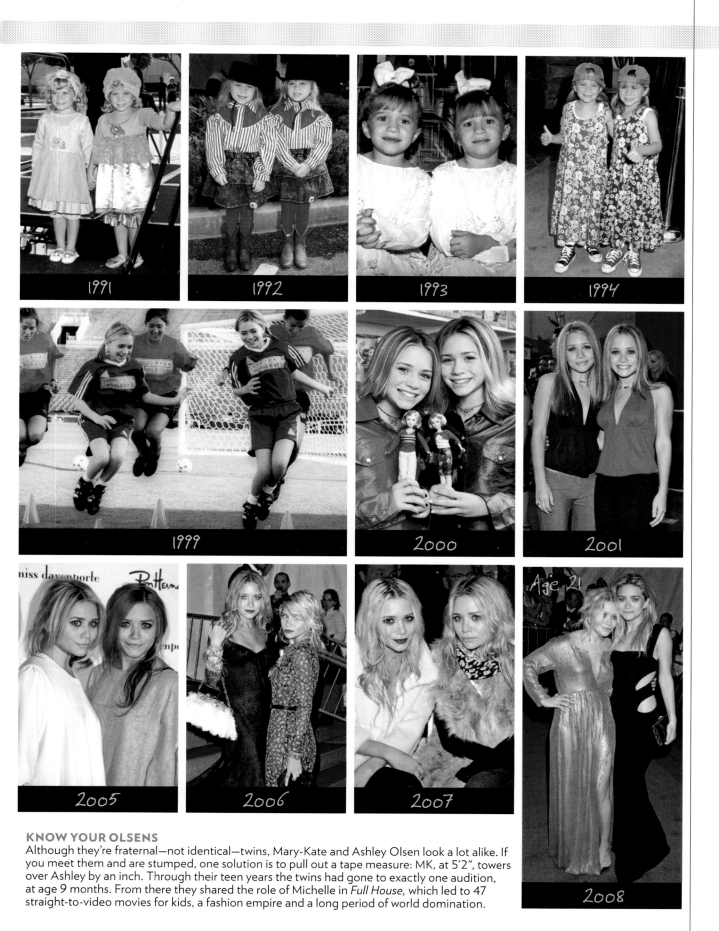

1991

1992

1993

1994

1999

2000

2001

2005

2006

2007

Age 21

2008

KNOW YOUR OLSENS

Although they're fraternal—not identical—twins, Mary-Kate and Ashley Olsen look a lot alike. If you meet them and are stumped, one solution is to pull out a tape measure: MK, at 5'2", towers over Ashley by an inch. Through their teen years the twins had gone to exactly one audition, at age 9 months. From there they shared the role of Michelle in *Full House,* which led to 47 straight-to-video movies for kids, a fashion empire and a long period of world domination.

Let's Get SMALL(ER)

GOODBYE TO ALL THAT: SOMETIMES CHANGE CAN BE *VERY* DRAMATIC

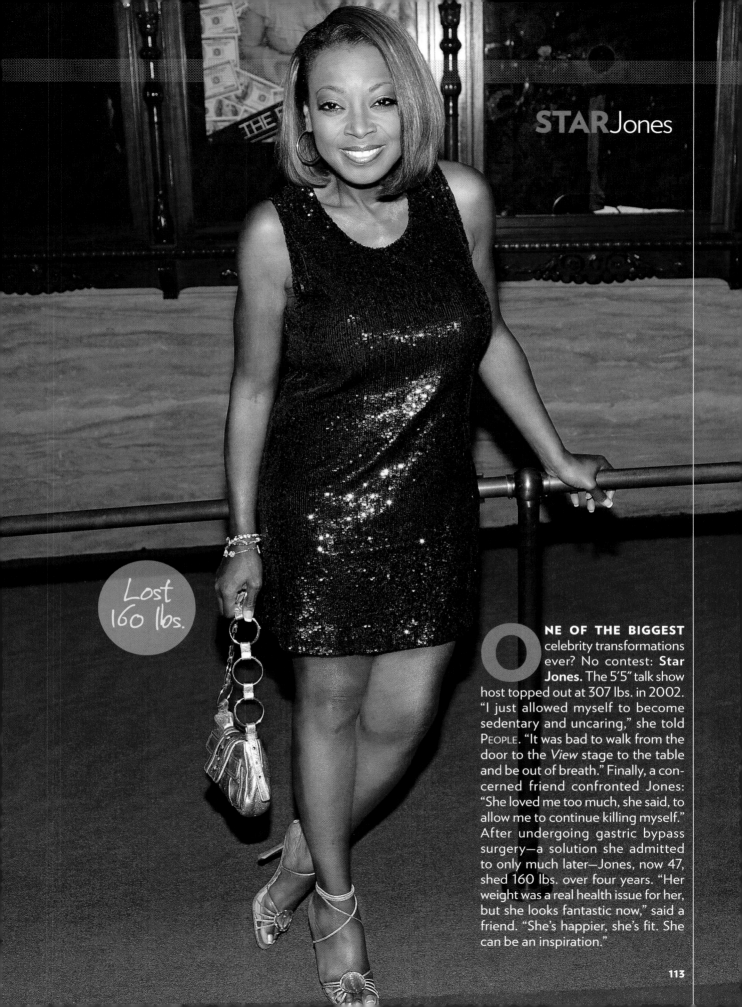

STAR Jones

Lost 160 lbs.

ONE OF THE BIGGEST celebrity transformations ever? No contest: **Star Jones.** The 5′5″ talk show host topped out at 307 lbs. in 2002. "I just allowed myself to become sedentary and uncaring," she told PEOPLE. "It was bad to walk from the door to the *View* stage to the table and be out of breath." Finally, a concerned friend confronted Jones: "She loved me too much, she said, to allow me to continue killing myself." After undergoing gastric bypass surgery—a solution she admitted to only much later—Jones, now 47, shed 160 lbs. over four years. "Her weight was a real health issue for her, but she looks fantastic now," said a friend. "She's happier, she's fit. She can be an inspiration."

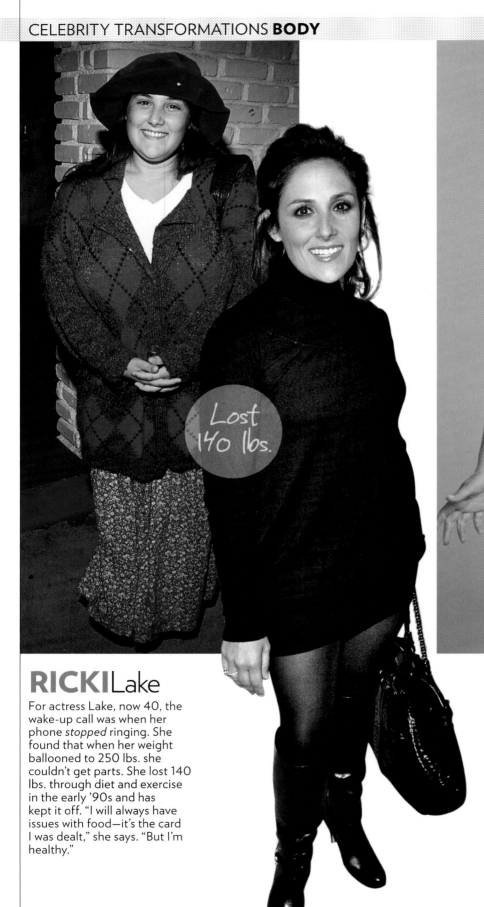

Lost 140 lbs.

RICKILake

For actress Lake, now 40, the wake-up call was when her phone *stopped* ringing. She found that when her weight ballooned to 250 lbs. she couldn't get parts. She lost 140 lbs. through diet and exercise in the early '90s and has kept it off. "I will always have issues with food—it's the card I was dealt," she says. "But I'm healthy."

Valerie **BERTINELLI**

The teenage star of the '70s sitcom *One Day at a Time* slooooowwwwly added pounds over the years—and woke up in 2007 40 lbs. overweight. She lost the weight using the Jenny Craig program (and became a company spokeswoman). "I'm so excited," she said. "I feel I have turned a corner. I've changed my life."

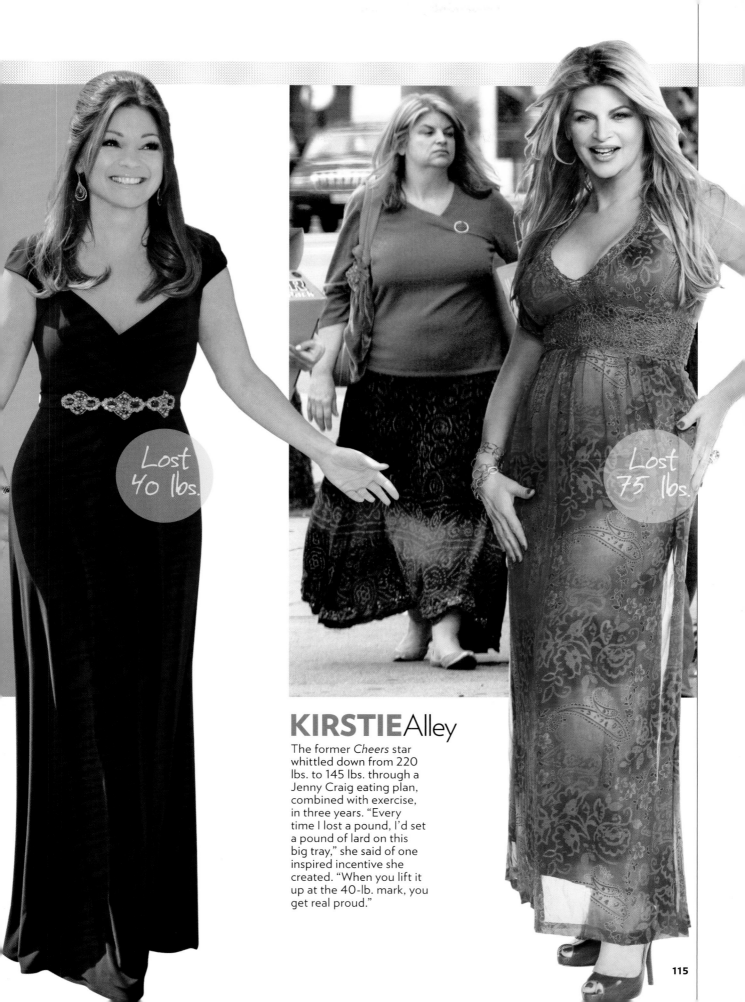

Lost 40 lbs.

Lost 75 lbs.

KIRSTIE Alley

The former *Cheers* star whittled down from 220 lbs. to 145 lbs. through a Jenny Craig eating plan, combined with exercise, in three years. "Every time I lost a pound, I'd set a pound of lard on this big tray," she said of one inspired incentive she created. "When you lift it up at the 40-lb. mark, you get real proud."

Lost 70 lbs.

CARNIEWilson

The world's most famous gastric bypass patient—she broadcast her surgery on the Internet in 1999—went from 300 to 148 lbs. in 16 months, then slipped into bad habits during and after pregnancy and hit 241. On *Celebrity Fit Club 4* in 2006, she brought her weight back down to 166.

OPRAHWinfrey

Grand Oprah? Lite Oprah? No one has battled her weight, over so many years, as publicly as the talk show goddess. Last December she admitted that she had regained 40 lbs. and vowed to again scale the mountain—and perhaps mount the scales?—in 2009.

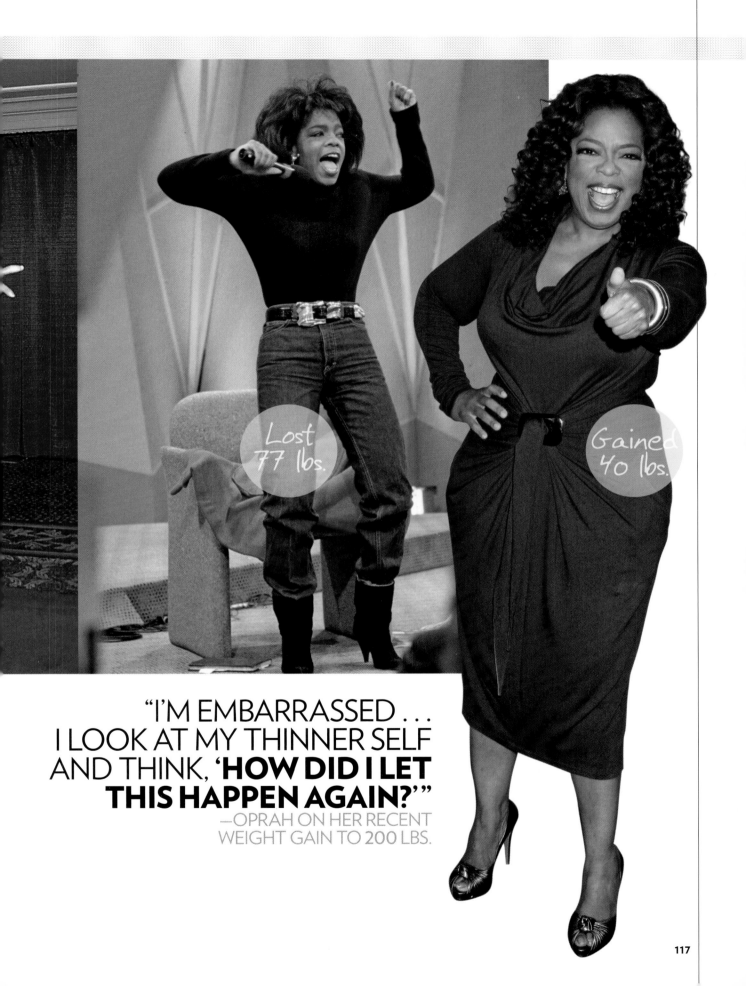

Lost 77 lbs.

Gained 40 lbs.

"I'M EMBARRASSED . . .
I LOOK AT MY THINNER SELF
AND THINK, '**HOW DID I LET
THIS HAPPEN AGAIN?**'"
—OPRAH ON HER RECENT
WEIGHT GAIN TO 200 LBS.

QUEEN Elizabeth

1920s

1930s

1940s
 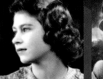 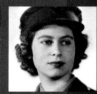

1950s
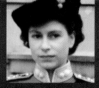 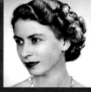 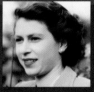 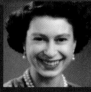 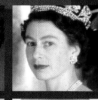

1960s
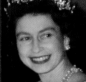 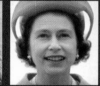

1970s
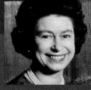 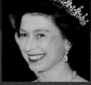 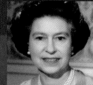 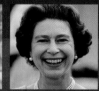 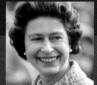 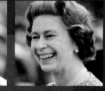

1980s
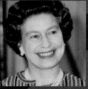 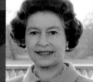 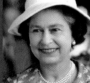 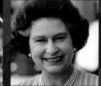 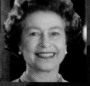 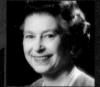

1990s
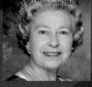 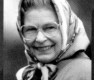 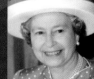 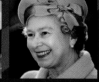 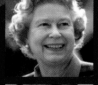 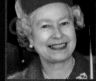

2000
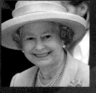 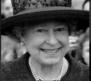 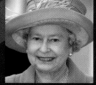 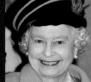 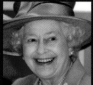 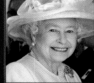

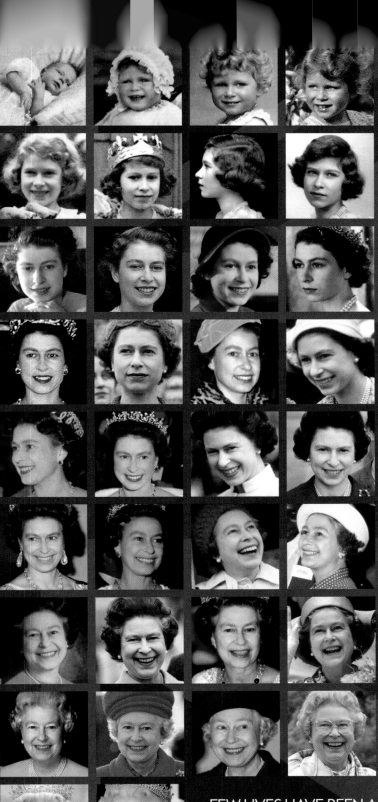

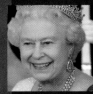

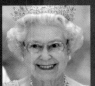

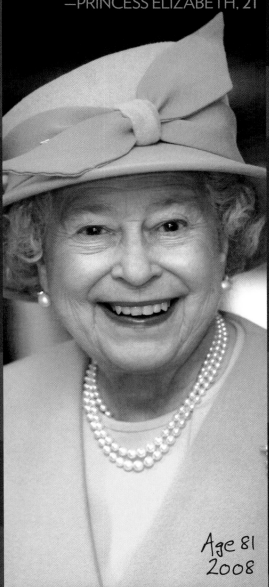

"I DECLARE BEFORE YOU ALL THAT MY WHOLE LIFE, WHETHER IT BE LONG OR SHORT, **SHALL BE DEVOTED TO YOUR SERVICE**"
—PRINCESS ELIZABETH, 21

Age 81 2008

FEW LIVES HAVE BEEN AS THOROUGHLY PHOTOGRAPHED AS THAT OF GREAT BRITAIN'S QUEEN ELIZABETH II, 82, AN OBJECT OF NATIONAL FASCINATION SINCE HER BIRTH ON APRIL 21, 1926

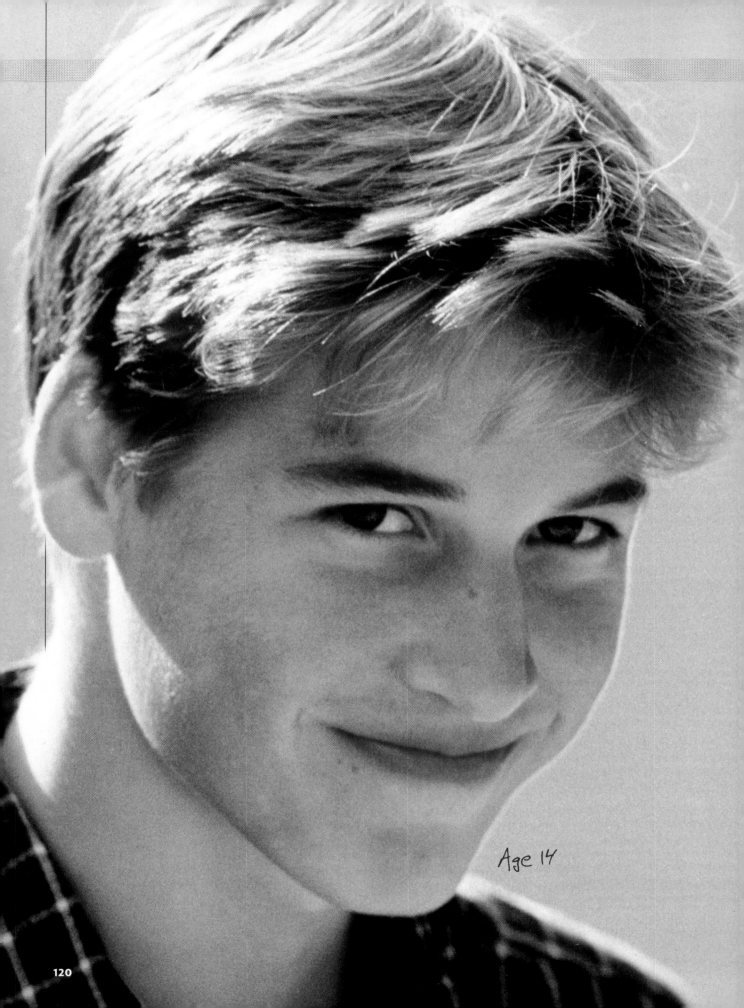

Age 14

Prince WILLIAM

A FUTURE KING WEARS HIS DESTINY WITH DISARMING EASE

Age 4

Age 18

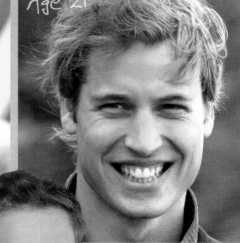
Age 21

Age 25

SOMEDAY, MIGHT THIS FACE BE COIN OF THE REALM?
"He has the sensitivity and thoughtfulness of Charles," said one observer, with Diana's "dirty sense of humor." As for grace, the prince was modest: "I love Scottish dancing," he said during college. "I'm hopeless, but I enjoy it. I throw my arms dangerously around, and girls fly across the dance floor."

IN THE BEGINNING, HE WAS KING TOT, THE tiny heir to the throne whose antics mesmerized a nation. Then, at about age 14, crushworthy cuteness struck, landing a mortified **Prince William** on the cover of British teen mags like *Smash Hits* (the issue that contained I Love Willy stickers sold a smashing 250,000 copies). "This is the first time a member of the royal family has been popular with teenagers," noted the editor of rival publication *Live & Kicking*. Will's secret? Perceived "snoggability" (translation: "kissability"). At his first dance, female contemporaries apparently tried to test that perception—which, but for one thing, seemed like a fine idea to the prince. "Lots of girls tried to kiss me," he reportedly told his mother, Princess Diana, "but I didn't do anything because the cameras are everywhere."

It's likely that during the next few years the prince, named one of PEOPLE's Sexiest Men Alive in 2003, made up for lost opportunity. Now 26, he's serving in the Royal Navy and very involved with longtime love Kate Middleton, 27.

2008

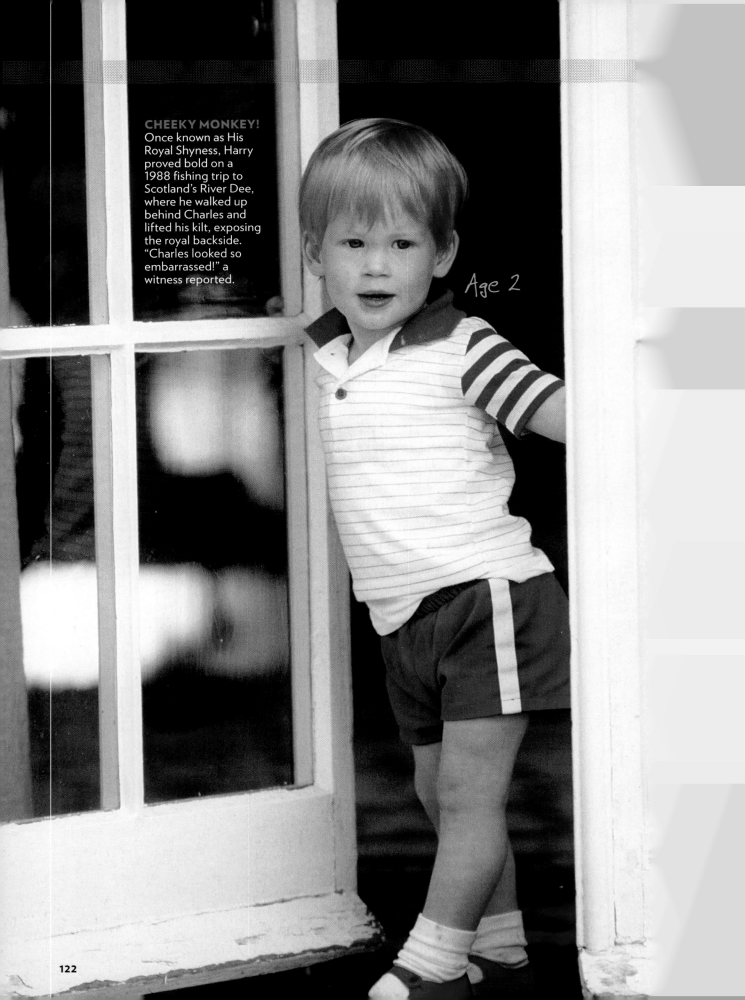

CHEEKY MONKEY!
Once known as His Royal Shyness, Harry proved bold on a 1988 fishing trip to Scotland's River Dee, where he walked up behind Charles and lifted his kilt, exposing the royal backside. "Charles looked so embarrassed!" a witness reported.

Age 2

Prince HARRY

DI'S WILD CHILD GROWS UP TO BE A SOLDIER—AND, STILL, A BIT OF A CHARMING SCAMP

Age 8

Age 13

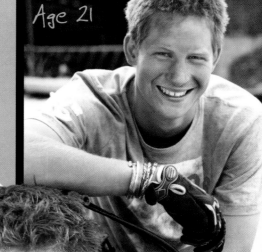

Age 21

HIS LIFE IN PICTURES
On Harry's first day of school, "there were 120 photographers" on hand to capture the moment, his former bodyguard recalled. "How do you deal with that as a 5-year-old? But his mother said to him, 'Wave your hand and smile. You are going to be doing that the rest of your life.'"

Age 22

TO HIS MUM, PRINCESS DIANA, HE WAS "the naughty one." To the more waggish British royal watchers, the little brother of Prince William, second in line to the throne of England, **Harry** (born Henry Charles Albert David) was known, fondly if irreverently, as "the spare." He was only 12 when Diana died, "A particularly vulnerable age," noted a family friend after Harry's teen partying—and, most notoriously, a mind-bendingly dumb decision to wear Nazi regalia to a costume event—landed him in the tabloids. In the end he managed to redeem himself with tact ("She's a wonderful woman, and she's made our father very, very happy," he said of Charles's marriage to Camilla Parker Bowles), a sense of duty (he lobbied hard, and successfully, to serve in Afghanistan in 2008) and a disarming, dimpled charm that reminds many of his mother. "He is," said a Palace source, "the one who remembers her most deeply."

2008

SPIRITUALChange

IT'S VERY POSSIBLE TO GO THROUGH A HUGE TRANSFORMATION AND STILL *LOOK* THE SAME. JUST ASK STEPHEN AND KIRK

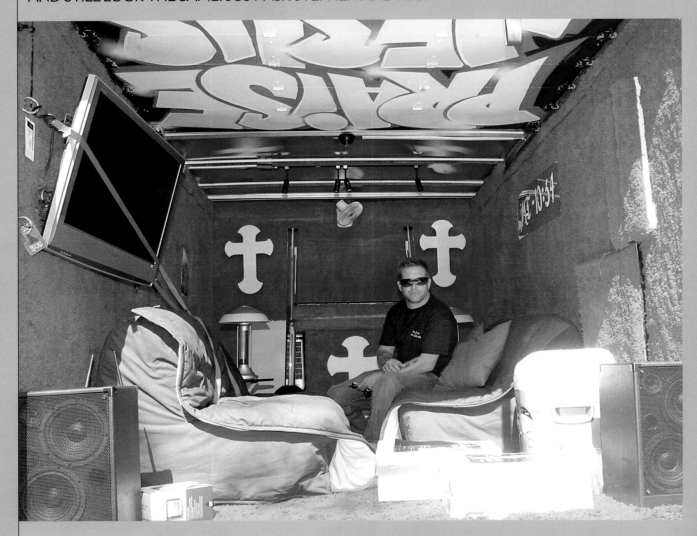

StephenBALDWIN

WHEN DID HE BECOME born-again? "After 9/11," says actor **Stephen Baldwin,** age 42. "It was an event I deemed to be a total impossibility. So, I thought, Now anything is possible. And if that's true, then it's possible Jesus Christ is the Savior." In 2006 he published *The Unusual Suspect,* about his life and conversion; to promote it, he traveled the U.S. in the Lord's Lounge, a truck outfitted with a shag carpet and a pulpit. He borrowed the idea from Matthew McConaughey. who, Baldwin noted, "shrink-wrapped his trailer [with an ad for the movie *Sahara*] and drove it cross-country."

A VAN AND A PLAN
Baldwin's truck had advertising on the side and a pulpit in the back. "When little kids look inside," he said, they go, "'Mom, we gotta get one of these.'"

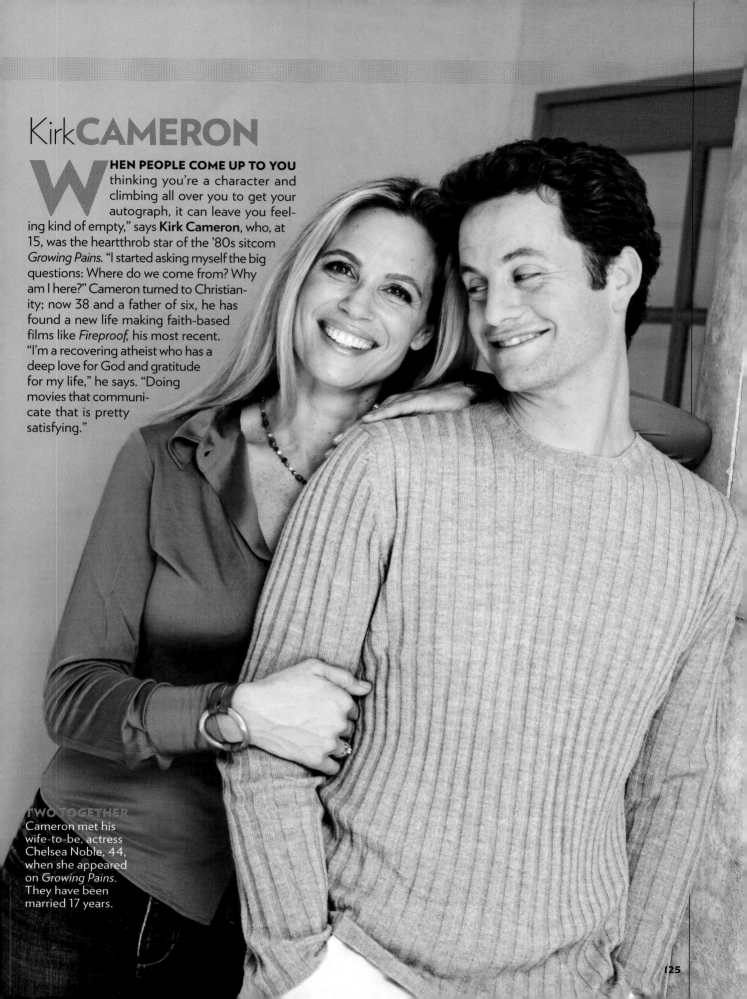

Kirk**CAMERON**

WHEN PEOPLE COME UP TO YOU thinking you're a character and climbing all over you to get your autograph, it can leave you feeling kind of empty," says **Kirk Cameron**, who, at 15, was the heartthrob star of the '80s sitcom *Growing Pains.* "I started asking myself the big questions: Where do we come from? Why am I here?" Cameron turned to Christianity; now 38 and a father of six, he has found a new life making faith-based films like *Fireproof,* his most recent. "I'm a recovering atheist who has a deep love for God and gratitude for my life," he says. "Doing movies that communicate that is pretty satisfying."

TWO TOGETHER
Cameron met his wife-to-be, actress Chelsea Noble, 44, when she appeared on *Growing Pains.* They have been married 17 years.

125

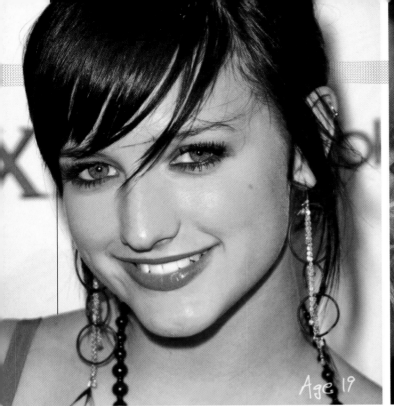

Age 19

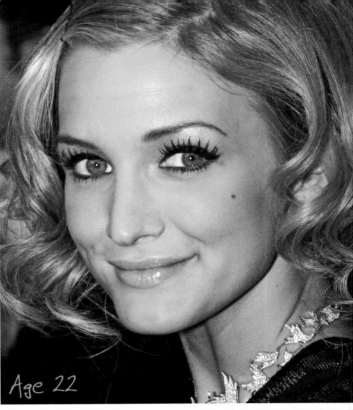

Age 22

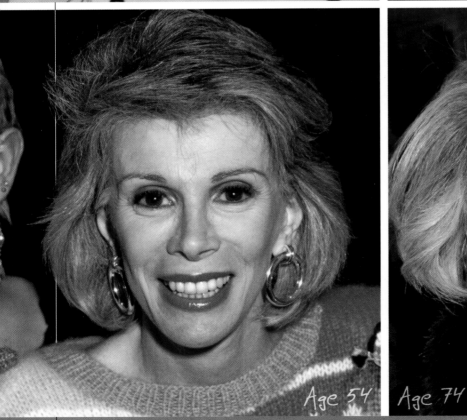

Age 54

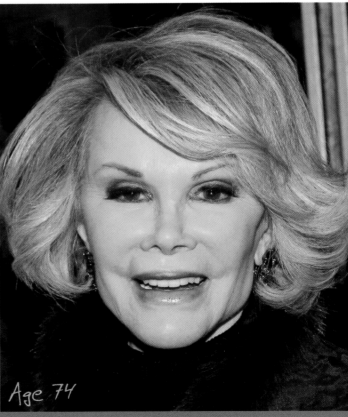

Age 74

MORE THAN MAKEUP?

SOMETHING'S DIFFERENT. IS IT YOUR HAIR?
WAIT, DON'T TELL ME, LET ME GUESS . . .

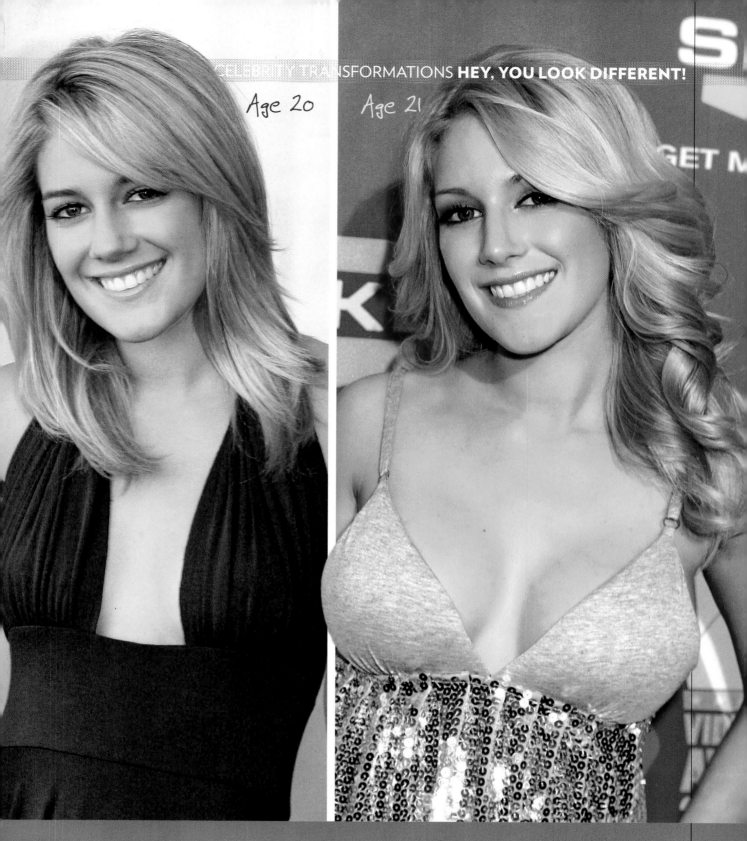

Age 20

Age 21

RUMORS CIRCULATED IN 2006 THAT **Ashlee Simpson** had a nose job (for the record, she has only said that plastic surgery is "a personal choice"). By contrast, *The Hills*'s **Heidi Montag** was up-front about having both a nose job and breast augmentation ("This was the right decision," she said, "and who's to judge or tell me otherwise?"). That, no doubt, made perfect sense to **Joan Rivers,** a fan of cosmetic surgery who has had multiple procedures (including lips, breasts, nose and eyes) and has even coauthored a women's guide to plastic surgery called *Men Are Stupid . . . And They Like Big Boobs.*

CH-CH-CHANGES Simpson (top left) with a new do . . . and more?; Rivers revised (left); and Montag, who, nowadays, can barely contain herself.

Masthead

EDITOR Cutler Durkee **CREATIVE DIRECTOR** Sara Williams **DIRECTOR OF PHOTOGRAPHY** Chris Dougherty **ART DIRECTOR** Scott A. Davis **PHOTOGRAPHY EDITOR** C. Tiffany Lee-Ramos **WRITER** Steve Dougherty **REPORTERS** Hugh McCarten, Gail Nussbaum, Ellen Shapiro, Mary Shaughnessy, Christina Tapper **COPY EDITORS** Ben Harte, Gabrielle Danchick, Alan Levine, Amanda Pennelly, Mary Radich, JoanAnn Scali, Jennifer Shotz **SCANNERS** Brien Foy, Stephen Pabarue **IMAGING** Romeo Cifelli, Francis Fitzgerald, Charles Guardino, Jeff Ingledue, Rob Roszkowski **SPECIAL THANKS TO** Robert Britton, David Barbee, Jane Bealer, Margery Frohlinger, Ean Sheehy, Céline Wojtala, Patrick Yang

TIME INC. HOME ENTERTAINMENT

PUBLISHER Richard Fraiman **GENERAL MANAGER** Steven Sandonato **EXECUTIVE DIRECTOR, MARKETING SERVICES** Carol Pittard **DIRECTOR, RETAIL & SPECIAL SALES** Tom Mifsud **DIRECTOR, NEW PRODUCT DEVELOPMENT** Peter Harper **DIRECTOR OF TRADE MARKETING** Sydney Webber **ASSISTANT DIRECTOR, BOOKAZINE MARKETING** Laura Adam **ASSISTANT DIRECTOR, BRAND MARKETING** Joy Butts **ASSOCIATE COUNSEL** Helen Wan **BOOK PRODUCTION MANAGER** Suzanne Janso **DESIGN & PREPRESS MANAGER** Anne-Michelle Gallero **BRAND & LICENSING MANAGER** Alexandra Bliss **SPECIAL THANKS TO** Glenn Buonocore, Susan Chodakiewicz, Lauren Hall, Margaret Hess, Jennifer Jacobs, Brynn Joyce, Melissa Kong, Robert Marasco, Amy Migliaccio, Brooke Reger, Ilene Schreider, Adriana Tierno, Alex Voznesenskiy

ISBN 10: 1-60320-066-5
ISBN 13: 978-1-60320-066-0
Library of Congress Number: 2009900528
Copyright © 2009 Time Inc. Home Entertainment. Published by People Books, Time Inc., 1271 Avenue of the Americas, New York, N.Y. 10020. All rights reserved.

Credits

FRONT COVER
(top from left) Lee Sporkin/Shooting Star; Stephane Cardinale/People Avenue/Corbis; Splash News; Gilbert Flores/Celebrity Photo; (middle from left) Marc Biggins/Getty Images; Bill Davila/Starttraks; Rex USA; Tim Wagner/Zuma; (bottom from left) Steve Granitz/Wireimage; Sonia Moskowitz/Globe; Gregg DeGuire/Wireimage; Dimitrios Kambouris/Wireimage

TITLE PAGE
1 (from top) Sylvia Sutton/Globe; Alpha/Globe; Steve Azzara/Corbis; Corbis; Janet Gough/Celebrity Photo

CONTENTS
2-3 (top, from left) Bauer-Griffin; Photo Image Press; London Features; Aaron Lambert/Getty Images; Gilbert Flores/Celebrity Photo; Myung Jung Kim/EPA/Landov; (bottom, from left) Seth Poppel/Yearbook Library; WENN; John Paschal/Celebrity Photo; Debbie Van Story/iPhoto; Michael Ochs Archives/Getty Images; Pauline French/Famous

MOVIES
4 Yariv Milchan/Corbis; 5 Philip Wong/Camera Press/Retna; 6 (clockwise from top left) Monica Roberts; Seth Poppel/Yearbook Library; Philip Wong/Camera Press/Retna; 7 (clockwise from left) George Holz/Contour by Getty Images; Jerry Watson/Camerapress/Retna; Gilbert Flores/Celebrity Photo; 8 (from left) Albert Ferreira/Startraks; Kevin Winter/Getty Images; 9 (clockwise from left) Vincent Kessler/Reuters; Gilbert Flores/Celebrity Photo; Jonathan Evans/Reuters; Matrix/Bauer-Griffin; Maciel-Alphax/X 17; 10 Lee Sporkin/Shooting Star; (inset) Seth Poppel/Yearbook Library; 11 (clockwise from top) Mirek Towski/DMI/Rex USA; Stephane Cardinale/People Avenue/Corbis; John Paschal/Celebrity Photo; 12 (clockwise from top left) Nicola Pittam/Splash News; Lynn McAfee/Retna; Michael Ferguson/Globe; Steve Granitz/Wireimage; Lockwood/Globe; 13 (clockwise from top left) Berry King/Wireimage; Alex Bailey/Corbis; Charles Sykes/Rex USA; Jason Kempin/Filmmagic; Evan Agostini/Getty Images; David Fisher/London Features; 14 Rex USA; 15 (clockwise from top left) Seth Poppel/Yearbook Library; Phil Loftus/Capital Pictures/Retna; Brad Stein/Startraks; Gregg DeGuire/Wireimage; 16 MPTV; 17 Ang/Fame; 18 (clockwise from top left) Splash News (2); Barry King/Shooting Star; Janet Gough/Celebrity Photo; Mark Leivdal/Shooting Star; 19 (clockwise from top right) Ron Tom/NBCU Photo Bank; Mark Leivdal/Shooting Star; Jeff Vespa/Wireimage; Frank Trapper/Corbis; Stephen Trupp/StarMax; 20 (clockwise from top left) Seth Poppel/Yearbook Library; Walter McBride/Retna; MPTV; Glenn Weiner/MPTV; Reuters; MPTV; 21 (clockwise from top left) Retna; Roxy Rifkin/Shooting Star; Jeff Kravitz/Filmmagic; Mark J. Terrill/AP; Andrea Renault/Globe; 22 Jim Smeal/Wireimage; 23 (clockwise from top left) Globe; K.Mazur/Wireimage; Vince Flores/Celebrity Photo; DPA/Landov; Sylvia Sutton/Globe; 24 (from left)

25 (from left) Baverel-Lefranc/Corbis; Hahn-Khayat/Abaca; 26 (clockwise from left) Genevieve Naylor/Corbis; Ron Galella/Wireimage; Bettmann/Corbis; 27 (clockwise from top left) Cat's Collection/Corbis; Everett; Steve Schapiro; Jon Kopaloff/Filmmagic; 28 Herb Ritts Foundation/Limefoto; 29 (clockwise from top left) Seth Poppel/Yearbook Library; STR/AFP/Getty Images; Raoul Gatchalian/Starmax; Retro-Hounsfield-Maude Press-Laz/SIPA; 30 Jade Albert; 31 Dimitrios Kambouris/Wireimage; 32 (clockwise from top left) Rose Prouser/Reuters; Ray Mickshaw/Wireimage; Sonia Moskowitz/Globe; 33 (clockwise from top) AlphaX/X 17; Simon Ferreira/Startraks; Shawn/X 17; 34 Hulton Archive/Getty Images; 35 Nigel Parry/CPi; 36 (from top) Peter C. Borsari; Bruce McBroom/MPTV; 37 (clockwise from right) Dave Allocca/Startraks; Alan Singer/CBS/Landov; Playboy; 38 Cliff Lipson/Wireimage; 39 (clockwise from top left) Seth Poppel/Yearbook Library; ScreenScenes; Janet Gough/Celebrity Photo; Debbie VanStory/RockinExposures/iPhoto; Matt Baron/Beimages; 40 Seth Poppel/Yearbook Library; 41 (from left) Phil Roach/IPOL/IPOL/Globe; George Pimentel/Wireimage; 42 (clockwise from top left) WENN (3); Lee Salem/Shooting Star; Carlo Allegri/Getty Images; Tony Barson/Wireimage; Glenn Weiner/MPTV; 43 Headpress/Retna; Eric Roberts/Corbis; Rex USA; Fernando Allende/Splash News; Gilbert Flores/Celebrity Photo; Michael Caulfield/Contour by Getty Images; 44 (from left) Camilla Morandi/Rex USA; Paul Buck/EPA; DS-ISM-BB/Flynet; 45 (from left) Axelle/Bauer-Griffin; WENN; Picture Perfect/Rex USA

SCREEN GODDESSES
46 Everett; 47 Bob Willoughby/MPTV; 48 (from left) Bob Landry/Time Life Pictures/Getty Images; Bob Willoughby/MPTV; 49 (clockwise from right) Getty Images; MPTV; Photofest; 50 (clockwise from top left) John Springer Collection/Corbis; Kobal; Peter Stackpole/Time Life Pictures/Getty Images; Everett; Scott Downie/Celebrity Photo; Globe; Yoram Kahana/Shooting Star; Hulton Archive/Getty Images; 51 (clockwise from top left) MPTV; Hulton Archive/Getty Images (2); Forum Press/Rex USA; Giulio Marcocchi/SIPA; Tammie Arroyo/AFF (2); Rex USA; SIPA; 52 Eugene Richee/MPTV; 53 (clockwise from top left) Natalie Perske/Hulton Archive/Getty Images; Bettmann/Corbis(2); John MacDougall/AFP/Getty Images; Photofest

MUSIC
54 Seth Poppel/Yearbook Library; 55 Steven Klein/H&M/ED/DW/Camera Press/Retna; 56 (from left) Alpha/Globe; London Features; 57 (from left) Oscar White/Corbis; Doc Pele/Stills/Retna; 58 (from left) Ralph Dominguez/Globe; Frank Micelotta/Getty Images; 59 (from left) Dan MacMedan/Wireimage; David Miller/Abaca; 60 MPTV; 61 Carlo Allegri/Getty Images; 62 (clockwise from top left) London Features; Jim McCrary/IPOL/Globe; Michael Ochs Archives/Getty Images; Andrew Shawaf/Getty Images; Ramey;

Gilbert Flores/Celebrity Photo; Neal Preston/Corbis; 63 (clockwise from top left) Dave Hogan/Getty Images; Polaris; Janet Gough/Celebrity Photo; Matt Baron/Beimages; Chris-Jason/National Photo Group; Ebet Roberts/Retna; 64 Lance Staedler/Corbis; 65 (clockwise from top left) Globe; Tom Hill/Wireimage; Sonia Moskowitz/Globe; CBS/Landov; 66 Mike Ruiz/Contour by Getty Images; 67 (clockwise from top left) Charlie Varley/SIPA (2); Seth Poppel/Yearbook Library; Marc Baptiste/Corbis; Seth Poppel/Yearbook Library; 68 Kevin Kane/Wireimage; 69 (clockwise from top left) Kevin Mazur/Wireimage; Robert Galbraith/Reuters; Greitschus/Agency People Image/SIPA; MBF/X 17; 70 Courtesy Cyrus Family; 71 Michael Lavine/CPi; 72 Courtesy Jonas Brothers; 73 Fontaine-Dalle/Retna; 74 Courtesy Elton John; 75 (clockwise from top left) David Dagley/Rex USA; Barrie Wentzell; Richard Young /Rex USA; Splash News; 76 George Rodriguez/Shooting Star; 77 (clockwise from top left) Michael Ochs Archives/Getty Images; Chris Walter/Wireimage; Jenny Bierlich/Starmax; Dominique Charriau/Wireimage; Kevin Mazur/Wireimage; David Buchan-Mike Carrillo/Pacific Coast News; Chris Pizzello/Landov; 79 (clockwise from top right) Fox; Henry McGee/Globe; Roger Karnbad/Celebrity Photo; Fox; Seth Poppel/Yearbook Library (2); 80 (from left) Seth Poppel/Yearbook Library; Steve Granitz/Wireimage; 81 George Holz/Contour by Getty Images; 82 Kevin Mazur/Wireimage; (inset) Everett; 83 (clockwise from top left) Ralph Dominguez/Globe; Eugene Adebari/Rex USA; Phil Roach/IPOL/Globe; Ron Galella/Wireimage; Kevin Mazur/Wireimage; Vince Bucci/Getty Images; Steve Granitz/Wireimage; Scott Downie/Celebrity Photo; 84 Lynn Goldsmith/Corbis; 85 Ben Watts/Corbis Outline; 86 MPTV; 87 (clockwise from top) MPTV; Peter Brooker/Rex USA; Michael Ferguson/Globe; Seth Poppel/Yearbook Library (2); 88 (clockwise from left) Toby Canham/Splash News; Seth Poppel/Yearbook Library; Evan Agostini/Beimages; 89 (clockwise from left) Jeff Vespa/Wireimage; Steve Azzara/Corbis; Frank Trapper/Corbis; Miranda Shen/Celebrity Photo; 90 (clockwise from top left) Splash News; John Elliot/Getty Images; News Ltd/Newspix/Rex USA; 91 Rick Diamond/Wireimage; 92 Dick Barnatt/Redferns/Retna; 93 (clockwise from top left) Mark Sennet/Shooting Star; David Ellis/Retna; London Weekend Television/Rex USA; Eugene Adebari/Rex USA; Kevin Winter/Getty Images

FASHION
94 (from left) Willi Schneider/Rex USA; Theo Wargo/Wireimage; Gilbert Flores/Celebrity Photo; 95 (from left) Matt Baron/Beimages; John B. Zissel/IPOL/Globe; Gary Lewis/Retna; 96 (clockwise from top left) Harry Page/News Int'l; Rex USA; Eamonn-James Clarke/PA Photos/Empics/Retna; Frank Harrison/Getty Images; Kevin Mazur/Wireimage; 97 (clockwise from top left) Kelly Jordan/Globe; Matrix/Bauer-Griffin; Splash News; Stephen Lovekin/Getty Images; Matt Baron/Beimages; Richard Young/Rex USA

TV
98 Bill Davila/Startraks; 99 Seth Poppel/Yearbook Library; 100 (clockwise from top left) Seth Poppel/Yearbook Library (2); The Tennessean; Everett; Splash News; Walter McBride/Retna; Scott Downie/Celebrity Photo; Ralph Dominguez/Globe; 101 (clockwise from top left) The Baltimore Sun Company; Kevin Horan/Zuma; Dana Fineman/Vistalux; Jim Ruymen/UPI/Landov; Tammie Arroyo/AFF; DMI/Rex USA; 102 (clockwise from top left) Bauer-Griffin; Gene Trindl/MPTV; Miranda Shen/Celebrity Photo; 103 (from left) Diana Lyn/Shooting Star; Everett; 104 (from left) Jim Smeal/Wireimage; John Paschal/Celebrity Photo; 105 (from left) AT1/Xposure/Starmax; George Taylor/Everett; 106 Elmar Biebl/Shooting Star; 107 Jeffrey Mayer/Wireimage; 108 (clockwise from top left) Seth Poppel/Yearbook Library; Globe; Ulvis Alberts/MPTV; Ron Galella/Wireimage; Russ Einhorn/Starmax; Ron Galella/Wireimage (2); Scott Downie/Celebrity Photo; 109 (clockwise from top left) Allan S. Adler/IPOL (2); Yoram Kahana/Shooting Star; Victor Malafronte/Celebrity Photo; Matt Baron/Beimages; Amy Graves/Wireimage; Fernando Allende/Celebrity Photo; Victor Malafronte/Celebrity Photo (2); 110 (clockwise from top left) ABC Photo Archives; Martha Noble/Globe; Bob D'Amico/ABC/Retna; Paul Fenton/Shooting Star; Splash News; Albert Ferreira/Startraks; Alberto Rodriguez/Beimages; Tammie Arroyo/JPI; Steve Granitz/Wireimage; Peter Freed/Corbis; 111 (clockwise from top left) Ron Galella/Wireimage; John Paschal/Celebrity Photo; Steve Eichner/Wireimage; Scott Downie/Celebrity Photo; Chris Weeks/Beimages; Gilbert Flores/Celebrity Photo; Jennifer Graylock/JPI; James Devaney/Wireimage; Matt Baron/Beimages; Susan Goldman/US Women's World Cup; Anders Krusberg/Startraks

SMALLER
112 Lawrence Lucier/Getty Images; 113 Alexander Tamargo/Getty Images; 114 (from left) Ralph Dominguez/Globe; Mavrix Photo; Stephen Danelian; 115 (from left) Chris Delmas/Visual Press; Fame; Brian Doben; 116 (from left) Kathy Hutchins/Hutchins; Marc Royce; Judie Burstein/Globe; 117 (from left) Charles Bennett/AP; James Murphy/Loud & Clear

ROYALS
118 (first row from left) Empics/PA; Hulton-Deutsch Collection/Corbis; Mirrorpix/Zuma; Richard Gardner/Rex USA; Marcus Adams/Camera Press/Retna (2); (second row from left) Marcus Adams/Camera Press/Retna (2); Cecil Beaton/The Royal Collection/Camera Press/Retna; Karsh/Camera Press/Retna; Bettmann/Corbis; Dorothy Wilding/Camera Press/Retna; (third row from left) Baron/Camera Press/Retna; Alpha/Globe; Dorothy Wilding/Camera Press/Retna; Bettmann/Corbis; Marcus Adams/Camera Press/Retna; Camera Press/Retna; (fourth row from left) Edward Wing/Rex USA; Alpha/Globe; John Bulmer/Camera Press/Retna; Hulton Archive/Getty Images; Cecil Beaton/Camera Press/Retna; Fox Photos/Getty Images; (fifth row from left) Keystone/Hulton Archive/Getty Images; Hulton Archive/Getty Images; Joan

Williams/Rex USA; Tim Graham Photo Library/Getty Images (3); (sixth row from left) T.Eyles/Rex USA; Joan Williams/Rex USA; JS Library/Camera Press/Retna; Tim Graham Photo Library/Getty Images; Joan Williams/Rex USA; John Lawrence/Camera Press/Retna; (seventh row from left) Terry O'Neill/Getty Images; Tim Graham Photo Library/Getty Images (3); David Hartley/Rex USA; Tim Graham Photo Library/Getty Images; (eighth row from left) Tim Graham Photo Library/Getty Images; Alpha/Globe; Steve Daniels/Alpha/Globe; Alpha/Globe; Rex USA; Tim Graham Photo Library/Getty Images; 119 (first row from left) Rex USA; Spice/Camera Press/Retna; Marcus Adams/Camera Press/Retna; The Royal Collection/Camera Press/Retna; (second row from left) Lisa Sheridan/Studio Lisa/Camera Press/Retna; Empics/PA; Marcus Adams/Camera Press/Retna (2); (third row from left) Lisa Sheridan/Studio Lisa/Getty Images; Bettmann/Corbis; Baron/Camera Press/Retna (2); (fourth row from left) Bettmann/Corbis (2); Edward Wing/Rex USA; Alpha/Globe; (fifth row from left) Keystone/Getty Images; Fox Photos/Getty Images; Alpha/Globe; Hulton-Deutsch Collection/Corbis; (sixth row from left) Alpha/Globe; Hulton Archive/Getty Images; Tim Graham/Getty Images; Hulton Archive/Getty Images; (seventh row from left) HRH Prince Andrew/Camera/Press/Retna; Tim Graham Photo Library/Getty Images; Nils Jorgensen/Rex USA; Glenn Harvey/Camera Press/Retna; Brian Aris/Camera Press/Retna; David Hartley/Rex USA; Tim Graham Photo Library/Getty Images; Mark Stewart/Camera Press/Retna; (ninth row from left) Ian Jones/PA/Abaca USA; Roger L. Wollenberg/Landov; Anwar Hussein Collection/ROTA/Wireimage; 120 James Gray/Rex USA; 121 (clockwise from top left) Tim Graham/Getty; Alpha/Globe; Postlethwaite/SIPA; John Stillwell/AP; 122 Tim Graham Photo Library/Getty Images; 123 (clockwise from top left) Martin Keene/PA/AP; Dave Chancellor/Alpha/Globe; Mario Testino/ROTA/Camera Press/Retna; Lewis Whyld/UPPA/Zuma

RELIGION
124 Lawrence Schwartzwald/Splash News; 125 Courtesy Kirk Cameron

HEY, YOU LOOK DIFFERENT!
126 (clockwise from top left) Lisa Rose; Bruce Gilkas/Filmmagic; Jemal Countess/Wireimage; Ron Galella/Wireimage; 127 (from left) Katy Winn/Getty Images; Mike Stotts/WPN

BACK COVER (top from left)
Ron Tom/NBCU Photo Bank; Jeff Vespa/Wireimage; Globe; Evan Agostini/Getty Images; (middle from left) Everett; Forum Press/Rex USA; Globe; (bottom from left) Lawrence Lucier/Getty Images; Alexander Tamargo/Getty Images; Gary Marshall/Shooting Star; WENN

BACK FLAP (clockwise from top left)
Seth Poppel/Yearbook Library; George Pimentel/Wireimage; Kevin Mazur/Wireimage; Hahn-Khayat/Abaca; Peter Brooker/Rex USA; Seth Poppel; Globe; Seth Poppel

A NOTE ABOUT AGES Throughout this book, great care has been taken to determine ages correctly. In many old photographs, however, only the year the image was taken—not the day or month—is known. In those cases, we followed a convention: For celebrities born January through June, we assumed their birthday had already occurred; for July through December, we assumed that year's birthday was still to come. In the absence of clear evidence for either the year of the picture or the age of the celebrity, we have marked the image "Age unknown," and, if it falls in a sequence of photographs, made an educated guess about where it belongs.